D0407559

How Georgia Became
O'Keeffe

How Georgia Became O'Keeffe

Lessons on the Art of Living

Karen Karbo

Guilford, Connecticut
An imprint of Globe Pequot Press

To buy books in quantity for corporate use
or incentives, call **(800) 962-0973**
or e-mail **premiums@GlobePequot.com.**

skirt! ® is an attitude . . . spirited, independent, outspoken, serious, playful
and irreverent, sometimes controversial, always passionate.

skirt! is a registered trademark of Morris Publishing Group, LLC,
and is used with express permission.

Grateful acknowledgment to the Georgia O'Keeffe Museum, the Museum of Modern
Art, the Art Students League of New York, the Art Institute of Chicago, Wadsworth
Atheneum Museum of Art, and the Museum of Fine Arts of St. Petersburg, Florida,
for making possible the inclusion of artwork by Georgia O'Keeffe.

Text design: Sheryl P. Kober
Layout: Mary Ballachino
Project editor: Kristen Mellitt

Library of Congress Cataloging-in-Publication Data is available on file.

ISBN 978-0-7627-7131-8

Printed in the United States of America

10 9 8 7 6 5 4 3 2 1

For Jerrod

Contents

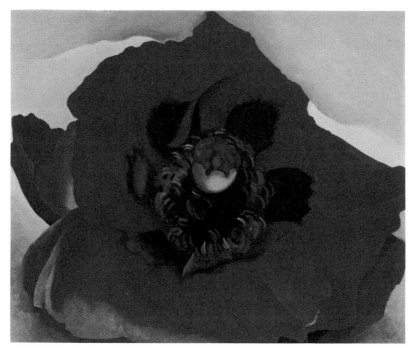

Georgia O'Keeffe
American (1887–1986)
Poppy, 1928
Oil on canvas

Gift of Charles C. and Margaret Stevenson Henderson in memory of

Jeanne Crawford Henderson 1971.32

Photograph by Thomas U. Gessler

1

DEFY

I don't see why we ever think of what others think of what we do — isn't it enough just to express yourself.

WHEN GEORGIA BECAME O'KEEFFE THERE WERE NO FEMALE art stars in America. Not one. In 1916 Georgia was an art teacher because that's what arty girls did. When she was twenty-eight, she was hired by West Texas State Normal College in the minuscule town of Canyon, Texas, due south of Amarillo. In Canyon there were a few churches, a few bars, a feed store, a blacksmith, a lot of cattle, and not much to do for sport but club rabbits. When Georgia arrived to assume her role as the entire art department, oil had yet to be discovered. Canyon was a flea on the immense dusty hide of the Texas prairie.

Georgia's students were the children of cattle ranchers. They sat on packing crates because there were no chairs.

Then, as now, staring down the barrel of thirty made many single women a little hysterical. A woman without a husband was a woman without a meaningful life. From all evidence this does not seem to have been the case with O'Keeffe. She could not have cared less. If there was a contest for making yourself as unattractive to the opposite sex as possible, Georgia would be the darling of the oddsmakers.

As a young woman she dressed as she would all her life—in long black dresses that resembled the vestments of a priest. Occasionally she went in for a white collar. When she was really in a crazy mood, she was known to pin a flower to her lapel. She was a stranger to makeup and wore her black hair pulled straight back from her face. Here, I feel the impulse to offer some details about the fashions of 1916, but it hardly matters. Whatever women were wearing in those days, this wasn't it.

Georgia's behavior was equally unconventional. The West may have been wild, but Canyon prided itself on its propriety. Ladies were expected in church on Sunday and at tea parties during the week. It didn't take much to create a stir. Georgia asked her landlords whether she might paint the trim in her attic room black, and before you could say *Don't they have any-thing better to gossip about?*, word spread that the new art teacher wanted to paint her entire room black. She ignored both church and teas, preferring to spend her time walking into the sunset. The extreme panhandle landscape had seduced

her. Every night after dinner she left town and walked west toward the orange sun easing down the back of the sky to the brown horizon. It was said she could outwalk any man. She could outlast him in that cheek-chapping middle of nowhere, reveling in the color of the sky.

It wasn't as if she had some disorder that made her clueless about the societal expectations of the day. She knew what people thought; she just didn't *care*. In a letter to her new friend Alfred Stieglitz—the so-called father of modern photography, and the man without whom the name Pablo Picasso would mean nothing to us—she wrote, "When there are so many things in the world to do it seems as if a woman ought not to feel exactly right about spending a whole day like I've spent today—and still—it did seem right—that's what gets me—it must be done—and if any one asked me—what it is—I can not even tell myself."

Lest you imagine Georgia's refusal to gussy herself up, her general bookish nature, and her compulsive need for a daily miles-long hike made her unattractive to men, think again. Georgia was rarely without suitors. By the time she'd taken the Texas teaching job in 1916, she'd already enjoyed several torturous, passionate love affairs. Arthur Whittier Macmahon, a well-heeled intellectual from Columbia University, bewitched by Georgia's perception of the natural world (it was a heady romance), wrote to her daily.

In Canyon, the local attorney, a Yale man, liked to take her for long drives on the prairie. She even enjoyed a vigorous

flirtation with a student, Ted Reid, whom she met while serving as the artistic advisor for the drama department's spring play. Reid was handsome and popular; even in those days, a star football player who also loved theater held a special appeal.

Reid was a student, O'Keeffe was a teacher. He was on one side of the twenties, she was on the other. In one account of these years, Reid was already engaged to the woman who would become his wife. On Saturdays Reid drove O'Keeffe to nearby Palo Duro Canyon ("The Grand Canyon of Texas," as it still bills itself), where they would pick their way to the bottom on the narrow cow paths, and O'Keeffe would sketch the cliffs, the sky, the occasional string of cattle that would wend its way into the canyon, seeking shelter against the merciless panhandle wind.

The townspeople tolerated what was, for the time, fairly shocking behavior, until the afternoon when O'Keeffe invited Ted Reid up to her room to see some photographs that she'd recently received from Stieglitz. This outrage was the last straw. When the gossip swirled throughout Canyon that the art teacher was entertaining one of its finest young men in her rented attic room, something happened that neatly makes the point I'm after here—that even before Georgia was O'Keeffe, when she was a near old maid trying to make ends meet, her determination to live life her own way afforded her an enviable freedom. If it were anyone else, she'd have been run out of town on a rail, but Reid was the one who received a stern

talking-to by the local matrons, Reid who was told his behavior was inappropriate and unacceptable.

One assumes that the reason the town scolds took Ted to task and not Georgia is because she had already been written off as the town eccentric, and Reid was not just one of their own, but also a favored son. Still, Georgia suffered only Ted's sudden lack of interest. She wasn't kicked out of the house in which she boarded, nor did she lose her job. As she would do for most of her life, O'Keeffe followed her own rules, and got away with it.

You'd be hard-pressed to find a life that's been more mythologized than Georgia O'Keeffe's. So many people have gushed so flagrantly over her singular style; her huge erotic flower paintings; her snappy (and occasionally snappish) bon mots; her long and unconventional marriage to Alfred Stieglitz; the otherworldly landscape of northern New Mexico, with its voluptuous land forms and many large dead animals, whose skulls and vertebrae she immortalized; and her prickly devotion to her privacy; it's amazing there aren't more O'Keeffe folk songs, limericks, totems, feast days, rituals, annual pilgrimages, and bank holidays. Given our feelings for everything she represents, it speaks well of the human race that we haven't fetched up a minor religion around her that worships independence, focus, creativity, and the proud wearing of

those bad scarves my mother used to don the day before she went to the beauty parlor.

Likewise, you'd be equally hard-pressed to find a writer who has waded into the long, productive life of O'Keeffe and who doesn't feel obligated to point all this out, the better to avoid the risk of trafficking in hagiography.* Along with many esteemed biographers and scholars (the *Selected* [emphasis mine] Bibliography: Recommended Reading list offered by the research center at the Georgia O'Keeffe Museum in Santa Fe is eight pages long), I would like to point out that much of what we know about O'Keeffe has been recast so that we might better revere her as a kick-ass lady who led a life that appeared to be charmed, epic, meaningful, and, ultimately, full of cool minimalist style.

One aspect of the myth is that there's an objective truth about her life, that somehow it's possible to know what really went on in her marriage to Stieglitz, or how much she colluded in creating her public persona as a private person, about whether Those Paintings really were vaginas, about whether she'd had affairs with women, about whether she was revered or reviled in Taos and its environs, about whether she was lonelier than she let on.

But aside from verifiable facts that have already been verified, everything is open to interpretation. Everything is always open to interpretation, maddeningly. We have her paintings.

* I hope I'm not the only one who has to keep reminding herself that this is not the study of hags, but writings on the saints. The term has come to mean the way that some biographers fawn embarrassingly over their subjects.

We have her letters, thousands of them, written to Stieglitz (sometimes several a day while they were apart), and to other boyfriends who predated him, to friends and colleagues, relatives, teachers, museum directors, critics, photographers, poets, other artists. We have all those astonishing black-and-white photographs of her, thousands of them. After Greta Garbo, Georgia O'Keeffe was the most photographed woman of the twentieth century.

And yet, she eludes us still.

But I'm okay with that. I realize this signals a lack of scholarly rigor, but I have no interest in getting to the bottom of things. I'm more interested in our fascination with O'Keeffe, generation after generation, museum show after museum show, biopic after biopic, "best of" list after "best of" list. What's behind our ongoing one-sided relationship with her image? What is it about her that speaks to us so deeply?

I was one of those college girls who hung the famous (and still best-selling) *Poppy* (1928) poster, first on the walls of her dorm and then the apartment walls of young adulthood, the white corners acquiring another pinhole with each move, in unceasing awe of O'Keeffe's absolute confidence in her own path and the power of her paintings (reproductions don't do them justice). I was deeply interested in the fact that she came from Sun Prairie, Wisconsin, a place made for leaving, from a family that was neither fabulously cultured and wealthy nor exotically dysfunctional and impoverished. I was, and still am, intrigued by her lifelong lack of interest in pretty shoes and skin care.

O'Keeffe attracts as she repels, and perhaps that's what makes her so intriguing. People like to say they don't give a damn, but O'Keeffe lived it. The proof? She was the embodiment of two aspects of living that most of us dread: being old and being alone. For O'Keeffe, forty was the new sixty. She had no problem being known for decades as the old lady in the desert with an affinity for cow skulls, an old lady in heavy black clothes with beautiful cheekbones and a lot of wrinkles, with no one for company but her various housekeepers and a pair of fierce chows who provided hours of entertainment by chasing off and occasionally biting unwanted guests.*

Few human beings manage to be so resolutely themselves for so much of their lives. If we're lucky, we're able to scrape together a few days of self-realization in high school, followed by a month or two in college, after which we fall in love and completely revamp our personality to please our beloved, or else we land a job that requires us to kiss up to someone to whom we normally wouldn't give the time of day, after which we have children and don the invisible T-shirt that says I LIVE TO SERVE.† By the time the kids are grown, we're tired and set in our ways, and all it takes is waking up in a hotel room in a new city to forget who we are completely.

O'Keeffe is the poster child for doing exactly what you want, in the service of an abiding passion. Intuitively, we know how rare this is. In 1999, Monster.com, the online employment agency, made a mockumentary commercial called

* For O'Keeffe, almost everyone fell into this category.
† I love children, and so did O'Keeffe, but the joy of raising them is another book entirely.

"When I Grow Up," which featured kids answering that age-old question. Instead of saying they wanted to be astronauts or the person who discovers the cure for cancer, they foretold their futures. "I want to file . . . all day," said one kid. "I want to climb my way to middle management," said another. "I want to be a yes-man!" said a third. The ad was wildly successful; we laughed in recognition of how hard it is to make our dreams come true.

How O'Keeffe Became Herself

Unless you're fifteen, when the point of defying convention is to piss off everyone around you, the main reason for refusing to go along with familial, societal, and economic expectations* is so you can free up your time and thoughts to pursue something meaningful. Living up to the expectations of the world can take up all your time and energy if you let it. The clearer we are about what we want and what may be our abiding passion, the easier it is to chart our own course.

In the art world, critics remain divided over whether O'Keeffe was a genius or merely an energetic fetishist who pressed upon us, year after year, her sexy yin and yang paintings of calla lilies, sweet peas, the various chalk-white bones of horses and cows, mysterious doorways, and adobe walls. What remains indisputable, however, is her genius for navigating the waters of her own vision, for discovering it, nurturing it, and never abandoning it. At a time when women still

* The economic welfare of the nation is based on our being good consumers.

didn't have the right to vote, when their life goal was marriage to pretty much anyone who would have them, O'Keeffe was having none of it. She had better fish to fry. How, we may ask, did she catch these all-important fish?

She wrote letters.

I realize I may as well be suggesting that you take up whittling, but the fact remains that one of the best ways to figure out what you're all about is to write letters. Many letters, hundreds of letters. Letters to friends, lovers, acquaintances, and colleagues, each one a mini-manifesto about how you waged the battles, both large and small, of each day, what you did, why you did it, and how you felt about it. I feel equally compelled to say that if you did this, in a short time you would have no friends at all.

There's always e-mail, except that e-mail, too, is about to join letter-writing as a lost art. A newsy, content-rich e-mail has too many sentences, and, God forbid, paragraphs. Social networking in all its manifestations may try to pass itself off as the modern iteration of letter-writing, but posting, tweeting, and so on is all about soliciting a response. It's about audience, not expression.

O'Keeffe claimed to have never trusted words. She said that she and words were not friends. To prove her point, she refused to learn how to punctuate. Still, every day for most of her life she was writing her struggles, trying to figure out what she was doing, what was important, and how she felt. O'Keeffe and her correspondents were one another's therapists in the

time before therapists, serving as witnesses to each other's struggles to locate themselves in their own lives.

In an oft-quoted letter to Anita Pollitzer, the college friend who hooked Stieglitz up with O'Keeffe's early, transcendent charcoal drawings, O'Keeffe attempts to both explain and sort out her mixed feelings about showing her work: "I always have a curious sort of feeling about some of my things. I hate to show them—I am perfectly inconsistent about it—I am afraid people won't understand them and—I hope they won't—and am afraid they will."

We could write such a thing in a journal, but no one would reply, reassuring us not to worry or telling us she understands. We could write such a thing in a blog, but it's a tender statement, one that requires a loving, supportive response and not an anonymous comment that may very well say *You suck.* Perhaps an ad on craigslist might work. Knitting has enjoyed a comeback; why not letter-writing?

She found a devotee.

One of the reasons O'Keeffe was able to flout the conventions of Canyon with such confidence and ease is because she had Stieglitz rooting her on from New York. Fat envelopes arrived from him daily. He sent her books to read, conversed with her about the work he'd included in a group show at 291,* closely monitored her current work, and cheered her on every baby step of the way.

* Her abstract watercolor *Blue Line,* now owned by the Metropolitan Museum of Art, hung alongside works by the more-established John Marin and Marsden Hartley.

On January 1, 1916, while O'Keeffe was still living and teaching in Columbia, South Carolina, before she had moved to Canyon, Anita Pollitzer marched over to 291* on a whim and showed Stieglitz some of O'Keeffe's charcoal drawings. Legend has it that Stieglitz fell into a memorable quote–producing swoon and gasped, "At last! A woman on paper." It's doubtful he said this, then or ever, but he behaved as if he did. When Pollitzer reported back to O'Keeffe, it was Georgia who sought out Stieglitz and wooed him with her letters about her work. People who knew her well said that she possessed the nose of a bloodhound when it came to finding people who would champion her art.

The best devotees are people whose interest in you is mixed up with their own self-interest. It's not only what they can do for you, but what you can do for them. Stieglitz was a compulsive educator. Art students used to bait him for fun. They would go to 291 and venture an unlearned opinion about the Picasso or Matisse currently on exhibit, just to see how many hours (five) Stieglitz could lecture them on their poor judgment.

Thus, he required an audience and a pupil, and she was there; she required someone who supported not only her radical approach to painting (how something made her feel was more important than how it looked), but also encouraged her rejection of middle-class expectations. That one day they would fall in love, marry, and wind up driving each other crazy was only to be expected.

* Stieglitz was the rare man who did not feel complete unless he was running an art gallery. The Little Galleries of the Photo-Secession at 291 Fifth Avenue was known simply as 291.

She defied all accepted conventions of feminine beauty.
I'm willing to accept that you're reading this book because someone gave it to you for your birthday, or because you like to take a stroll around an art museum on occasion. But even if you don't seek to defy every social norm so that you may pioneer a new school of art and become a personal icon to millions of women and aspiring painters everywhere—not to mention a one-woman tourist magnet for a previously overlooked yet majestic corner of our fine and enormous nation—please nonetheless consider abandoning the pursuit of robo-beauty in favor of accepting—and even celebrating—a few flaws.

With her fabulous rawboned frame, straggly brows, and schoolmarm's bun, her black vestments, man's shoes, and odd assortment of hats and turbans, O'Keeffe was out there. There was no one like her, then or ever.* A few months before she left her teaching post in Canyon, when someone mustered up the nerve to timidly ask her why she wore her hair that way, O'Keeffe said, "Because I like it." Freeing herself from the endless demands of looking like other women released her into a parallel, and freer, universe. After people adjusted to her curious look, they accepted it and expected nothing else.

Let your freak flag fly. Or at least retire your flat iron. You just may gain a sense of yourself as a unique human being, rather than as a mere consumer of lip plumpers and designer handbags. Do this in the interest of your own self-worth.

* Maybe a deranged old widow in Sicily.

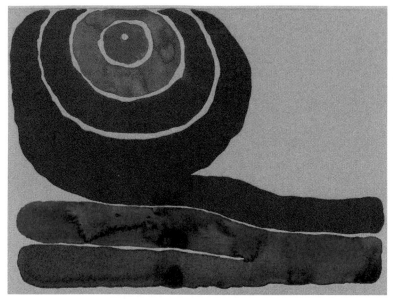

Georgia O'Keeffe
American (1887–1986)
Evening Star III, 1917
Watercolor on paper, 8⅞ x 11⅞ in.

Mr. and Mrs. Donald B. Straus Fund

The Museum of Modern Art, New York, NY

Digital Image © The Museum of Modern Art/Licensed by SCALA/Art Resource, NY

2

GROW

Where I come from, the earth means everything.

IN MY PREVIOUS BOOKS I WROTE ABOUT KATHARINE HEPBURN and Coco Chanel—like O'Keeffe, among the most dazzling, if not *the* most dazzling, female icons of the twentieth century. I deconstructed their lives with my special, somewhat eccentric, fine-toothed comb. I examined the choices they made in their lives, the opportunities they seized, the people they enraged, their stamina, opinions, and work ethic, their panache and style. I imagined that by running their lives through my own consciousness, by figuring out what they did right, and what they did wrong (no one's perfect), I would not only figure out how I should then live, but also, that some of their luster might rub off on me, and by extension, you.

It's a good theory, but the one thing I could never get past was the childhoods of Hepburn and Chanel, which differed so radically from my own (and perhaps yours). Sure, I could rouse myself every morning at the crack of dawn for a brisk swim, as Hepburn did, or eat standing up like a thoroughbred, as Chanel did, but in the end I secretly despaired of ever possessing even a smidge of their force of personality, because our formative years had been so different. Whoever I was, whatever I would be able to achieve, was rooted in the fact that I hailed from the loins of a sensible, hardworking, middle-class couple who lived in the suburbs.

I could never ignore the truth of that old Jesuit maxim, *Give me the boy (girl) until he is seven and I will give you the (wo)man.* Hepburn came from a cultured life of WASPy privilege. Her father was a well-respected doctor; her mother belonged to the Corning family (of cookware fame) and was instrumental in helping women gain the vote. George Bernard Shaw, whom Kate referred to simply as "Shaw," was a family friend.

On the other end of the spectrum was Chanel, who was born in a literal poorhouse—her name was misspelled *Chasnel* on her birth certificate—to a tragic, eternally pregnant young woman who died when Chanel was a wee thing. Her father, a classic good-looking roué, had split years before, and Coco and her sister were shuttled off to the nearest orphanage. The orphanage was run by nuns, and when Chanel turned eighteen, since she had no interest in pursuing a religious

vocation, she was turned out onto the street, without a sou to her name, to live by her wits. We all know how that turned out.

My relationship to their upbringings resembled that of Goldilocks to the Three Bears: Hepburn's was too high and Chanel's was too low. Hepburn's family imbued her with a sense of security and entitlement, providing her with a lot of opportunities and a safe and cushy haven to return to when life sucked. Chanel's "family" taught her to be crafty, industrious, and dead-serious about her own survival.

The childhood of Georgia Totto O'Keeffe, on the other hand, was, if not relatable, at least recognizable. She, too, was from a sensible, hardworking, middle-class family. It was neither too high, nor too low, but just right. Or right enough.

O'Keeffe: The Early Years

O'Keeffe was born in 1887, just outside the beautiful and bucolic-sounding Sun Prairie, Wisconsin, to Frank and Ida Totto O'Keeffe. Frank was Irish and Ida was Hungarian. This Irish-and-Something-Else is a common mixed breed in America; indeed, for many generations (except perhaps the current one), it is *the* mixed breed. Irish seems to have mixed with everything.[*]

Ida and Frank's relationship was typical of its time. It wasn't a marriage so much as a merger, a union rigged to help the

[*] My own mixture: Richard Karbowski and Joan Mary Sharkey.

Totto and O'Keeffe families, who lived on neighboring farms. The O'Keeffes had leased the Tottos' land ever since George Totto had abandoned his wife and daughters and returned to Hungary, where there was allegedly an inheritance awaiting him. More likely, farm living was not all it was cracked up to be. Isabella, his wife, had moved to Madison with her daughters, where she saw that they were educated and exposed to culture. She wanted them to marry into the professional classes, but when Frank O'Keeffe began courting Ida, she saw immediately that Ida's marriage to him would be a way to hang on to the Totto farm.

The tiny detail that everyone overlooked in the land grab was the one that would eventually derail the marriage: Ida was the daughter of a genuine Hungarian count, George Victor Totto. Royalty! This made her not only erudite, snooty, and uptight, but also determined to make sure that no one ever forgot she had married down when she agreed to hook up with the Irish Catholic farm boy next door. Every marriage has, at its core, an unspoken agreement, and this was Frank's and Ida's. Unspoken but not unnoticed, Georgia would grow up to make a marriage that also had, at its core, several substantial unspoken agreements.

Frank and Ida were different in the way of so many husbands and wives—of so many of our parents, I'd wager. Frank was a softie who played the fiddle, carried candy in his pocket to dole out to passing children, and, while hardworking, nevertheless amassed enough debt to eventually sink the farm.

Ida was a prisoner of pregnancy, eventually giving birth to seven children, from whom she always remained a little removed. She was cool; he was warm. She was Episcopalian; he was Catholic. She believed in the value of education, culture, and discipline; he believed in the value of having a really good time.

Does this not strike a familiar chord? One parent is strict, the other happy-go-lucky? One warm and engaging, the other exacting and aloof? One parent says potato, the other says private art lessons in the home of a watercolorist who lives three-and-a-half miles away in the town of Sun Prairie? Ida was determined that no matter the state of the O'Keeffes' precarious finances (farming being the ultimate high-stakes game), her daughters were going to be trained in the demure and culturally approved activity of drawing and painting. Like playing the violin (O'Keeffe sawed away with great enjoyment, even though she wasn't very good), being able to draw was an appropriate skill for a young lady, and increased her appeal as the future mate of someone who, like O'Keeffe's father, couldn't care less about that stuff but was proud of having a wife who did.

Ida and Frank O'Keeffe didn't have much in common aside from their acreage, but during the all-important wonder years of their eldest daughter, Georgia (the only one we care about), that was enough. The household was busy, and with each year became more so. After Francis Jr. (1885) came Georgia (1887), named for her grandfather the Count, then

Ida Jr. (1889), Anita (1891), Alexius (1892), Catherine (1895), and Claudia (1899). Whew!

Georgia, as the oldest girl, had her own room in the big white Victorian farmhouse. Her room had a view of Wisconsin's gently rolling plains and apricot-hued sunsets. For a time, during the height of the O'Keeffes' prosperity, her father owned the land as far as her eye could see. This would help explain how, as a famous painter in midlife, she assumed that the mountains and mesas that rose outside her homes in northern New Mexico belonged to her. Georgia started school a year early, and her best subject was recess, where she could (and did) outrun the other farm children.

In later years O'Keeffe would always remember her childhood as being a time of intoxicating freedom, where her love of flowers, landscape, and extreme weather was imprinted upon her. Her family was well-off. As an old woman O'Keeffe still boasted that they had the first telephone in Sun Prairie— but then, O'Keeffe had a tendency to put a good spin on things. Was this denial or determined optimism? Life, then and now, is complicated; it was probably both.

When Georgia turned ten, the idyll ended for good. Her O'Keeffe and Totto grandmothers were farm matrons of the first order. Unlike Ida, they didn't seem to have any conflicted feelings about their roles. With a song in their hearts and a bounce in their fierce frontierswoman steps, they put up the tomatoes and churned the butter, planted and tended the kitchen garden, fed, slaughtered, plucked, dressed, and

roasted the chickens, managed the house budget, nursed the sick, cuddled the children, and threw their backs into other turn-of-the-last-century rural chores that I can't begin to name. In their free time* they both also painted. Then they died. First Grandma Totto, then Grandma O'Keeffe. The lights in the farmhouse shone dimmer, extended family scattered.

Then, more bad news: Uncle Bernard started to lose weight, began to cough up blood. Two of Frank O'Keeffe's other brothers had died of tuberculosis, and when Bernard finally succumbed, Georgia's cheerful, hardworking dad silently freaked out. He was the only O'Keeffe brother left. He believed he was marked for death. Matters were not helped by the economy (are they ever?). For several years the country had been staggering through the worst depression in history,† which made everything that was already difficult even more so.

O'Keeffe's Impressively Spotty Education

Her first year of high school Georgia attended the swanky Sacred Heart Academy in Madison. Located in an old mansion on the shores of picturesque Lake Wingra, the school had much to offer Miss O'Keeffe who, at fourteen, had grown into

* Yes, these women had free time. If there was ever a reason to get rid of cable, this may be it.

† The year 1893 marked the worst depression the nation had ever known. Georgia was six. The banks and the railroad industry collapsed, credit became scarce, unemployment was as high as 19 percent during the worst of it, hardworking middle-class folks were forced to walk away from their mortgages, etc., etc. Sound familiar?

an exotic is-she-homely-or-is-she-beautiful? young woman. The exclusive boarding school provided O'Keeffe with strict convent-style rules (which she loved, the controlled bedlam of her own family, with all those little kids underfoot, being too loosey-goosey for her disciplined ways) and nuns who taught art. After getting off on the wrong foot with Sister Angelique, who criticized her small, dark, and fussy rendering of a baby's hand from a plaster cast, Georgia learned to make her sketches larger, lighter, more expansive. I love this glimpse into O'Keeffe's younger, eager-to-please self. It's one of the lesser-noted aspects of her fearsome personality: She was not completely unyielding. Throughout her life, the pragmatic Midwestern farm girl side of her would rear up and instruct the otherworldly visionary to make the most of the current situation. At the end of the term, Georgia was awarded a prize for Most Improvement in Illustration and Drawing.

Sophomore year money was tight, and Georgia was sent to public school in Madison, where, like fifteen-year-olds the world over, she skated through her classes earning mostly Bs, but was otherwise half-asleep.

Meanwhile, her father thought he'd found a solution to both his growing financial difficulties and fear of disease: sell the dairy farm, and with the capital move his family far away from the place where tuberculosis stalked and killed his brothers—Williamsburg, Virginia. For once, Ida was in full agreement. She was never really cut out for farm living; Williamsburg, one-time capital of the great colony of Virginia,

was the home of the second-oldest university in the nation, the prestigious College of William & Mary, alma mater of Thomas Jefferson; and there were bound to be more cultural options than Saturday-night talent shows at the Grange.

Today's Williamsburg, with its meticulously restored Colonial District, cutting-edge Asian/Southern fusion restaurants, elegant wineries, and world-class Spa of Colonial Williamsburg, is nothing like the sad backwater the O'Keeffes discovered when they rolled into town in 1902. The famous college was on the verge of bankruptcy; the rutted, potholed main street was unpaved and smothered in dust; the grand eighteenth-century houses were collapsing in on themselves, like Halloween pumpkins past their prime. With the proceeds from the farm, Frank O'Keeffe purchased a white homestead on nine acres called Wheatland, and a small grocery. The eighteen-room house had pillars, but almost no furniture, because now Frank O'Keeffe was more strapped for cash than ever before.

After spending a sultry summer in Williamsburg, giving the neighbors plenty to talk about—even at sixteen Georgia was a straight-talking Midwesterner who preferred neutral, tailored clothes and flat shoes, her long dark hair pulled off her face; in demeanor, outlook, and style she was the opposite of a Southern belle—Georgia was shipped off to Chatham, an Episcopal, all-girls boarding school.

Chatham was not as fancy as Sacred Heart. It catered to the daughters of the gentry who had fallen on hard times. For

some reason, the urge to excel academically had abandoned Georgia completely. She was a gregarious, spirited trouble-maker, and had learned that by breaking rules she could draw attention to herself. She was skinny and handsome with her hooded blue eyes, her strong jaw. She eschewed corsets. The only ribbon she wore was at the end of her braid, to keep it from coming undone. She kept a running game of poker going in her room. She stole fresh onions from the school garden, which she would then eat raw. Despite her high jinks, her art teacher, and even the headmistress, recognized her talent. During her two years at Chatham she developed a lifelong habit of working intensely, then slacking off. After serving as the art editor of the high school yearbook, she graduated with the other five girls of her class. The year after she graduated, the school burned down, taking two of her watercolors (one of lilacs, the other of red corn) with it.

June 1905. Revolution broke out in Russia; the first theater dedicated solely to motion pictures opened; Freud published his theory of sexuality. Georgia O'Keeffe was seventeen. Upon graduation, most of her classmates already had at least one marriage proposal in hand, but Georgia's future was unknown. She'd claimed at age twelve that she was going to be an artist, but that was unlikely, the equivalent of a modern preteen girl aspiring to be an army five-star general or an NFL quarterback.

Aside from the highborn Mary Cassatt, daughter of a Philadelphia stockbroker, who had studied and lived in Europe

and was a member in good standing of the school of French Impressionism, there were few, if any, American women artists.* What there was, however, was an amazing number of lady art teachers. Ida O'Keeffe believed that given the artistic leanings of her eldest daughter, this would be just the career for her, and so in the fall of 1905 Georgia took the train from Williamsburg to Chicago, where she enrolled in the distinguished Art Institute of Chicago.

The Art Institute wasn't chosen for its prestige, but rather for its proximity to the apartment of Uncle Charles and Aunt Ollie, two unmarried, eccentric Totto relatives. In pictures they look Seussian, she with her jaunty feathered hat, he with a handlebar mustache that extended inches beyond his cheeks. Aunt Ollie, who lived to be 102, and was known for being opinionated, self-sufficient, and industrious, was famous in the family for having been the only female proofreader at the *Milwaukee Sentinel.* Whether or not she was a direct influence on the woman who would become O'Keeffe can only be assumed; Ollie didn't have a maternal bone in her body, and even though she provided her favorite niece with a roof over her head, Georgia was on her own in the big city.

Every morning Georgia would put on her long black dress, braid her hair, and take a streetcar across town where she

* By which I mean women who made their living by their art. There were many women, old and young, who loved to paint, and did so to entertain and enrich themselves, without a thought to selling their work. Working in watercolors was so popular among women that when O'Keeffe's friend and colleague John Marin began using them, his paintings were initially dismissed by critics as being lightweight and inconsequential.

would hunker down in the airless basement studios of the Institute and copy plaster casts of body parts, mostly human torsos. More plaster casts. Ugh.

The Art Institute was old-school. Inside its immense, cool galleries it was 1880, not 1905. Their idea of modern was paintings by mid-nineteenth-century artists of the French Barbizon school.* Impressionism, which had already been accepted in Europe, was too out there.

The classes were taught using the punishing French method: In every class students and their work were ranked. Those with the highest ranking got the best easels and the best location in the next class. Even though O'Keeffe was uninspired, she worked her way up to first rank among twenty-nine students by the end of the first year. But her ability to work the system didn't make her feel any better. She was searching for something, but she didn't know what. If this was art, she wasn't sure she wanted any part of it. All she knew was that art was dead here.

At the end of the term, she returned to Williamsburg, just in time for typhoid season. Frank O'Keeffe had left tuberculosis in Wisconsin (or so he thought) only to rush straight into the arms of a host of other infectious diseases. Hot, swampy Williamsburg in the spring was host to malaria and typhoid. Within weeks of her return, Georgia was stricken by the fever.

* Naturalistic depictions of gentle landscapes and dignified peasants in soothing neutrals.

How to Raise an Art Star

I'm pretty sure that in 1905 no one imagined that one day millions of American children would hope to grow up to be visual artists, or that, weirder still, their parents would harbor the same hopes. Once, a well-off parent dreamt of having a Van Gogh on the wall, but had no interest in raising the next Van Gogh.* Parents, in their role as nurturers, want their kids to grow up to be responsible and self-sufficient, to be able to buy their own home, comprehensive car insurance, and high-quality leafy greens—things artists can rarely afford. Unless, of course, your child becomes the next Damien Hirst.†

Ida O'Keeffe, who would give the current crop of "bad mommies" a run for their money, had no idea she was raising the girl who would become, by the end of her life, one of the most popular and beloved artists in the nation. I wish I could add "critically acclaimed" to that list of adjectives, but Georgia's gender, combined with her popularity, especially among other people of the same gender, make that an impossibility. There's no question that Georgia inherited the art gene from both grandmothers, but beyond that, what was Ida's secret contribution to her daughter's eventual unparalleled success?

* Too tortured, too crazy, too much lead paint.
† As of this writing considered to be the most successful artist in the world; in 2008, his *Golden Calf*—a real cow tricked out with gold horns and hooves, preserved in formaldehyde—sold for about $17 million.

The power of benign neglect.
Georgia was the oldest girl and the second-oldest child, a perfect place in the birth order for flying under the radar. Her older brother Francis was Ida's favorite, the one she fawned over, and the younger children occupied the rest of her waking hours. For years at a stretch there were two kids in diapers at any given time, which was as time-consuming then as it is now. Georgia, who was quiet and an expert at sneaking around, was left to her own devices. One of the many facets of her genius, manifested at a young age, was the ability to obey enough of the rules to give the adults the impression she was obedient, after which she did whatever she damn well pleased, a strategy to which she resorted for most of her life.

There was another aspect of Georgia's unsupervised childhood, something that, as the mother of a daughter, I can barely entertain: Ida thought Georgia, who was angular and tomboyish even as a toddler, was homely. One hundred odd years ago parents did not automatically believe their children were the world's most beautiful humans; Georgia was even deemed too unattractive to have on hand when company came to call. Whenever there was a knock on the door of the big white farmhouse, she was locked in a room (!) or told to go away and stay out of sight.

Later in life Georgia admitted that being her mother's least favorite had hurt her feelings, but she got over it when she realized that it allowed her the sort of freedom she would otherwise never have known. Elder daughters of yore were

trained from a young age to be junior wives and mothers, but not so with Georgia. She developed a taste and a skill for entertaining herself, and Ida left her alone.

For those of us raised in the Time Before Car Seats, or by slacker moms who lacked the necessary ambition/energy/discipline to make sure our lives were an endless whirl of activity, this kind of *laissez-faire* parenting is reassuring.* It means that we still might amount to something, even though we had mothers who never managed our schedules or chauffeured us to daily theater rehearsals or stayed up until midnight helping us with our science fair projects. If we're parents, it means our children might amount to something even if we never went to Gymboree or enrolled them in an elite soccer clinic or made a second career out of finding the right SAT-prep tutor.

If we are where we came from, then the parenting style known as benign neglect needs to be reevaluated. If O'Keeffe's epic life is any indication, it seems that the less your parents pay attention to you, the better. If you're a girl, it's even better if your mother doesn't invest any stock in your looks, because then there will truly be no expectations placed upon your lovely beribboned head.

* My own mom complained when I was underfoot, and was happiest when I occupied myself by playing in the neighborhood "until the streetlights came on." That this was almost 10:00 p.m. during the summer made no difference to her. If she occasionally had to rush me to the emergency room (where we were on a first-name basis with the staff) because I'd leapt from a secret tree house and snagged my nostril on a protruding nail on the way down, that was simply the price we had to pay for her special brand of free-range parenting.

Notice the term is benign neglect.
Before I further extol the virtues of having been ignored as a kid/ignoring your kids, and before all you exhausted, over-committed, overinvolved-by-necessity* moms write me an e-mail thanking me for allowing you to tell your kids to revive that once-popular parental directive, *Go play on the freeway*, do consider this: Ida O'Keeffe did not completely ignore her future genius. There were the previously-noted drawing, painting, and music lessons; also, Ida neither encouraged nor discouraged her daughters, thereby teaching them that their art was their own, and that they should aim for excellence only because they wanted to.

Ida may not have pushed Georgia, but she did place her daughter's early drawings and paintings in ornate gilt frames that signified the importance of her efforts. Later, O'Keeffe the daughter, the modernist and minimalist, would snort with derision at those ridiculous fancy frames, calling them pretentious. They were pretentious. They were Ida pretending her daughter was already an artist who made paintings suitable for framing.

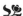

And what, we may ask, did Georgia *do* with all this free time on her hands, this time when no one was paying attention to her?

* The pressure to force-feed our children enrichment activities like a French goose on his way to becoming pâté has been well documented. Our fear, as mothers, is that failing to overmanage our children's time will doom them to a life lived out of a shopping cart beneath a bridge. No one means well more than a modern mother.

Given that at around age twelve she told a girl at school that she was going to become an artist, you might imagine that she spent hours in the shade of a sugar maple, her white-stockinged legs tucked beneath her, sketching a purple coneflower or wild petunia. But O'Keeffe was no Picasso-style prodigy, who at age nine completed his first full-scale painting. I'm here to report that the nation's greatest woman artist engaged in the most ordinary activity known to girls: She played with dolls. Yet more evidence that whatever our gifts might be, they need not reveal themselves before our fourteen-year molars.

Georgia had a wooden dollhouse around which she fashioned a complex empire. A shingle in a dishpan was a boat on a lake. The apron of green lawn that surrounded the farmhouse was an endless pasture for her doll family's imaginary herd of horses. She sewed tiny, perfect clothes for her genderless china dolls, made them female and male alike. She was dissatisfied with the pants for the boy doll. In the same way her mother banished her because of her own unacceptable looks, so too did Georgia pretend the husband doll was never around, so she wouldn't have to look at his fat legs.

What this meant for Georgia (and for us) was that she became comfortable living in and ruling over her own world. This, as any enthusiastic *New York Times* Op-Ed page–contributing expert on child development and the underestimated value of play, as well as a number of behavioral science people at MIT, will tell you, is the advantage of tossing your kid out the front door and telling her to find something to do.

Hour by hour, she becomes the creator of her own vision and— value added!—she becomes confident in her ability to create. There was no one around to either approve or disapprove of Georgia's dollhouse empire. And so she developed the habit, at a young age, of only pleasing herself. She became comfortable with the idea of herself as an innovator.

The power of adventure stories.
Georgia's mother was the opposite of a hugger. By today's standards she'd be considered cold and withholding. The fact that Georgia learned how to cuddle at all (not really) was because of Annie, a boisterous German "hired girl" who seemed to prefer the arrow-straight, self-reliant Georgia to the other children, and didn't hesitate to envelop her in a big embrace whenever Georgia demanded a hug.

But what Ida lacked in warmth, she made up for in the avid reading of stories. It was acceptable maternal behavior, but with the required cultural/intellectual spin. Because Francis Jr. was the favorite (and also had poor eyesight), Ida picked books that he would find most entertaining, specifically James Fenimore Cooper's *Leatherstocking Tales*, featuring the intrepid Natty Bumppo, a fearless white guy raised by Indians, who was a master of the long rifle, loved and respected the wilderness, and had many exciting adventures in the middle of nowhere. There is no evidence that Francis Jr., who would grow up to become a stuffy New York architect, absorbed the spirit and

daring of those stories. Instead, it was Georgia who was smitten. Deep into her old age O'Keeffe traced her devotion to the wildest that nature had to offer to being forced to sit and listen to her mother read. The lesson, I suppose, is to be careful what you read to your kids. You may inspire the least likely to become masters of the long rifle.*

The only discipline is self-discipline.
Aside from her aptitude for winning foot races, Georgia's grammar school teacher noticed something else: her pupil's self-discipline. Unlike every other child who, when offered the rare treat of an oatmeal cookie, gobbled it down, Georgia ate around the raisins, saving her favorite part for last. Is it possible to teach a child to save the raisins?†

A literary expert friend once told me that the way to teach your child to love and respect reading is not to read *to* them, but rather to refuse to allow yourself to be interrupted while you're reading. Might this be applied to teaching self-discipline? The next time you eat an oatmeal cookie with your child, save the raisins for last. See what happens. You will probably wind up as a post on your child's Facebook page, but it's worth the risk.

* When O'Keeffe was living and teaching in Canyon, Texas, her favorite way to relax was shooting tin cans out on the prairie.
† Or in this day of gummy worms and Reese's Peanut Butter Cups, is it possible for a raisin to even qualify as a delicious treat?

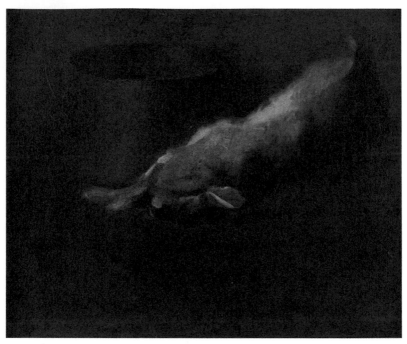

Georgia O'Keeffe
American (1887–1986)
Untitled (Dead Rabbit with Copper Pot), 1908
Oil on canvas, 19 x 23½ in.

Permanent collection, The Art Students League of New York

3

ADOPT

The best course is the one that leaves my mind freest.

IT TOOK GEORGIA A YEAR TO RECOVER FROM TYPHOID. If the only brush you've ever had with this disease was enduring mild flu-like symptoms and a hot, throbbing arm after having received the required vaccine before jetting off to Southeast Asia or some other part of the developing world, where the locals die of it on a regular basis, here is a quick overview.

The first week you experience a high fever, headache, and cough. The second week features a higher fever, diarrhea, and delirium, and maybe an itchy and unsightly rash. The third week can bring complications in the form of intestinal hemorrhaging and metastatic abscesses. I'm not sure what that last one is, but you know it can't be fun. All of these symptoms proceed

into the fourth week where, if you've managed to survive, the fever slowly abates and you're left, as Georgia was, with no hair.

During her months of recovery she read Faust in a lace cap that covered her bald head and made desultory sketches of her younger siblings—the older ones having all left home to start their lives. Even if she'd wanted to return to the Art Institute of Chicago, in September when classes began she was still too weak to go back, and the family finances worsened with each successive failed business undertaken by her father. The grocery went belly-up, followed by a creamery. There was a brief foray into real estate. Mostly, he was becoming more despondent and alienating the locals with his inexplicable Yankee ways. Ida, her mother, daughter of the genuine Hungarian count, who believed Williamsburg was going to be a step up from Wisconsin farm life (even though the local ladies suspected Frank's Yankee ways, they did admire Ida's emerald earrings), was forced to help make ends meet by feeding local college students. Georgia, in her lace cap, helped.

Life largely sucked, the way it does when you're almost twenty and life's bounty, if it exists, is being harvested by others, elsewhere.

Becoming Patsy O'Keeffe

A year passed, and Ida had saved enough to send Georgia to the Art Students League of New York. The Art Students League was

established in 1875 as an alternative to the fuddy-duddy "traditional" art schools;* it had no requirements for admission, major areas of study (aside from art), or required courses. It was a hippie school long before there were hippies, and Georgia loved it.

When she arrived in New York she was easily the poorest girl at the League, but she didn't care. She was giddy to have escaped the Dostoevskian drama that was shaping up back in Williamsburg: her depressed, frustrated father; her determined, increasingly bitter mother. Her hair had grown into a chin-length bob, the kind flappers would popularize a decade later. It's probably safe to say that this was the first and last time in Georgia's life her hairdo could be considered cutting-edge. For a few dollars a month she shared a room with a fellow student with the sweet, early-twentieth-century name of Florence Cooney. In Virginia Georgia was mocked for her plain way of talking and dressing; in Chicago fellow students and teachers had been indifferent to her familiar, no-nonsense Midwestern mien; but in New York, she was considered an androgynous beauty with snappy blue eyes, a chic head of curls, a sly and playful wit. People got her. Her fellow students called her Patsy; with her love of dancing, music, and practical jokes, she seemed very Irish. Aside from having to watch every penny, "Patsy" O'Keeffe flourished. She attracted admirers, including a fellow classmate named George Dannenberg, an

* Like the Art Institute of Chicago.

exotic San Franciscan—she called him the Man from the Far West—who was bewitched by her easy individuality and liked to take her to dances.

Patsy also began acquiring artistic influences, a taste for what to embrace and what to ignore. She despised her life drawing class, but loved her still life class with William Merritt Chase, a famous American Impressionist of the time who later founded what would become Parsons The New School for Design. The eccentric Chase—he wore a black top hat to class—had become famous and rich primarily as a society portrait painter. He believed in O'Keeffe's talent, even though she was at a disadvantage for genius because of her sex.

According to the great scientific thinkers of the time, women could never be artists because an artist needed to devote himself to his art wholeheartedly, which meant days, not to say years, of undivided time and attention. A woman could conceivably arrange such a thing, except that an artist also needed to work from his true nature, and a woman could only access her true nature by having children, and to have children meant a woman would never have the undivided time and attention to devote to her art. Chase didn't care about all that, and proved it by supporting Georgia as a candidate for the League's Still Life Scholarship, which she managed to win, despite her gender. The prize was an all-expenses paid summer of painting at the Outdoor School in Lake George, New York.

In someone else's life story, this would be the beginning of everything coming together. After surviving a life-threatening

illness, Patsy had freed herself from her soul-crushing home situation. She'd found her tribe. She'd found a respected mentor. She had a hot boyfriend who adored her. All she needed was a pair of signature boots and a rock anthem and she'd be set. And it was about time. She was twenty, and in 1907, when the average woman married for the first time at twenty-one and died, on average, at fifty-two, this was exactly the right age for a young woman to get her act together.

Fortunately for me, and my search for O'Keeffian life lessons, it was not the beginning of everything coming together. My mother used to say that no one ever learns anything when things are going well, and however well Patsy's life may have looked from the outside, inside she was in turmoil.

Like so many people leaving childhood and taking those first tentative steps into adulthood, Georgia suffered deeply from she knew not what. Because she was a Midwestern farm girl she didn't grumble, but she was unhappy. Her scholarship had been awarded based on a painting of a dead rabbit slung beside a copper pot that looked as if it hadn't seen a good polishing since the first Thanksgiving, done in the smeary style of her mentor, Merritt Chase. In her heart, she knew that if this was what painting was all about—duplicating objective reality—she didn't want anything to do with it. And anyway, there were people who were much better at doing that than she was, despite Chase's encouragement. Even the Impressionists, so up-to-the-minute, so cutting-edge, were still giving their *impressions* of what they saw. The eyes still

ruled the day. What about the heart? Was there no room for feelings in painting?

The Lake George countryside was a lush blanket of blooming flowers, the lake itself a sun-kissed sapphire, yet she felt no urge to paint. Instead, she rowed desultorily around the lake with the sensitive, smitten Dannenberg, until one day the rowboat was stolen, and with it, her interest in pursuing a career as an artist.

After her stint at Lake George ended, Patsy went home to dispiriting Williamsburg, with its decaying mansions and cold neighbors. Georgia—no one called her Patsy at home—dusted the living room in the morning and read in the long, lazy afternoons. Because it was another time, and people didn't air their money troubles, Georgia's only clue that family finances were on their way from bad to worse was that when September came, only her brother Alexius was sent to school. Education for girls a hundred years ago was a luxury on par with having a personal trainer or a twice-weekly housecleaner; when money got tight, it was the first thing to go.

Some Lessons for Getting through Challenging Times

Screw the lemonade—seriously.

Sometimes when life gives you lemons, you stick them in the fridge and forget about them, until one day months later you're cleaning out the vegetable drawer (because every time

you open the door something smells), and lo and behold, you discover an old bag of radishes with liquefied greens, and while times may be challenging, they're not *impossible*. You're not a complete wreck; you just aren't sure what you're supposed to be doing next. You manage to get it together enough to sling those nasty radishes into the garbage. Meanwhile, at the back of the drawer you come across these shriveled yellow artifacts, perhaps spotted with white mold. Yes, those annoying lemons. The ones that you were supposed to use for the lemonade you didn't want. My point is, sometimes there's no making the best of things. Georgia may have been half Irish, but she was half Hungarian too (i.e., capable of being dour and petulant).

For all the ways in which Georgia was not like us, in some ways she was. She was given lemons and she did not make lemonade. She did not rise above her circumstances and do something inspiring and amazing. Instead, she dragged herself back to Chicago (gray, uninspiring), moved back in with her uncle Charles and aunt Ollie (nice of them to have her back; still), and proceeded to "pursue" a "career" in commercial art. Basically, she was hired to work in a sweatshop that made drawings for dress catalogs. Georgia's subspecialty was lace collars and cuffs. She loathed it. She wrote in a letter to her sister Catherine that she was making a living, but it wasn't worth the price. Somewhere along the line the legend sprang up that during this time Georgia designed the iconic little

Dutch girl* who famously occupied the bottom half of the Old Dutch Cleanser can, which more than anything reflects our need to rehabilitate this dull and nonproductive time in the life of the great O'Keeffe, to show that the long hours spent bent over that Chicago drawing table weren't a complete waste of her life and talent, that it wasn't a dead end, that something "good"—okay, it was just a cleanser label, but as far as product logos go, it's a beloved classic—came out of these miserable years.

Maybe there was nothing redemptive about this time in Chicago; maybe this was just an awful time to be gotten through. Maybe, to use an analogy from the long-lost Sun Prairie farm, the ground of O'Keeffe's life needed to lie fallow. Maybe, this deadly year of cuff and collar drawing was just what she needed to realize what she *didn't* want. It's all well and good to know what we want to do; sometimes it's just as handy to know what we don't want to do.

Thank your lucky infectious disease.

For someone who lived to be almost one hundred, Georgia survived a number of serious ailments. She was saved from the slow-mo calamity of a career in commercial art by a case of the

* Some others who might have been the brain trust behind the little Dutch girl, listed in no particular order: Maude E. Sutherland of Westville, Nova Scotia; Chester Marhoff, employee of the Cudahy Packing Co. in Chicago; Horst Schreck, who was awarded $2.00 in a national brand logo contest when his little blue and white girl in the wooden shoes was chosen the winner. Mr. Schreck's family also claims that he designed the logo for Arm & Hammer, clearly unaware that now they were going too far.

measles. After two years of grinding away in Chicago, one day she awoke and felt feverish and itchy. It will come as no surprise to you that the first measles vaccine came along around the same time as the Beatles. In Georgia's case, not only did she suffer from a high fever, cough, and bright red rash, but her suffering was further complicated by corneal ulceration (inflammation of the cornea), which made it impossible to render tiny buttons and lacy textures. Once again, she went home.

When she arrived in Williamsburg she discovered that only her father was there, unemployed and living alone. While Georgia had been away, her mother had been diagnosed with early-stage tuberculosis and had moved with her other daughters to Charlottesville, in the dry, cool, and presumably restorative foothills of the Blue Ridge Mountains.

Georgia was, among other things, private. She endured a lot of misfortune, and didn't have much to say about having done so. The degree to which she was devastated by the news of her mother's diagnosis is unknown. Frank, her once happy-go-lucky dad, he who loved to dance after having logged in a good twelve hours on the farm in Sun Prairie, was depressed. His life had turned into a walking O. Henry* story: He'd given up the land and life he'd loved to flee tuberculosis, only to

* Do they still assign O. Henry stories in school? "The Gift of the Magi," about the impoverished husband and wife, is still the best, neatest lesson on life's injustice. In an effort to buy one another the best Christmas present they can find, they each sell their finest possession. He sells his gold watch to purchase a beautiful comb for her hair, and she cuts off and sells her beautiful hair to buy him a new strap for his watch. The moral of the story is, skip Christmas altogether and splurge on a trip to Cabo.

meet it head on in a place he couldn't abide, and that couldn't abide him.

In Williamsburg, Georgia spent several months recuperating. The great thing about recuperating is that no one expects you to do anything. You have nothing but time to sit and ponder. This is the case, then as now, although it's infinitely more difficult to be granted the time to get back on your feet these days. People who beg to be allowed to get over a cold are viewed as slackers, and the sorts of diseases that allowed Georgia's generation the luxury of lolling around on the divan for months on end have been wiped out or prevented by vaccines. Now, we need extreme measures to be allowed a little time to convalesce.

Several years ago I needed surgery to remove a benign nodule on my thyroid. It was an easy day surgery, in at seven a.m., home on the couch recuperating by three. I'm a fairly irrational patient. The week before my yearly checkup—it doesn't matter which one—I'm already practicing living under a death sentence. Even though it ignites an instant feeling of gratitude for my morning cup of coffee and the pink roses that struggle to bloom in the front yard, it's stressful having only six weeks left to live. For this reason I'd booked the operation for the day before Thanksgiving, imagining the place would be empty, and thus less anxiety-producing, the nurses sitting around yawning and playing solitaire on their desktop computers, the doctors placing bets on the next day's football games.

Instead, the OR was so packed there was no room for me in recovery when I was out of surgery. They had to park me in the hallway near the pre-op staging area, which was also full. In the narrow slot between each set of illusion-of-privacy-providing curtains there lay a woman, hooked up to an IV, entertaining friends and family members there to offer support. It was downright festive, all these women—yes, all women—who were preparing to go under the knife. Why, you may ask, were they all so giddy, aside from the Valium in their IV drips? Because their surgeries were giving them a free pass from mounting the annual eat-a-thon that is Thanksgiving. There was a woman two slots over who said, "Thank God I don't have to make any gravy this year!" She was delirious with joy; she couldn't be expected to be useful the next day, because she was going to be recuperating.

Recuperating is a lost art. A hundred years ago people like Marcel Proust spent their entire lives recuperating. Now, we have TheraFlu. The next time you're sick, stay in your bathrobe for two days longer than you feel you have any right to. Think of it as recuperation for the mind. Georgia recuperated. Then, a bit of luck: Her old art teacher at Chatham Episcopal, Miss Willis, hankered for a sabbatical and asked Georgia if she'd step in for her. The final piece of the lesson on taking time to recuperate is knowing when it's time to get out of your bathrobe, and on with it.

Drink someone else's lemonade.

Yes, the lemons again; if you were a young woman in the early part of the last century, these metaphorical lemons were part of life. This time they belonged to Georgia's sisters, Ida and Anita.*

In 1912 the University of Virginia admitted men only, except in the summer. Ida and Anita made the best of not being excluded for those few short months, and both enrolled. Anita signed up for a drawing class taught by a beloved weirdo named Alon Bement. Because Georgia was also a weirdo (see footnote), Anita suggested Georgia take the class, too.

Georgia's line of thinking was: Why the hell not? She had nothing else going on. Her alleged true love, George Dannenberg, the Man from the Far West—who'd written in a letter that he had half a mind to show up on her doorstep and take her away with him to Paris—had listened to the other half of his mind, which told him to leave her behind. He was now ensconced in the Latin Quarter, living *la vie Bohème,* and she was stuck in Charlottesville, back to dusting the living room.

She was almost twenty-five and living at home. File under "The more things change, the more they stay the same." When

* If there's any doubt about the role personality plays in what we think of as "genius," Ida *mère* believed that Ida *fille* was the most artistically gifted O'Keeffe, and Georgia believed that Anita was the most talented. All of them thought Georgia was weird. Then and now, it takes nerve to be weird—and I mean genuinely out of step with everyone else, not hipster-weird, where you affect the weirdness embraced by everyone else at the coffee shop.

she was at the Art Students League, during what seemed like another lifetime, a fellow student named Eugene Edward Speicher, who would grow up to be a moderately celebrated and fogeyish portrait artist known for his perfect draftsmanship and methodical compositions—yawn—begged her to model for him. She had turned him down, saying she was too busy with her own work. He had responded by telling her she might as well pose for him, since one day he would be a celebrated artist and she would be teaching art at some girls' school. But even that didn't look like it was going to happen. After Georgia's gig substituting for Miss Willis at Chatham, she applied to teach in the Williamsburg school system, thinking that teaching would save her from having to return to the hellhole sweatshop nightmare that was Chicago.

Williamsburg turned her application down flat.

Georgia showed up at Bement's class and Anita was right. He was an effeminate goofball, who called himself Bementie, and pranced around the classroom in a silk tunic. Georgia adored him, and Bement, in turn, taught O'Keeffe a few things about art that finally made sense to her. It's one of the great contradictions of O'Keeffe's personality: Her devotion to her own intuition was balanced by her pragmatism; if something didn't make sense to her, she saw no point in moving forward. Because of this, she'd stopped painting completely.

Please recall that the thing that turned Georgia off to art in her early twenties was the expectation that the job of

a painting was to imitate reality, preferably in the way of the European masters. The subject was the thing, the artist merely a servant of what he saw.

But Bementie brought news from New York, specifically Arthur Wesley Dow, the dean of Fine Arts at Teachers College, Columbia University: A painting was more than just its subject. What went on inside the frame created by the canvas was just as—if not more—important. The composition, the way the forms related to one another, the positive and negative space, should all be balanced in a visually satisfying fashion. And who decided what was visually satisfying? The artist.

Enchanted by the simplicity of Japanese art, and the voluptuous lines and shapes of Art Nouveau, Dow had tossed the dusty plaster casts aside and asked his students, on the first day of class, to draw a line on their paper, thus beginning the process of defining the space. This was pure radicalism in 1912. It was the beginning of modernism, a declaration of independence for the artist. "I had stopped arting when I just happened to meet him and get a new idea that interested me enough to start me going again," said Georgia, in a letter to a friend.

Bement, for all his vanity and affectation, accurately read O'Keeffe's enthusiasm. He saw the lightbulb go on over her head. After the term was over he asked her to be his teaching assistant. There was a hitch, however; the position required her to have secondary-school teaching experience. The only high school teacher O'Keeffe knew was Alice Peretta, an old

classmate from Chatham, who taught at the public high school in Amarillo, Texas. Peretta pulled some strings, and O'Keeffe was hired. It was the first job she'd had in two years.

❧

Amarillo was a cattle-shipping station, a flat, dusty place where railroads crossed paths, smack in the middle of the rattlesnake-infested Texas panhandle. I'm using all the literary self-control I can muster not to use the cliché "middle of nowhere." But clichés don't spring into the culture fully formed like Athena out of Zeus's head; Amarillo, founded the same year as Georgia was born, was nothing more than a train depot for cows.

Georgia arrived in the middle of August and ensconced herself in the Magnolia Hotel. A more apt name would have been the Sunburned Cornea Inn, or Relentless Crazy-Making Howling Wind Lodge. There were no magnolias for hundreds of miles, let alone any other growing thing aside from the wild grass that covered the plains. In Paris and New York, abstract art struggled to be born, but in Amarillo, Georgia already inhabited an abstract painting. In every direction the low horizon was plumb-line straight, nothing but dun-colored prairie and the occasional collection of dark-hued dots, a herd of cattle in the distance. Every day the sky was the same punitive blue, the sun a blazing lip-blistering orb.

The extreme landscape and weather possessed Georgia, but she also loved teaching. She was still a-swoon with new ideas. She taught her students—the sons and daughters of ranchers and railroad men—the new commandments of art, that it was not just a painting hanging in a fancy big-city museum, but the way you arranged the objects in your life, where you placed a rocking chair in a room or lined up the toes of your shoes against the baseboard. Feng shui had been kicking around China since antiquity, but you can bet no one in the Texas panhandle had heard of it.

When Georgia arrived the new high school hadn't been finished yet, nor did she have any books or supplies. She didn't mind. In fact, she preferred it. As she would her entire life, she used what was at hand. Once, a boy rode his pony to school and Georgia coaxed the animal inside so he could serve as a model for the day's lesson on line and form. "I enjoyed teaching people who had no particular interest in art," she said later in life, remembering these unsung years.

I'm not the first person who has written about Georgia to try and square this giving, inventive, popular high school teacher with the solitary, secretive, bleached-cow-bone-loving misanthrope she became in her dotage, but we can't forget that the other thing she loved about teaching was that people left her alone.

To be a woman in 1912 meant to be a wife or not-a-wife. To be not-a-wife meant being an old maid forced to live with

your parents or other relatives. Or, you could be a school-teacher. Schoolteachers were usually also old maids, but they had their own money, could come and go as they pleased, wear odd shoes, and cultivate strange enthusiasms, and no one paid them any mind. Being a teacher allowed Georgia to hide in plain sight. She could get away with wearing her customary black clothes and flat men's shoes, take daylong walks out on the prairie and then come home to the Magnolia Hotel where she would beat windburned cowboys and gap-toothed prospectors at dominoes, because no one saw her anyway. *To live happy, live hidden,* or so the French proverb goes, and Georgia was living proof.

Living at the Tail End of the World

Would Georgia have become O'Keeffe had she taken the job at the University of Virginia? After a year in Amarillo she returned to Charlottesville to work in the summer program as Alon Bement's teaching assistant. She was offered a full-time position that was more prestigious, paid more, and allowed her to be closer to her family,* but she couldn't quit Texas and those over-the-top sunsets that begged her to stop every day and stare. Whatever it was about that bellowing wind, that scorching sun, she could not give it up. It not only spoke to

* This sounds good, but then as now, in the same way that good fences make good neighbors, many miles make happy families.

her, but it also made her feel in tune with her true self. She taught for a second year in Amarillo, but was not asked back. Her eccentricities caught up with her; the school board wanted her to use a stodgy but well-respected textbook and she wasn't having any of it. She preferred to use ponies. Or, she may have made one too many cracks about what she considered to be the cloying, dumbheaded patriotism exhibited by the upstanding residents of Amarillo, as they and the rest of the country faced American involvement in World War I. Or, her complicated nature simply demanded she move on. By 1914 standards (she held the position in Amarillo through spring of that year) this failure to settle down signified a failure to launch. It was one thing to be an old maid schoolteacher, and quite another to—well, no one really knew *what* she was doing, including Georgia herself.

For the next six years a list of her addresses reads like one belonging to a felon trying to get back on her feet. New York. Charlottesville. Columbia, South Carolina.* Back to New York. Back to Charlottesville. On to Canyon, Texas, for more teaching in the middle of nowhere.

Of all the Georgia O'Keeffes—the devoted and uncompromising artist, the mysterious much younger lover of Alfred Stieglitz, the iconoclastic painter of erotic abstractions and monumental big flowers, the middle-aged woman in black

* During her late twenties, every time O'Keeffe turned around she was in one Columbia or another: She attended the Teachers College at Columbia University in New York and later taught at Columbia College in Columbia, South Carolina.

who put northern New Mexico on the map, the self-sufficient crone with a weather-beaten face whose work was rediscovered and cherished by feminists in the 1970s—this little-known, in-the-process-of-being-defined twentysomething O'Keeffe is the one I cherish.

She moved around because that was where the work was. She needed to work. She was learning the hard way how life is without money. Usually, decisions to take a job or enroll in a class were made at the last minute. She kept her options open, a polite way of saying she dithered until she could no longer afford to. She kept returning to Teachers College at Columbia University in New York, to take classes toward the teaching degree she was required to have, but didn't really want. She always seemed to be one course short of the prerequisite required by whatever institution wanted to hire her. Aside from the feelings she'd expressed in Amarillo about patriotism, World War I came and went like a mid-grade two a.m. earthquake. She hardly noticed. Years passed. She avoided coming down with any more infectious diseases. She owned almost nothing. An excellent seamstress, she made her own simple clothes, including her underwear. In New York she lived in a small, drab room, bare except for a red potted geranium she kept on the windowsill.

In the fall of 1915, Georgia accepted a teaching position at the tail end of the world: Columbia, South Carolina. Columbia College was an all women's college specializing in the training of music teachers. It was small and insular and

had fallen on hard times. Georgia may have been offered the job because they couldn't pay much, and her lack of a teaching degree put her in no position to bargain. It mattered little to O'Keeffe: Her idea was to sequester herself there, teaching only four classes a week, leaving the rest of the time to paint. Whatever charms the school and its environs might have possessed, they were lost on Georgia. In a letter to her friend Anita Pollitzer, she drew a tiny, chaotic-looking picture of a jagged hole surrounded by pieces of broken plaster captioned, "Thats [sic] the hole I kicked in the wall because everyone here is so stupid—I never saw a bunch of nuts—It makes me mad—"

She lived in the dorms. She was miserable, and glad of it. Her letters from Pollitzer, who was still in New York, nourished her. Georgia wrote repeatedly that she felt a tremendous vacancy in her life—that she was lost, floundering, in a muddle, and enjoying it; that she was determined to "wonder and fight and think alone." What was happening, of course, is that, removed from New York, the stimulation of new art, new friends, new teachers, new ideas, stuck in a place where she knew no one, her influences—more about them in the next chapter—could marinate. I'm not much of a cook, but I can tell you that every hunk of meat tastes better when it's been sitting in the fridge in a nice marinade for a day or two. Likewise, most casseroles—by which I mean my chicken enchiladas—taste better the next day.

She wrote about having nothing to paint, about priming canvas after canvas but having nothing to express. Along the way her old mentor and boss, Alon Bement, had pressed into her hands a copy of Wassily Kandinsky's *Concerning the Spiritual in Art*. Kandinsky gave O'Keeffe the get-out-of-realism-jail card she needed. He said, in effect, that the true subject of any painting was the artist's inner world, and that every line, color, and form she chose should reflect that, rather than the "realistic" apple in the bowl, the woman sitting on the settee. Boy howdy and hallelujah.

I haven't lost track of the lesson: Live at the tail end of the world. I wish I was the kind of person who could recommend, in good conscience, and with absolute authority, that you should sell your house in Atlanta or Petaluma or Cherry Hill and move to the modern-day equivalent of Columbia, South Carolina, where people are existing rather than living, and there's no one worth knowing and nothing going on, the better to write, paint, sculpt, compose a song, storyboard a movie, create the new social networking paradigm, or devote yourself to something else that has currency in your inner world, but I am not that person. For one thing, I know how much it costs to hire movers, not to mention the giant garbage bags in which you jam all the stuff going to Goodwill. I know that you might have a partner or spouse with a good job (with benefits!) and kids that are clam-happy in school. In other words, it's a lesson with a big price tag, and those are a lot harder to implement than, say, *Think happy thoughts.*

But it hardly matters if you pull up stakes in Beaverton or Provo or Silver Springs; there is no tail end of the world left anyway. In the Maldives, the most enchanting tail-end-of-the-world island nation on earth, the tallest thing in the country is a palm tree, and the most common cause of death is getting beaned by a falling coconut. The nearest college is five hundred miles away and across the Laccadive Sea in Sri Lanka. In 2005 I stayed at a resort with over-water bungalows, where you could stand on your deck and glimpse baby blacktip reef sharks and silky stingrays gliding over the pale sand beneath your feet. You *could* do this: Most of the guests preferred to wait in line at the computer in the "business center," where they could check their e-mail, look up the lyrics to "The Pina Colada Song," and comparison-shop for Frye boots. I know this because I was one of them.

These days, if you want to live at the tail end of the world, you must get off the Internet. You must disable your connection, put down your smartphone, stop checking whatever it is you're checking. Like O'Keeffe, however, I'm pragmatic. I realize that the longest you can be expected to live at the webless tail end of the world is about ten hours at the outside, and that's only if you're having open-heart surgery. I know it's difficult. During the writing of this paragraph, I checked my Facebook newsfeed using the android phone app several times. It's pure habit, like fingernail biting. I have no idea why I do this, other than to escape the anguish of following

a thought to its conclusion (I'm lost, I'm floundering, I'm in a muddle . . .).

In case you suppose that I'm keeping up with the interesting doings of close friends, or my daughter who's away at college,* this is not the case. For some reason the Facebook phone app does not display the same newsfeed I see on my laptop; rather, this newsfeed contains only the most banal updates from the most boring friends on my list. You know: those compulsive updaters who post pictures of their pesto, divulge their favorite wart-removal remedy, how far they ran today, what the doctor said, how much they loved the love theme from *Titanic,* or that Jenn is going to be meeting Zack at Applebee's. It's as if I'm part of some secret digital experiment to see how often people log in to check up on people they hardly know and couldn't care less about—indeed, people they find irritating and would avoid in real life.

I suspect it may be more difficult for women to disconnect than men. We are, after all, the gender that is hardwired to forge connections. Ping! An e-mail drops in our box and our double XXs go all shivery, anxious to respond. Over the last several years, we've come to expect shorter and shorter response times. E-mail has become harder to ignore. Now, if you don't e-mail someone back that day, they'll assume you

* Mark Zuckerberg did a profound public service to the parents of older teenagers the world over: Instead of obsessively calling or texting them to make sure they're not dead in a ditch somewhere, we can Facebook-stalk them. If they're posting, they're still breathing. Thank you, Mark.

died in a fiery crash. Facebook messages and notifications fall under this heading, and don't get me started on Twitter. If being unable to disconnect has derailed our collective trains of thought, Twitter—which by its very nature demands a continuous state of receptivity to every random idiot thought of a stream of utter strangers—has destroyed the train completely, leaving us with single freight cars with nothing in them but an old hobo of a germ of a notion dozing in the corner.

Even if you don't want to become a painter whose work winds up in every major museum in America and revolutionizes modern art, but only want to write a poem or two, or figure out how best to plant your garden, or figure out how to throw an original birthday party for your beloved—turn off the computer, and leave your phone at home.

If there's any doubt about this, look at the online lives of the most creative, innovative, groundbreaking creators and thinkers out there. Does David Sedaris even have a website?

It would be unfair to press this lesson on you without offering a few tips on how to accomplish this.

1. Forget the apps (especially Jewels, which has reduced my own IQ by at least 20 points).

2. Get the dumbest phone available.

3. See how long you can ignore your e-mail before someone calls on your landline to see if you've died in a fiery

crash. If you feel anxious with all that e-mail piling up, just delete it at the end of the day. A side benefit is that you'll see how few people really care when you don't answer.

4. Pretend you actually *are* living at the tail end of the world, and can only get on the computer for half an hour a day.

5. Read a book. (After this one.)

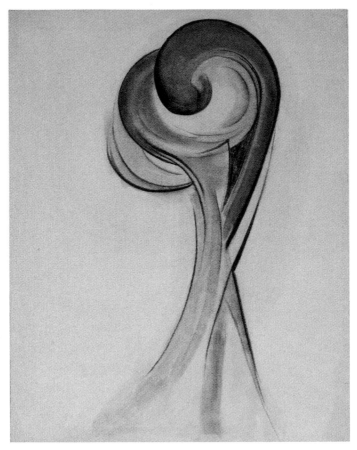

Georgia O'Keeffe
American (1887–1986)
No. 12 Special, 1916
Charcoal on paper, 24 x 19 in.

Gift of the Georgia O'Keeffe Foundation.

4

MUDDLE

Imagination certainly is an entertaining thing to have — and it is great to be a fool.

I MUST STOP FOR A BRIEF ART HISTORY INTERLUDE. THERE'S no need to worry. I dropped my lone art history class in college. I thought I was signing up for the section where you study nothing older than Toulouse-Lautrec's comely whores in their sassy thigh-highs, but wound up in the Venus of Willendorf* section by mistake. Beyond that, my art education, aside from my autodidactic love of O'Keeffe, stimulated by the *Poppy* Poster of My Youth, consists of slogging through one of those

* Thought to be the oldest statue of the female form, dated 24,000 BCE–22,000 BCE. With her bad posture, back fat, huge boobs and belly, Venus makes you wish you could afford a personal Pilates instructor or lived 23,000 years ago, when such a figure was believed to be a thing of great beauty.

mammoth biographies of Picasso,* buying the DVD of *Pollock*,†
and power-walking through the great museums of the world.

While we're on the subject of museums, I should also
admit that sometimes I'm really more of a gift-shop person.
For me, the gift shop is often the reward for having endured
the exhibits. My spin through the museum is the five miles
I run in order to savor the apple fritter that is the gift shop.
I realize I could go straight to the gift shop, but I'm not that
much of a Philistine. (Do they even have Philistines anymore,
or is that a term straight out of Patsy O'Keeffe's time at the Art
Students League?)

So, modern art. It began with the French Impressionists
in 1860 or thereabouts, but then there's *really* modern art. The
critics of Impressionism thought the work was sketchy, sloppy,
and undisciplined, but at least they understood they were
looking at a lady with a platter hat and creamy bosoms boating
on a pond; *really* modern art, the kind that well-upholstered
matrons and stuffy city fathers believed was a scourge on par
with Internet porn, can be dated to the time when Georgia
was in her twenties, taking a long time to figure out her life.

While she was busy teaching the children of cattlemen in
Amarillo how to draw a pony, going about her internal busi-
ness at the tail end of the world, modern art was elbowing its
way into the consciousness of the American culturati. It was

* There is no other kind.
† Ed Harris!

slow going. The center of the art universe was Paris, not New York, specifically the salon of Gertrude and Leo Stein. In 1904 the brother-sister art-collecting duo sprung for Gauguin's *Three Tahitians* and Cézanne's *Bathers*. A year later they picked up Matisse's *Woman with a Hat.** They'd discovered the manic cubist Picasso, in a modern art league all his own, but meanwhile, here in the States, we considered thirty-year-old French Impressionism, those gauzy landscapes and soft-edged ballet dancers, those picnicking pink-skinned Parisians boating on lakes of aquamarine and cerulean blue, to be all the rage. On this side of the pond we were an art revolution or two behind the times.

By *we*, I mean everyone but Alfred Stieglitz.

I've held off introducing Stieglitz into the story of O'Keeffe because I fear that here, as in life, he'll dominate the "conversation." The quotes are mine, because it's doubtful the man ever had a genuine conversation; Stieglitz was a relentless, spittle-lipped monologist, commanding every room he entered. Force of nature doesn't begin to describe his personality. Even a hurricane ends, a tsunami recedes. Stieglitz was indefatigable. Every thought that entered his head needed to be verbalized. Here was a man who wrote at least fifty thousand letters, and *hand-copied each one* before mailing it, for his

* A personal favorite, I visit this painting every time I go to the San Francisco Museum of Modern Art. I also recommend the gift shop, which has an eclectic selection of art books, notebooks, and witty erasers.

records. Just the thought of him makes me want to take a nap. In pictures, his big, dark eyes hold the penetrating gaze of a serial killer with a credo.

Monographs and biographies as hefty as those dedicated to O'Keeffe have been produced about Stieglitz and his staggering contributions to photography—it was Stieglitz who insisted a photograph should be called a picture, and so it has come to pass—and everything we think of when we think of contemporary art and the way it's exhibited, discussed, promoted, and appreciated. He single-handedly elevated photography from something akin to surveying a residential street for a new sewage pipe to a respected fine-art form; inaugurated the concept of the one-man (or one-woman) show; understood the importance of regulating the market for an artist's work by pricing the work high and limiting inventory; and reconfirmed the suspicion the human race has harbored since Eve held the apple out to Adam: Sex sells. Stieglitz was to modern art in America what Bill Gates is to personal computing: It wouldn't exist, in the way it exists, without him.

Stieglitz: An Enthusiast Like No Other

At this very moment, on the floor of the room in which I'm writing, *Camera Work: The Complete Photographs 1903–1917* (Taschen), at 552 pages an exquisite brick of a book, is flatten-

ing one side of a poster.* *Camera Work* was one of Stieglitz's passions, an avant-garde magazine devoted to publishing fine-art photography (*fine art* and *photography* being two mutually exclusive terms in 1903), in which he spared no expense and let no one else have a say. It was a typical Stieglitzian enterprise, a forum for new ideas in which no one else was allowed to get a word in edgewise.

Stieglitz was intoxicated not so much by his Picassos, Matisses, and Braques, but by his role as explainer of them. He was there, explaining, years before the 1913 International Exhibition of Modern Art, aka The Armory Show, which introduced thunderstruck New Yorkers to a bunch of new –isms (among them fauve-, cube-, and future-), and was so shocking that City Hall wanted the exhibit closed immediately for promoting anarchy and immorality. The normally sober *New York Times* called it "pathological." Even President Theodore Roosevelt weighed in: "That's not art!" Most famous among the Not-Art was Marcel Duchamp's *Nude Descending a Staircase*, which one wag described as "an explosion in a shingle factory."

Georgia knew Stieglitz the way every art student in New York knew him: from his gallery, 291—a small room with gray walls, heavy brown woodwork, and a skylight. In 1908, when Georgia was Patsy, the fun-loving girl at the Art Students League, she trekked over to 291 with a gaggle of other students

* *Red Canna* (1923).

to see Stieglitz's exhibit of racy Rodin sketches.* In 1914, during her stint at Columbia University's Teachers College, she visited 291 to see Stieglitz's exhibitions of works by Braque, Picasso, and the out-there American abstract watercolorist, John Marin.

Visiting 291 was not like visiting an ordinary gallery, where the gallerist sits at a desk in the back in his Italian loafers, glancing up only long enough to see if you look as if you have the money to buy anything. Stieglitz was more of a lying-in-wait kind of guy. He'd position himself in the middle of the small, square room and pounce on his visitors, goading them into saying something ignorant about the art so he could educate them. It was not unusual for his impromptu lectures to last an entire afternoon.

No one who visited 291 escaped Stieglitz's notice. He was extremely interested in young women, except for Patsy O'Keeffe, who was lanky, reserved, standoffish, and nobody's fool. She was a laconic daughter of the Midwest. She believed in doing, not saying; she believed in making art, not blathering about it. Stieglitz, in her opinion, was a blatherer. Plus, if his behavior toward her friend Anita Pollitzer† was any indication, he also stood too close and asked too many personal questions, somewhat creepy for a guy who was twenty-four years

* Loose pencil drawings of naked ladies, their limbs akimbo. Shocking on several fronts: the casual approach, the open legs, etc.

† Seven years younger than O'Keeffe, Pollitzer was small, dimpled, sparkly-eyed, enthusiastic, and cute as a damn button.

older than O'Keeffe, thirty-one years older than Pollitzer. Yes, yesterday's lecher is today's sex addict.

I realize I haven't portrayed the father of modern photography (also the father of a daughter, Kitty, with whom he had a troubled, distant, and tragic relationship) in a favorable light. I'm leaving that to whoever writes *How Alfred Became Stieglitz*. We are on Team O'Keeffe. He can find his own apologist.

Still, O'Keeffe knew that when it came to art, Stieglitz's opinion was the one that mattered. There's a mini lesson in here: Always aim high. In October 1915, while Georgia wondered, fought, and thought alone in South Carolina, she wrote in a letter to Anita, "I believe I would rather have Stieglitz like some thing—anything I had done—than anyone else I know of." It's astonishing how one poorly punctuated sentence can change a person's life.

During this time Georgia had a habit of sending drawings to her friends. She was working in charcoal at the time. Every biography of O'Keeffe mentions this, the sending of the pictures, but there are no details about how this was accomplished. Charcoal is sidewalk chalk for the arty, the smeariest art material there is. Did she send them in a flat envelope between two pieces of cardboard, protected by a sheet of nice vellum? Anita spoke of receiving the "batch"* and swooning with joy at Georgia's breakthrough—tucking them under her

* I can just see the ghost imprint of the second charcoal drawing on the backside of the first.

arm (!) and hurrying out to a performance of *Peter Pan* at the Empire Theater,* after which she re-tucked them under her arm and raced over to 291, where she found Stieglitz. It was New Year's Day and his birthday, so naturally he was working.

What happened next is the stuff of modern art lore: Anita, whom Stieglitz once called *my dear little friend* in a letter he wrote in response to her letter to him (asking whether he might send some issue of *Camera Work* to her friend, Miss O'Keeffe), gazed at Georgia's voluptuous and otherworldly swirls and pronounced, "Finally, a woman on paper." What he meant was, there was no doubt that Georgia was expressing something essentially feminine. People have argued whether he did or didn't actually say that. Clearly, based on everything that happened afterwards, he said something along those lines. My question is whether his enthusiasm was calculated to mirror Anita's, and thus was a hookup ploy, or whether what he was really saying was, "You can tell a woman sent this because it was stuffed in an envelope without any cardboard or nice protective vellum."

No matter. It changed everything. In that batch of charcoal drawings, which Georgia called, simply, *Specials*, Stieglitz saw the future of American art. Georgia was twenty-eight, nearly penniless. Stieglitz was fifty-four, restless in his marriage—and frankly, a little tired of promoting avant-garde European art.

* What? She put them on the floor, where they were stepped on along with the discarded Playbills and dirty tissues?

Since The Armory Show had been such a cause célèbre, modern art had gained a few more defenders, which, for Stieglitz, was a few too many. He was arguably the oldest and first sufferer of what we now call Oppositional Defiant Disorder, which for most people resolves itself before high school graduation night. But by the time Stieglitz saw Georgia's charcoal drawings, photography had become respectable, and the Metropolitan Museum of Art (Stieglitz loathed museums) had purchased its first piece of post-Impressionism, Cézanne's *Hill of the Poor (View of the Domaine Saint-Joseph)*; clearly, it was time to forge ahead into another realm. Like maybe a woman-on-paper realm; an American woman on paper; an old maid schoolteacher from the tail end of the world on paper. Who among Americans had ever seen art that expressed what went on inside a woman's heart?

How Georgia Found Her Voice and Changed the History of Art, Not to Mention Wall Calendars: Some Lessons on Creativity

Art is theft, art is armed robbery, art is not pleasing your mother.
I wish I'd said this,* but in the spirit of this lesson, I'm stealing it. The best art comes from knowing the best stuff to steal from

* It was Janet Malcolm, fearless journalist and staff writer for the *New Yorker*, who's made a career of writing books that piss people off *(In the Freud Archives, The Journalist and the Murderer*, etc.).

other people. This is known as having influences, and Georgia had a ton, even though later in life she would deny she'd had any. She was a magpie. She had a natural habit of absorbing anything and everything that would prove useful to her in her quest to express that for which she had no words, for making her "unknown known." Her influences were far-reaching and random:

Alon Bement (a teacher who was a disciple of someone else)

Wassily Kandinsky's *Concerning the Spiritual in Art* (a book)

Art Nouveau (a craft movement)

Music (another art form, which she felt was superior to painting)

The neck of her violin (a common shape)

The bright white primer the neighbor in the apartment across the way used to prime his own canvases (the fruit of voyeurism)

Whatever nature thing was currently floating her boat (trees, stones, mountains, sunsets, etc.)

The thing is not to try to do something brand-new, which is impossible, but to steal the best stuff—defined as that which really speaks to you—then toss it into the VitaMix blender of your consciousness, take a walk (O'Keeffe was a big fan of what she called *tramping*), and then come back and have at it.

And while I'm on the subject of having at it:

Paint the headache.

I'm relieved to report that Georgia did not work every blessed day of the Lord. Sometimes you read about these people. They do their thing seven days a week for forty-seven years. They show up in their studio at seven a.m. and don't leave until midnight, even on Christmas. I'm convinced that the only reason people no longer read Trollope* is because they hear about how he wrote every morning before he went to work at the post office, and how, if he finished one epic novel during his writing hours, he simply grabbed a new piece of paper and started a new one. His productivity is so off-putting that we'd rather see what's going on over at gofugyourself.com.

But Georgia was a proto slacker. She would go through phases when she would work every day, but there were days and weeks when she would read, spend hours tramping around outside, write letters, sew, and play dominoes with the cowboys. When she was at the height of her fame, she spent an inordinate amount of time doing housework, as Stieglitz's domestic skills were diametrically opposed to his genius for discovering great artists.

But when Georgia worked, she worked her ass off.

During her first stint at the Art Students League, when she was a mere babe of twenty, she learned and absorbed a lesson from William Merritt Chase that would serve her well for the length of her long life: Paint a picture a day. The idea was a

* English writer guy famous in his time, now only read by PhD candidates.

multifaceted lesson of genius. Painting a picture a day trains you to:

a) not take your work or yourself too seriously;

b) capture the energy that led you to paint this particular thing in the first place;

c) loosen up (you've only got a day, so no fussing around);

d) remember there are more where this one came from (there's always tomorrow); and

e) love the process; the enjoyment you had painting that kitten in a basket is more valuable than the painting itself.

I learned (e) when I took a life drawing class at Otis College of Art and Design in Los Angeles. The only thing I remember about it, aside from the fact that the teacher looked like Tom Petty (to the degree that now, in my memory, the class *was* taught by Tom Petty), is that at the end of every class, we threw away everything we'd drawn that day. It was mind-blowing. We'd work with gusto for three hours, then cackle like maniacs as we ripped our drawings in two and stuffed them into a garbage can, while Tom Petty sat at the back of the room and chain-smoked. Over beer and pizza after the last class, everyone agreed that this was the best art class they'd ever taken.

A year later I ran into one of the other students in Tom's class at—yes—the gift shop at the Los Angeles County Museum of Art, and he said that Tom Petty had died. That he'd been living with terminal lung cancer during our class. I still ponder his lesson plan: Was he trying to teach us that process is all that matters, or that everything turns to shit, so you might as well have a hand in hastening the process, or, some standard-issue *carpe diem* thing? And, more important, why the chain-smoking?

Georgia, had she been into discussing ideas, would have probably come down on the side of process-is-what-matters. Once she was immersed in a mad art-making phase, she kept at it until she felt as if she'd gone as far with the theme as she possibly could. "I have a single-track mind," she said, "I work on an idea for a long time. It is like getting acquainted with a person. And I don't get acquainted easily." Which explains why there are series of poppies, calla lilies, jimsonweed, iris, New York skyscrapers, cow skulls, black crosses, doors in adobe walls, clouds, and pink-and-blue vulviform abstractions known informally as "what the gynecologist saw."

Once, during the mad phase at the end of 1915, when she was drawing every night on the floor on her hands and knees, she had a roaring headache. Someone else (me) would use this as an excuse to take three Advil and settle in for a night of *What Not to Wear*. But Georgia thought, "I feel like my brains are going to explode all over the inside of my cranium, so why not work with it?" And that's what *Drawing No. 9* (1915) looks

like. (You could also argue that it looks like what it feels like the moment *before* the explosion.)

As anyone who has ever had a migraine will tell you, *this* is realism—not some lady in a big hat sitting in a rowboat. Georgia would express similar views in an interview in the *New York Sun* after she had become O'Keeffe: Nothing is less real than realism.

The lost art of sublimation.

This will be the most unpopular lesson in the book; no offense taken if you feel the need to skip ahead to the section on How to Be a Man Magnet (hint: It has nothing to do with your shoes) or How to Avoid Looking Like a Starving Artist (hint: It has everything to do with your shoes).

You can't always get what you want. So said the poet Jagger, at a time in American history when his college-educated, fringe-vest-wearing fan base was getting pretty much everything it wanted, compared to young people in, say, 1914, the year Georgia met and fell in grown-woman love with Arthur Macmahon.

She'd met Macmahon in the summer of 1915, during one of her teaching stints at the University of Virginia. He was a handsome, soft-spoken political science professor from Columbia University, teaching government at UV summer school. He was entranced by Georgia, her love of nature, her sensual interest in leaves and flowers, her mania for tramping through the piney woods, her long, elegant fingers.

Then, like summer romances since the world began, this one ended. He went back to New York. Before he left he made some noise about her joining him in Manhattan, but then he left and she didn't hear from him. Frustrated by his silence, she wrote to him, admitting that she wasn't into game-playing like so many women; she wanted to write to him, so she did.

The exchange of smokin' letters began. But Macmahon was a graduate of the Stop it Some More, Stop it Some More School of Courtship. He ran hot and cold. Georgia would receive a letter that gave her hope for their romance, and she'd zip one back to him. Then, nothing. It was the 1915 equivalent of The Phone Did Not Ring. She would worry that she'd been too forward, that writing that thing about not playing games like other women was a big mistake. Was she an idiot? Why did she say that? Then, she'd receive a letter from him. Hooray! He'd talk about perhaps going away together to a cabin in the woods, then instead of asking her, switch topics and recommend that she read Olive Schreiner's *Woman and Labor*. She was beside herself.

Then, "like a thunderbolt out of a clear sky,"* Macmahon wrote and invited himself to visit her in Columbia for Thanksgiving. She was elated. He showed up a day late, but she put that behind her. They talked. They walked in the piney woods. She dared to take her shoes off and dabble her feet in a

* We will forgive her for this somewhat trite phrase, written in a letter to Anita Pollitzer. She was in love!

stream, while still wearing her stockings. Then, probably, they had sex.

I wish it all didn't come down to nookie. Who Georgia slept with is none of our business. We're not the village elders in one of those barbaric cultures who insist on waving bloodied sheets out the window the morning after the wedding night. Still, after this weekend, when Macmahon returned to New York and resumed his maddening passive-aggressive Stop It Some More ways, Georgia, delirious with the memory of their presumably hot time together, frustrated by his mixed messages, started in on the group of charcoal drawings that would capture the eye of Stieglitz and change her life.

If Georgia had lived, say, now, she would not have poured her raging heart into her work. She would have rolled up her sleeves, Googled "How to get and keep your man," sprung for a weekend workshop on applying the principles of *The Secret* to her situation, moved to New York, waxed the proper body hair, found out which Power Yoga class Arthur frequented, and arranged to accidentally bump into him. In short, she would have found a way to make him hers!

Georgia was not the only one to sublimate her roiling unhappiness and frustration into her work. Sublimation is not just a woman thing. Stieglitz's entire early career was also one long adventure in sublimation.

Without putting too fine a point on it, Stieglitz had married his wife, Emmeline "Emmy" Obermeyer, for money. She

was the heiress to a brewing fortune, and by 1893, the year they were married in a restaurant on Fifth Avenue, it had become clear to Stieglitz's father, Edward, that his eldest son was going to need a sugar mama if he was to survive. A deal was struck: Her trust fund would pay for their bourgeois upper-middle-class lifestyle, and Edward would settle enough money on him so that he could pursue his photography.

Since Stieglitz was adamant in his refusal to sell his photographs, or work for magazines, or take commissions for fear his art would be compromised by the quest for filthy lucre, and since every enthusiasm that entered his head demanded its own little avant-garde magazine, and since he could barely get out of bed in the morning if he didn't have a gallery to go to, where he could hector people, Emmy's money wound up paying for more or less everything.

Moreover, Stieglitz wasn't really interested in being a husband, in the traditional sense of the word. On their honeymoon, he left his wife in various hotel rooms around Europe to visit galleries or take photographs. Emmy retaliated in the time-honored tradition: She withheld sex. She was really good at it. After a coitus-free year, Stieglitz came down with a bad case of pneumonia, which prompted Emmy to promise that if he recovered, he'd get some.

Alfred and Emmy managed to produce one child, a daughter named Katherine. After her birth they moved to a big apartment on Madison Avenue where Emmy hired a cook, a maid,

and a nanny. Meanwhile, Alfred busied himself photographing skyscrapers at all hours of the day and night, in every sort of weather, after which he camped out in his darkroom, producing one turn-of-the-last-century masterpiece after another.

Sublimation is a powerful thing.

Best of all, it'll never let you down. Are most of us not, at least some of the time, frustrated by our jobs, disappointed by our mates, envious of the slim-ass receptionist at the gym? The good news is, we needn't fix anything. We need not get another job, a divorce, or strangle the receptionist while she's restocking the towels. We need only start a blog.

Say yes to no frills.

You do not need a new laptop. You do not need to update your software. Whatever app you think you need, you don't. You don't need an iPad, or an i-anything, for that matter. You don't need to clean your study. You don't even need a study. You don't need a secluded cabin in the woods. You don't need a better chair. You don't need the best hours of the day. You don't need big ideas, or even any ideas.

Georgia abandoned color. She'd been working in watercolor and hated the result. At her tenth attempt to capture one flower she wrote to Anita, speaking in the voice of the painting: "Am I Not Deliciously Ugly and Unbalanced."

Georgia abandoned painting. She went back to charcoal, a humble and impossible material. She unrolled cheap manila paper on the floor and had at it, late at night, after she was

done teaching, tramping, and letter-writing. She wrote to Anita that she developed bad cramps in her feet from crawling around the floor. She worried that she was going insane, just drawing what she felt without censoring herself. Anita responded that she shouldn't worry—that Cézanne, Van Gogh, and Gauguin were all "raving lunatics." She embodied the wisdom I heard somewhere once, that to create something meaningful you must love the expression of your heart more than you love yourself.

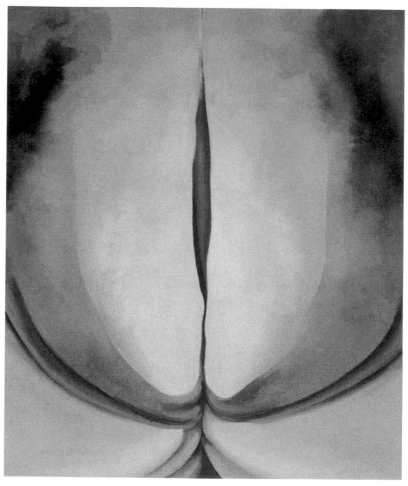

Georgia O'Keeffe
American (1887–1986)
Blue Line, 1919
Oil on canvas, 20⅛ x 17⅛

Gift of the Burnett Foundation and the Georgia O'Keeffe Foundation

Photograph by Malcolm Varon, 2001

The Georgia O'Keeffe Museum, Santa Fe, NM

Georgia O'Keeffe Museum, Santa Fe/Art Resource, NY

5

EMBRACE

As I came up the street into the sunset after supper—I wondered—can I stand it—the terrible fineness and beauty of the intensity of you—

MAY 1916. WORLD WAR I RAGED IN EUROPE; ALBERT EINSTEIN had just presented his General Theory of Relativity in Berlin; the formula for Coca-Cola was being readied for market; and Georgia had returned to New York, where she was enrolled in an art methods class at Teachers College.

In January, days after Stieglitz had discovered her strange and moving charcoal *Specials,* Georgia had received a teaching offer from R. B. Cousins, president of the West Texas Normal College. Cousins asked her to head their art department with the proviso that she complete the required methods class at Teachers College. The course was taught by none other than

Arthur Wesley Dow, the guru of Alon Bement, who'd rocked Georgia's world with his revolutionary ideas on painting. Georgia was thrilled at the thought of returning to the vast, dusty plains of Texas, and even happier to be asked to make a lengthy detour through Manhattan. Even though Georgia had been toiling at her teaching job in the other Columbia, she was still broke. Then as now, teachers are poorly paid. To make it work, she borrowed a few hundred bucks, and took Anita Pollitzer up on an offer of a free place to stay—the spare room in her uncle's apartment on East 60th Street.

Arthur—yes, the same one who had inspired the *Specials*— taught poli sci at Columbia. Now they could be together! Except, it wasn't that simple. Before Georgia quit her job in the other Columbia, she kept running into women who "knew" Arthur. Given that she lived at the tail end of the world, one wonders how this was possible. Did Arthur really get around that much? Did he really have more than one lady friend in Columbia, South Carolina? Several times Georgia would ask him to account for this blonde or that brunette, and he would offer some generic reassurance, and their relationship would struggle along like every long-distance relationship does, like a plant that's stuck in a northern-facing window and watered just enough to keep it alive.

She saw Arthur while she was in New York, but she also spent a lot of time visiting 291, where she saw some aggressive Marsden Hartley military-themed paintings, which she thought resembled "a brass band locked in a closet," and also

a small, moody John Marin watercolor, which convinced her that if his work could sell, then so could hers. The Marin was quiet and introspective, as was her own work. This was a revelation: Georgia had never given a thought to making a living as an artist. She was ambitious, but she wasn't crazy. The only people who made a living with their art were men like Merritt Chase, society painters who were paid a lot to paint flattering portraits of dowagers and hunting dogs, not Wisconsin-born schoolmarms whose erotic swoops and zigzags predated abstract expressionism by thirty years.

When O'Keeffe and Stieglitz Collide

Stieglitz had talked about exhibiting Georgia's charcoals, but Stieglitz was a big talker. In a letter dated January 20, in one of the first of the thousands of letters he was to write to Georgia*over the next thirty years, he said, "If at all possible I would like to show them, but we will see about this." Months passed, and then one day there was a movie moment. It's possible this never happened, or it did happen, but not in such an obviously dramatic fashion. It's possible this is an example of the old truism, "When legend becomes fact, print the legend."

One day Georgia was minding her own business, eating lunch in the cafeteria at Teachers College, when another young woman rushed up and asked her if she was Virginia O'Keeffe.

* *My Faraway One: The Selected Letters of Georgia O'Keeffe and Alfred Stieglitz: Volume One, 1915–1933* is 832 pages long.

"I'm *Georgia* O'Keeffe," she is said to have said.

"There's a new exhibit by someone named Virginia O'Keeffe up at 291 right now," said the young woman.

Georgia stood up, left her tray sitting there (maybe I'm embellishing), and marched down to 291. She was determined to give Mr. Stieglitz a piece of her mind. How dare he show her work without her permission? She strode into the gallery and was taken aback to see her small drawings on their cheap paper hung with care on the gray walls of the famous gallery. She was told that Stieglitz was at jury duty. (They should add *jury duty* to *death and taxes* as things you can count on in life.)

Georgia showed up again several days later so they could have the argument that would define their relationship. She'd already adopted black as Her Color, years ahead of beatniks, hipsters, artists, and every woman in New York who has to go to a dressy function after work. She wore her dark hair pulled straight back off her face. It was still round and Irish-looking; the angular jaw that would become part of her iconic persona was not yet in evidence. O'Keeffe was arresting, as beautiful as she was eccentric. She had blue eyes, pale skin, and enormous dimples. She tried to downplay them in photos by refusing to smile. Some of her legendary sternness sprang from simple self-consciousness; she despised those dimples. Still, she liked to laugh. As her friend, famed photographer Ansel Adams, would say of her, "When Georgia O'Keeffe smiles, the entire earth cracks open."

But she wasn't smiling that day. She was livid . . . and also flattered. As always, she was enlivened by her mixed emotions. She was outraged that Stieglitz would show her work without consulting her; on the other hand, she was thrilled that Stieglitz was so captivated by what she'd done that he exhibited her work without consulting her.

Before this day in 1916, Stieglitz and Georgia had exchanged some letters and chatted a bit at 291, but they'd never squared off before, never stood toe-to-toe and looked directly into each other's eyes.

I realize that in an earlier chapter I was a little hard on Stieglitz. It perhaps says more about me that I think he suffered from narcissistic personality disorder than it does about Stieglitz. Then again, I can think of no other explanation for his behavior over the years, especially when it came to the ladies.

An example, from a few years hence: Stieglitz and O'Keeffe summer, as they do every year, at the Stieglitz family compound at Lake George, New York. Stieglitz likes to have people around, lots of them, all the time. This summer the parade of visitors includes Alfred's brother Lee and his wife, Lizzie; Stieglitz's niece Elizabeth and her husband, Donald; art critic Paul Rosenfeld; a German artist named Arnold Rönnebeck; Rebecca "Beck" Strand, the wife of photographer Paul Strand (more about him in a minute); and Katharine Nash Rhoades, also a painter, and the woman Stieglitz loved before Georgia.

By this time Stieglitz and O'Keeffe have been together for six years. He's fully aware of Georgia's immense need not only for privacy, but also for routine and order, as well as her squeamishness in the face of emotional turmoil, something upon which the gregarious, talkative, boundary-free, self-dramatizing Stieglitz family thrived. Still, he invites Beck Strand, whom he has been photographing in the nude,* and Katharine Rhoades to visit at the same time. He harbors a belief that all the women he loves should all love one another and enjoy one another's company,† and also enjoy the awkwardness and emotionally freighted behavior that results (empty places at the table; heavy silences; doors slammed with a little too much oomph; secret crying jags). That Georgia feels distress over this arrangement mystifies him. Her unhappiness is simply more evidence of the high-strung irrationality that is an expression of her feminine nature.

But, at this moment in time, in May 1916, his charisma and role as high priest of modern art were irresistible. He was handsome. His head was nicely shaped, his nose had authority. He had a low hairline, and thick graying hair full of cowlicks. Long before Einstein made mad-scientist hair a style, Stieglitz had a head of sticking-up gray tufts, and perhaps it's this crazy hair that made him look more demented than he was. It always sounds like an exaggeration to say someone

* O'Keeffe's biographers differ on whether or not he and Beck were technically having an affair. Seriously?

† Perhaps it should have been Stieglitz, and not O'Keeffe, whose reputation enjoyed a resurgence in the 1970s.

is impossible to resist. It's absolutely on par with *always* and *never*, and therefore likely to be untrue. But if anyone was impossible to resist, it was Alfred Stieglitz.

Georgia appeared at 291, and their conversation went something like this:

Georgia: Take my pictures down right now! [Not really; see how amazing they look?]

Stieglitz: That's impossible. [It's my opinion that they should stay right where they are, and since I am always right, so they shall.]

Georgia: I didn't give you permission. [I know how respect works, buster. If I don't respect myself, you won't respect me.]

Stieglitz: You have no more right to withhold those pictures than to withdraw a child from the world. [I will wear down your resistance with my bizarre hyperbole.]

Georgia: *glares* [What?]

Stieglitz: Do you have any idea what you've done here, child? [Even though I'm one of the nation's first modernists, I'm still a Victorian at heart, and think women and children are interchangeable.]

Georgia: Of course! Do you think I'm an idiot? [Does he think I'm an idiot?]

This disagreement, their first, illustrated a little-remarked-upon truism about any long-term relationship:

The first thing a man does to annoy you will always annoy you, and become more annoying over time. It's possible that the annoying thing does not, in fact, become more annoying, but that everything about him with which we're besotted—the slight space between his front teeth, the way he writes important phone numbers on the back of junk mail he then recycles, his devotion to the elderly gas guzzler he drove in college, his undying enthusiasm for Pink Floyd and his compulsion to lecture on the unsung genius of the guitar work in "Money," his habit of making a gargantuan Saturday-morning breakfast,* the way, after a shower, he sits on the end of the bed and, buck naked, looks between his toes as if seeking an answer to one of life's most burning questions—diminishes over time, leaving that first annoying thing sticking out like Octomom's belly.

It should go without saying that this applies to women as well. That is, if you're a straight guy and you're reading this (unlikely, since there's a flower on the cover and the only thing more man-repellent is a high-heeled shoe, unless the book is entitled *The Collected Letters from Penthouse*), you can apply it to the woman in your life: The first thing she does to annoy you will always annoy you, and become more annoying over time.

From this moment on, Stieglitz would always know best, even when he knew nothing (like most relationships, it became both more and less complex over time). A large part of his role was self-appointed representative of Big Concepts that He Felt Compelled to Capitalize. Art. Love. Sex. Womanhood. Because

* Both waffles AND pancakes, sausage AND bacon . . .

he had unshakable faith in his own ideas, and because, admittedly, so many of those ideas had proven revolutionary, prescient, and, when it came to "his" artists,* career-making, and because O'Keeffe, the mystical, earthy, innocent genius from America's heartland, was his idea, Georgia couldn't help but embrace his interest, his friendship, and, eventually, his love. Stieglitz would become Georgia's faithful, devoted champion, showing her work in his various little galleries year after year, through the Roaring Twenties, the Great Depression, the Second World War, through good productive years of staggering creativity and bad years of illness, misery, and crapola.

Georgia would pay a price for his devotion: In exchange for being perceived by the world as a complex, intelligent woman, a genuine intellectual who had recently immersed herself in Ibsen, Dante, and Nietzsche, for God's sake, and who had absorbed all on her own a number of unlikely, disparate, and rarified influences and, pressing them through the sieve of her deep emotional life, and in the process basically invented abstract art, she would accept his simple, unoriginal Victorian version of her as Woman-Child. She was the Eternal Feminine, an earthy and unschooled ingénue from the Midwest, at one with both the land and her lady parts.

Aside from all this heady business, they had few things in common that make it possible for people to spend more than a weekend together: He was a city mouse and she was a

* The Stieglitz 7 included, in no particular order of fame or talent, John Marin, Marsden Hartley, Arthur Dove, Charles Demuth, himself, and Georgia O'Keeffe, and whatever wild-card artist he was into at the time.

country mouse. He loved trading ideas, arguing, and debating. She ran in terror from all that nattering. She loved to travel, tramp, and get lost in the wilderness. He despised traveling, and the only natural setting he could abide was the one at Lake George, where the Stieglitz clan would retire for months during the summer to argue and get on each other's nerves while their servants waited on them. She had never had a servant. He was immobilized without them.

And yet, they would go on to enjoy one of the epic marriages of the twentieth century.

Meanwhile, on May 1, 1916, Ida O'Keeffe, the cultured and cool-hearted mother who had scrimped pennies so that her girls could have art lessons, died. It happened around the same time the above conversation at 291 took place. Georgia's mother and the younger O'Keeffe daughters were barely making ends meet in Charlottesville. Ida's tuberculosis, which she had contracted in Williamsburg (where Frank O'Keeffe had moved the family specifically to flee the tuberculosis he felt sure he would contract in Sun Prairie), had steadily worsened. The women were behind on the rent. The landlady came to collect it. When Claudia, the baby of the family, answered the door and said her mother wasn't feeling well, the landlady was unmoved. She'd apparently heard this excuse before. She refused to budge. Distressed, Claudia called for Ida, who

dragged herself out of bed but collapsed on the way to the front door, dead of a pulmonary hemorrhage. She was the same age as Stieglitz.

Georgia received word of her mother's death by telegram in Manhattan. She was surprised by the depth of her grief. Frank Jr. had been her mother's favorite. Anita was the prettiest, and Ida, the most artistically gifted. Georgia was quirky and willful. In a letter to Stieglitz, she said she and her mother were so different; she had essentially raised herself, "wriggling up alone—bumping my head and thinking it was worth it." It never matters, does it, that we were not our mother's favorite? Georgia was not the kind of woman to eat her way through a chocolate cake to make herself feel better. Even in the face of grief, something most of us spend a lifetime trying to dodge, she was in thrall to her emotions. She submitted to her sadness with Midwestern stoicism. She dreamt about touching her mother's face, massaging her temples with her thumbs. She sometimes wept in private, but mostly she trudged through her days at the University of Virginia, where she was once again teaching summer school. It was a measure of her despondency that nature—in this case, the spunky bright green of early summer, the rolling wooded hills—left her cold.

Work had become both a habit and a source of solace (sublimate!), and when she returned to it, she also returned to working with color. Her charcoal-only days died with Ida. She began a calligraphic series of lines, rendered first in charcoal, then black watercolor, and finally, her spirits lifting, blue. Two

deep blue lines travel up the page from a horizontal pond of blue; two-thirds of the way up one line zigs down, zags back up, then continues along its way, once again parallel to its mate. She sent it to Stieglitz, who was so smitten by its self-assurance and austerity that he hung it on a wall where he could gaze upon it from his office, so that he could look at it whenever he pleased.

A Few Modest Lessons on Falling in Love

You must write to one another.

After Georgia left for Canyon, Texas, and West Texas State Normal College in late August 1916, she and Stieglitz struck up a correspondence that was so lively, consistent, and increasingly intimate* that it could have only ended in bed. Every thought that entered their heads was fit to be part of their communication. From a letter dated September 3, 1916, in which Georgia complained that the narrow-minded citizens of Canyon were like "petty little sores" on the plains, described the locust-sound of the prairie wind, expressed fear and loathing of the pink roses on the wallpaper of her rented room ("Give me flies and mosquitoes and ticks—even fleas"), and made coy, passing reference to being naked, she writes:

* "A greeting from Boston," wrote Stieglitz in June 1916; two years later it was "Flower of my soul's yearning . . . You Wonder of All Wonders—You Glorious Bit of All That's Human."

You know—I—

I waited till later to finish the above sentence—thinking that maybe I must stop somewhere with the things I want to say—but I want to say it and I'll trust to luck that you'll understand—

She reports that she prefers to wear her coat buttoned, and how the sound of her pen scritching along as she writes drives her mad.

He details every cloud that drifts overhead, the feeling of ice on the tips of his mustache, his thoughts about the drawings and paintings she sends to him on a regular basis ("Gripping"), his conversations with other artists, advice on how to cure a sore throat. The more they wrote to one another—sometimes two or three letters a day—both adopting her manic use of dashes in place of standard punctuation—intoxicated by the romance they were creating and the depth of their communication—by the connection they were developing—the more their letters became a richly textured work of art that belonged to no one but them.

Now that letter-writing is dead and e-mails are on life support, how do we develop this kind of rich, multifaceted attachment to someone we're interested in? I'm probably being unrealistic in assuming that most people still think this is an effort worth making. After all, when Georgia and Stieglitz began their passionate correspondence, people didn't even

have radio, much less six seasons of *Lost* to catch up on (available on DVD and for instant streaming on Netflix). A lot of this mad letter-writing was also something that passed the time. It was fun, 1916-style. It was Angry Birds and *I Can Has Cheezburger* and *American Idol* and retail therapy, and everything else we moderns like to do. Also, when Georgia and Stieglitz began, they weren't looking to fall in love. Stieglitz was older and long-married, and Georgia was still technically seeing Arthur Macmahon. They were merely messing around.

Nowadays, we simply don't have the time to mess around, to bounce ideas off each other, chase each other's thoughts, and in the process create a private world built of ideas, feelings, and language. One day we're single, the next we're on Match.com. In a perfect world, we would be able to go straight from being "winked at" to a meeting with the wedding planner. We don't want to futz around e-mailing someone about the sound of the rain on the roof, or how we took the dog for a walk around the block and admired the plum trees in bloom, or how our sister came to visit and made her special lasagna. A friend of mine* who's an avid online dater said that she'd made a policy to write off any potential suitor who e-mailed her for more than two weeks without making a coffee date. Such foot-dragging was a sure sign that either he wasn't interested, or he had intimacy issues. The idea that maybe her online crush wanted to flirt a little, throw out a few jokes to see if she got them, reference a book he'd read or a movie he'd seen, or

* Actually, someone I barely know.

test the political waters to see if they both avidly supported/mutually loathed the president had never occurred to her. She was busy and wanted to get busy. She wanted to dispense with the niceties of getting to know what goes on inside her potential beloved's head and get straight to the cha cha cha and ooh la la.

The only people left in the world who build and nurture the sort of deep, complex connection that is created via correspondence do so because they have no other choice: They're either in love with a soldier serving a tour of duty in a developing country with unreliable Internet, a Peace Corps volunteer, or someone serving a long prison term.

And lucky them. Because they're forced to communicate via writing they're able to ascertain, over time, their beloved's true character. I'm not talking about discovering his likes and dislikes or most embarrassing moment in middle school. I mean learning whether he possesses the ability to see and love them for who they are, support them in their goals to do whatever, and make them laugh.*

It's essential to know this about anyone you think you might be serious about, and really, the best way to gauge this is over time, without the interference of pesky hormones. This shouldn't need to be said, but there is no correlation between a guy's washboard abs and his ability to champion your fondest hopes and dreams. I wish I could find a more elegant way

* This is not my own bias. It's impossible to maintain any relationship longer than about a month and a half without a sense of humor.

of saying this: People in passionate long-term relationships put up with a lot of shit from one another. That's just the way of it. You can learn how to communicate better, or add spice to the bedroom, or make time for weekend getaways that feature a hotel with en suite hot tub, but people can't escape their essential personalities. And neither can their significant others.

I'm belaboring this point so you can see why O'Keeffe loved Stieglitz, and continued to love him once he started behaving badly. For all of his off-putting qualities, no one on earth believed in her vision and her genius more profoundly than did Stieglitz, and because of that he was irreplaceable.

But how, you may ask, with letters long dead and e-mails about to exhale their death rattle at any moment, can you begin a meaningful correspondence with someone? What is the would-be writer of love letters to do? There is an answer, but I suspect you won't like it: video games.

I met Jerrod, my own Glorious Bit of All that's Human, playing EverQuest.* I played a high elf magician and he played a wood elf bard, and one day our avatars "met" in a zone called The Estate of Unrest, where we were each killing ghouls, zombies, and reanimated scarecrows. There's a heavy chat component to these games. In between slaying two-headed ogres and raising your sewing skill by "making" the same cloth hat four hundred times in a row, there are hours of typing back and

* Until World of Warcraft came along, the most popular MMORPG (Massively Multiplayer Online Role-Playing Game) in the world.

forth. Not letter-writing, but just as time-consuming. "Mozi" and I quested together and chatted every night for months. The courtship was Victorian even by Stieglitzian standards. In the event he was an unemployed pothead in a stained T-shirt living in his mother's basement, I was reluctant to give him my real name. I was smitten by his sense of humor (on many occasions I really did LOL), his California roots (like me, he grew up in a tragically dull suburb), and the clincher, the fact he knew that "a lot" was two words.* Finally, I told him my name. That was ten years ago.

The greatest aphrodisiac is vitality.

By the time she'd settled in Canyon, Georgia was a full-blown eccentric. You'd be hard-pressed to find a woman so astoundingly herself, not just of that time, but of any time. In a bit of fashion synergy that echoed what was going on in the same decade in the atelier of Coco Chanel, half a continent and an ocean away in Paris, Georgia wore only straight, sheath-like black dresses. She tromped around wherever she pleased in flat, mannish shoes. The only time she changed her footwear into something more dainty and acceptable was when she wanted to resist the urge to hike for miles out into the prairie, or scramble up and down the rocks at nearby Palo Duro Canyon; high heels were for self-hobbling only. She was known for the spot-on impersonations she did of other teachers, her biting wit, and her knowledge of something called cubism.

* You'd never discover that about someone during a coffee date.

She was as on the fringe as they came, and yet, she attracted a variety of men. They weren't afraid of her oddness, her competence, her lack of bows and small talk. George Dannenberg, The Man from the Far West, was still writing to her, as was Arthur, her first lover. For a time Arthur wanted to marry her, but she wasn't interested enough to encourage him to press his hand. There was also her student, Ted Reid, and of course, Stieglitz.

She was not yet the famous O'Keeffe. She was merely the local bohemian. And yet, all these men, all of a different stripe (the arty San Franciscan who loved to dance; the handsome, straitlaced political science teacher; the local football hero; the equally eccentric Father of Photography), couldn't stay away.

Her secret? Loving her own life. Finding the things that came her way of immense interest and animating them. No matter what was going on, it was great to be her, starring in her own true-life adventure. My mother, who knew about these things, advised me when I was thirteen and boy-crazy to ignore the boys and focus on my schoolwork, swim team, horseback riding (which I could never get enough of), making macramé plant hangers, and keeping up with *The Man from U.N.C.L.E.* She said that loving things in life makes people love you. She said, it's like how we trained the dog Smitty to come. We didn't stand there and holler *Come!* We didn't entice him with a dog treat. Instead, we would ignore him, then rush over to the other side of the room and pretend we'd found something exciting. Then he would rush over to see what the fuss

was about. It didn't take long for Smitty to rush over to me every time I entered the room, so sure was he that I was up to something interesting.

Resistance is futile.

After the end of spring term, 1917, O'Keeffe hopped on a train and went to New York. To buy the ticket, she convinced the banker to open the bank on Sunday so she could withdraw her savings. This was not something people routinely did, hopping on a train at the spur of the moment. When she showed up at 291, Stieglitz was both impressed and titillated by what he thought of as her girlish "American" spontaneity. On April 3, 1917, he had opened her first solo show, including some of the charcoal *Specials*, some watercolors from Canyon, and the esoteric and elegant *Blue Lines* (1916), but by the time she arrived it had been dismantled; he insisted on rehanging it for her private pleasure.

During her ten-day stay she met Paul Strand, a young photographer and one of Stieglitz's recently acquired disciples. Stieglitz loved nothing more than having a new disciple. A decade earlier the Belgian-born photographer Edward Steichen had sought him out during a trip to New York in 1900. Stieglitz immediately pegged Steichen as a fellow photographic visionary. Steichen designed the logo of *Camera Work*, and Stieglitz dedicated several issues to Steichen's photographs. Even though Stieglitz had been born in Hoboken, the two men shared a European sensibility. It was Steichen who

had turned Stieglitz on to Rodin, Cézanne, Matisse, Picasso, and Brancusi.

But inevitably, Steichen betrayed his mentor by committing the unpardonable sin of inventing fashion photography,* then further rubbed salt into the wound by proving his youth and manliness by joining the army after the United States entered World War I, where he commanded a photographic division of American Expeditionary Forces. Stieglitz was both too old and too conflicted about the war to join in.

Acolytes came, then disappointed and left, so there was always an opening for a new one. Paul Strand was the latest and brightest. He discovered photography in high school, when his class at The Ethical Culture School took a field trip to 291 in 1907. Like Steichen before him, when Strand met Stieglitz[†] he was dazzled by possibilities and dared believe that he could make a career of photography. Strand was handsome in the way of the cutest male high school teacher, and the moment Georgia met him she fell for him, and he for her.

On Memorial Day, Stieglitz, Strand, and some other photographer who isn't important to the story took a trolley to Coney Island. Georgia was in a swoon. At twenty-nine, the Patsy O'Keeffe part of Georgia's personality, the fun-loving Irish girl who liked to dance and pull pranks, had been allowed to atrophy. Years earlier Georgia had realized that there were

* His 1911 pictures of French designer Paul Poiret's gowns that appeared in *Art et Décoration* were the first fashion layout.

† It appears that every man who was important to O'Keeffe had a surname that began with an "S."

only so many hours in the day, and that if she stayed out late dancing, she wouldn't be able to paint the next day. She'd begun to understand both time and emotional energy were art supplies, every bit as important as fine brushes and high-quality paint. She simply never allowed herself to have fun like this. On the trolley ride home, Stieglitz wrapped O'Keeffe in his heavy loden cape to keep her warm. Georgia couldn't help but view Stieglitz as avuncular. He was old enough to be her father, with iron-gray hair and a well-upholstered marriage made in the last century.

Back she went to Canyon. Now she had a new correspon-dent, the adorable and age-appropriate Paul Strand. He was bewitched by her and, moreover, their work bore striking similarities. They were a generation younger than Stieglitz, and their sensibilities were completely modern. After the 1913 Armory Show, Strand became interested in cubism. A few months after Georgia had made her charcoal *Specials,* Strand found a set of bowls in the kitchen and began photographing them in clusters in extreme close-up. The black-and-white pictures were hypnotic, the shadows as important to the com-position as the objects themselves. Georgia had made the first abstract paintings, Strand, the first abstract photographs.

Georgia's second year in Canyon was not as magical as the first. Around Christmastime things began to go bad. In April America had entered World War I, and a shop in Canyon was selling let's-slaughter-the-Germans Christmas cards. When Georgia wrote a letter to the shop owner saying that this

sentiment wasn't in keeping with the season, or, for that matter, Christianity, word spread that she was against the war. It was more than tiny, conservative Canyon could take.

Something happened in February upon which no one quite agrees: Either it was suggested she take a leave of absence, or else she came down with the flu. Even though the Spanish flu pandemic of 1918 was not quite under way, then as now, a lot of people said *flu* when they meant a really bad cold. Georgia left Canyon for the ranch belonging to her friend, Leah Harris, in Waring, Texas. She was allegedly recovering from her illness there, but in one letter she reports that after gardening, cooking, cleaning, and sewing, she walked to town and back.

In New York, Stieglitz, a hypochondriac of some renown, read the word *flu* in one of her letters and panicked. He started to obsess, something he had plenty of time to do because he'd been forced to close 291 for lack of funding. He was at loose ends, without a cultural battle to wage. He'd convinced the world that photography could be fine art, as well as the seemingly nonsensical cubes and lines of Picasso, the sinuous shapes of Matisse, Cézanne's rough-hewn apples and pears. Now, he was being nudged aside by younger artists. Now, modern art had a number of supporters. He was depressed. At home, his marriage had deteriorated. He was sleeping in the study.

Stieglitz knew that Strand was also smitten with Georgia. The only enjoyable moments of his day were spent comparing notes with Strand about Georgia. The more they discussed her and her "flu," the more important it seemed to rescue her

from Texas and bring her to New York. A plan was hatched: Strand would go to Texas and bring Georgia back, at Stieglitz's bidding. The old alpha dog had roused himself and decided it was time to act. Strand arrived in Texas and presented Georgia with an opportunity: Elizabeth, Stieglitz's niece, had a small studio where Georgia could stay, rent-free.

It's a mystery why Georgia and Paul Strand never hooked up. Perhaps things had already been put in motion with Stieglitz; they'd gone too far down that road to turn back. Or perhaps the fact that he'd come all the way to Texas as Stieglitz's errand boy made him less attractive. Maybe since they were both protégés of Big Daddy Stieglitz, she saw Strand more as a brother. Maybe it was simply fate.

At any rate, Georgia realized it was time to play her hand. Georgia's intuition was not only impeccable, but she also trusted it without reservation. The time had come for a change. She agreed to accompany Strand back to New York, a city she had never particularly liked, to see what lay in store for her.

When she arrived in New York in June, she was thin and tired.* Stieglitz whisked her off to Elizabeth's tiny two-room studio on East 59th Street, where history was made. He put her to bed. The Victorian in him was roused by the sight of powerful, passionately alive Georgia languishing on the small cot in her kimono. She was sick! He would take care

* As anyone would be after all that gardening, cleaning, cooking, sewing, and walking back and forth to town.

of her! He immediately found someone to teach him how to boil an egg.

June, 1918. The Russian Revolution was in full swing, as was World War I. The U.S. Postal Service had just invented air mail. *Out West,* starring Buster Keaton and Fatty Arbuckle, was in the theaters. In the small, bright studio on East 59th Street (the walls were painted yellow, the floor, orange), Stieglitz dragged out his big box camera and tripod and began his epic photographic portrait of the woman who had become his lover. Each photograph required a three- to four-minute exposure. In 1917 he'd made some pictures of Georgia's sinuous hands, but that was just foreplay. Now he spent hours photographing her jaw and neck, her shoulders, breasts, rib cage, feet, back, torso, lady parts. She looked rakish in a black bowler and black cape, erotically androgynous in a man's suit, helpless and ravaged in her white kimono, her hair splayed around her shoulders. It was hard work, all the posing in the small, hot studio, all the sex that happened in between sittings.*

Georgia was bowled over. She had been unsure what she looked like until she saw these pictures. It was 1918. Women didn't study themselves for hours in the mirror; indeed, Georgia had rarely had a mirror in her small rented rooms. "You see," she would tell a reporter sixty years later, "I'd never known what I looked like or thought about it much. I was amazed to find my face was lean and structured. I'd always

* Obviously, she had recovered from the "flu."

thought it was round." She'd always said that the experience was worth the risk, and whatever she was risking here, it was worth it. She had never been made to feel this beautiful.

Eventually, the portrait would run to five hundred prints. The last one would be taken in 1937. Two hundred of them were taken here, during the first, heady months of the relationship. Stieglitz famously said, "Whenever I take a photograph I make love." And so he did.

Which leads me to the final lesson: *If your boyfriend takes a naked picture of you, be prepared for the world to see it.*

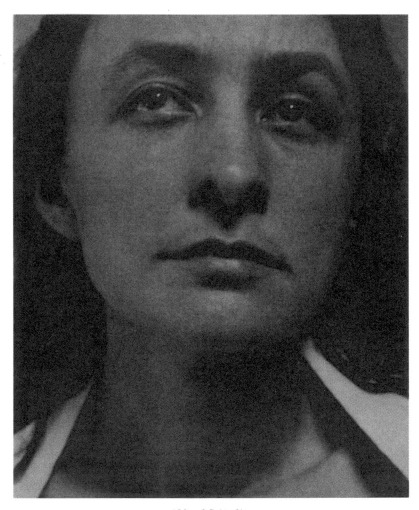

Alfred Stieglitz
American (1864–1946)
Georgia O'Keeffe, 1918
Palladium print, 9⅝ x 7⅝ in.

Alfred Stieglitz Collection. Gift of Georgia O'Keeffe

The Museum of Modern Art, New York, NY

Digital Image © The Museum of Modern Art/Licensed by SCALA/Art Resource NY

6

BARE

If I stop to think of what others—authorities— would say . . . I'd not be able to do anything.

ON A COLD DAY IN FEBRUARY, 1921, GEORGIA WALKED INTO the Anderson Galleries to view the photographic retrospective of Alfred Stieglitz (145 prints from 1886 to 1921). He was fifty-seven years old. His hair was iron-gray. The artists and intellectuals of his circle thought he'd put down his camera for good. Instead, he'd discovered Georgia O'Keeffe, her art, passion, and comely buttocks, and made not just a comeback, but a masterpiece.

Of the 145 pictures, 45 of them featured Georgia. I won't make you do the math: That's a little less than one-third. The care and devotion with which Stieglitz had documented her body was boggling. Thousands of viewers poured into the tiny

space to check out every hollow, knuckle, knob, and pore. Moreover, Georgia was a babe. Without Zumba or Pilates or whatever exercise craze is trending when you read this, she was lithe and well-formed.

Among the forty-five pictures, there was a notable amount of bosom-clutching. Fully dressed in a black suit, simple white blouse, and black bowler, she clutches her bosom; with matted hair, goofy postcoital daze, in slinky white kimono opened at the front, she clutches one boob; presumably naked, fresh from a skinny dip, her long black hair tucked into a bathing cap, a white towel held to her midriff—where are her hands? Where else. In the straight-up naked torso pictures where she is either standing or reclining, the photo cropped so that she is headless and legless, she holds her arms at her side; to boob-clutch here would nudge the picture over the line into erotica, the white-tablecloth name for porn, which Stieglitz, that rascally genius, knew all too well. There is one picture that still takes the breath away: O'Keeffe, her kimono open, sits with her legs apart, her crotch in soft focus, the hair an indistinguishable mass of deep blackness; a black cave of mystery, a temple of doom which men, so I hear, spend their entire lives in fear of getting sucked into, like a sci-fi villain whose execution entails being shoved into the mother ship's airlock, then sucked into outer space.

Stieglitz was a pioneer of modern photography, but he was not the first guy to take a nude photograph. Whatever day it was in 1835 that French chemist and artist Louis Daguerre

perfected his first daguerreotype, the world's inaugural main-stream photographic process, by the end of it the first naked lady had been photographed, probably reclining against a pile of tasseled throw pillows.

But these first Playmates were generally nameless prostitutes or artists' models. Stieglitz's photographs of Georgia were unprecedented: Not only was he the high priest of fine art in America, but she was also his (much younger) protégée, who had already gained some critical notice for her own one-woman show at 291. The gossip surrounding the exhibit was scorching, as was the affair to which the pictures bore witness. Wasn't she young enough to be his daughter? Wasn't he still married? Weren't they living together in sin?

What did Georgia think as she stood in the gallery that day? What could she have been thinking as she surveyed the scene—the heavy-breathing men, the teary-eyed women?* Was she pleased, mortified, or some irrational combination of both? We know that, unlike most of us, she liked the way she looked on film, never having realized she was composed of such fetching lines, that she possessed such a fabulous jaw or slim, girlish waist. Still, she was a private person in an era when decent folks were expected to cherish their privacy.

Oh, I know. Times have changed. These days, the only girls (as grown women insist on being called) who don't believe

* *Verklempt,* because Stieglitz was clearly completely, desperately in love with her, in a way that their husbands, who didn't own a camera (much less know how to operate one) were not in love with them.

that having an oft-downloaded sex tape is résumé-worthy are members of a strict religion or A-list actresses whose reputations rather touchingly rest on their saying no to full frontal nudity. We are living in an age where couples across the land argue because he did *not* make the private pictures or tapes public, and she sobs tearfully, *Am I not hot enough? Is it because I wouldn't dress up as Princess Leia?* But in 1921, the naked pictures of O'Keeffe were scandalous.

There is no official record of O'Keeffe's response, but if the 2009 made-for-TV biopic *Georgia O'Keeffe* is to be believed,* she was humiliated and coldly furious. Joan Allen, best known, at least in our house, for her snappy portrayal of CIA officer Pam Landy in *The Bourne Supremacy* and *The Bourne Ultimatum*, shows O'Keeffe moving impassively through the galleries, absorbing the pictures and the whispers around her, then roaring at Stieglitz (Jeremy Irons) in private, so enraged that a vein sticks out on her forehead.

One of the things I love about O'Keeffe is that for all the ways in which she was a one-of-a-kind genius—busy giving birth to abstract expressionism while Jackson Pollock was still in kindergarten, while also demonstrating how women, who still didn't even have the vote, might live a life of both passionate connection and equally passionate independence—she still made a lot of the same errors in judgment the rest of us do. If you've ever logged on to the Internet to find the private

* Which I do, since the film was directed by the esteemed Bob Balaban, also an actor who costarred in *Capote*, where he played William Shawn, the editor of the *New Yorker*, a magazine that has always been obsessed with getting the facts right.

sex tape you made with your boyfriend "leaked" and merrily streaming along online, displaying for all the world to see your dimpled bum and "orangutan face" (you thought that was a private joke, didn't you?), take comfort in the fact that the esteemed Miss O'Keeffe was there before you. She said yes yes oh yes baby yes yes to Stieglitz; then she said WTF?*

She was a woman in love, which meant that wherever Stieglitz would lead, she would follow. She was dazed and confused. She struck every last pose willingly. She trusted him to do her justice. She had no idea, if she'd even given it a thought, that one day strange men with beefy, be-dandruffed shoulders would be examining the image of her thick pubic hair and wondering how Stieglitz got his blacks so dark and velvety.

I should stop for a moment and confess that I have no experience of anything remotely like this. I despise having my picture taken. At a tender age I realized the only possible way to look while having your picture taken was mysterious and slightly stoned—what I imagined one of Joni Mitchell's Ladies of the Canyon looked like. I pulled my hair into my face and stared moodily into the lens of my mother's Instamatic. My mother told me I looked like a Polish dock worker who'd just lost his job and, indeed, when we picked up the pictures at the photo department of Sav-On Drugs a week later, I appeared to be the world's saddest sixth grader.

To remedy this, my mother told me every time someone wanted to take my picture, I should scrunch up my face the

* Or the 1921 equivalent, which may have actually been "What the fuck, Alfred?"

way you might if someone was going to throw a bucket of water on you, then release it into a joyous smile, lips slightly parted, eyes a-sparkle. This technique was guaranteed to make me look cute and fun. Need I number the times the photo was snapped while I was mid-unscrunch: lips bunched, brow furrowed, eyes half-open? The net result has been a lifetime of paralyzing self-consciousness so profound that when someone says "Let me take a picture," I feel the same way I do when the doctor says "You're going to feel a slight pinch." If there's a nearby bathroom in which to lock myself, or a shrub to hide behind, so much the better.

Which isn't to say that I've never yearned for a guy to suggest he take some private photos, but by the time we reached the sheet-rumpling stage of the relationship, he already knew that I preferred to be *behind* the camera,* and didn't dare pursue the matter. Which, paradoxically, has made me feel a little forlorn over the years, and offers a clue as to why Georgia not only said yes to Alfred, but cooperated with zeal. He pushed past whatever resistance she might have had—she was shy, self-conscious about her dimples, the least attractive sister in the O'Keeffe family—and made her a thing of beauty. Who can say no to that?

What Every Woman Apparently Knows
Stieglitz was well aware that his pictures of Georgia, as elegant, stunning, and fine-arty as they were, would make her an

* Thank you, film school, for teaching me this handy, slightly pretentious phrase.

immediate household name among New York's culturati. The man was a genius not just of photography, but also of marketing. He made Georgia an "instant newspaper celebrity,"* then devoted himself to keeping her in the limelight until he died of a stroke in 1946. For Georgia—who yearned to be recognized as a serious artist, while at the same time felt nauseated at the thought of other people *looking* at her work, much less purchasing it—life became complicated.

I don't think O'Keeffe had any qualms about being seen naked. She used to like to paint in the nude in her tiny studio, built on the edge of the property at the Stieglitz summer house at Lake George, and she enjoyed sunbathing in the nude during her first summer in New Mexico. What she minded deeply was that in one fell swoop Stieglitz had both made her name and determined how she would be perceived. He had an idea about who she was, and worked hard in his overbearing, Stieglitzian fashion, to make sure everyone else agreed with him.

Every year, beginning in 1923, two years after the fateful photo exhibit, Stieglitz mounted an exhibit of O'Keeffe's work.† For thirteen years O'Keeffe lived in the midst of preparing for a major show. Some years were richer in nervous breakdowns than masterpieces, but the net result was a staggering amount

* According to Henry McBride, critic for the *New York Sun*, who saw through a lot of the nonsense and realized that O'Keeffe's work was more complex than people gave her credit for.

† Except in 1932 and 1938; in 1931 he opened her exhibit in December and it carried over into the next year. In 1937 he opened exhibits in both February and December. Stieglitz may not have been a faithful husband, but I defy anyone to find a more devoted promoter of a wife's art.

of new work, and an endless opportunity for art critics to write long, feverish reviews about what they presumed was O'Keeffe's one and only subject: sex.

The world of modern art was tiny, and the Men, as Georgia called the writers, critics, and fellow artists who would come to their apartment to talk until three in the morning, or meet Alfred for cheap Chinese at a poorly lit restaurant on Columbus Circle, still took their cues from Stieglitz. Her paintings and drawings were abstract. They were voluptuous and arousing, trafficked in the colors and shapes of private parts. Still, the Men had no real idea what was going on. Stieglitz schooled them. He'd thought long and hard about who this woman was—Georgia O'Keeffe, American: an untutored* genius from the heartland, an intuitive† girl‡ who had escaped sexual repression,§ and created from the center of her pure¶ Woman-Child core. It was hard to argue with Stieglitz. He'd championed Picasso and Cézanne, and now their paintings hung in the Metropolitan Museum of Art.

"Her art is gloriously female," wrote someone who, were he still alive, would thank me for allowing him to remain nameless. "Her great painful and ecstatic climaxes make us at least know something that man has always wanted to know. For here, in painting, there is registered the manner of perception

* For a woman of the time she would have been considered educated.
† O'Keeffe was actually a practical and pragmatic intellectual, well-read in the classics.
‡ Thirty-two years old.
§ Sure, all things being relative.
¶ She'd never been to Europe.

anchored in the constitution of the woman. The organs that differentiate the sex speak. Women, one would judge, always feel, when they feel strongly, through the womb." Another critic wrote that her paintings were "one long, loud blast of sex . . . sex bulging, sex tumescent, sex deflated."

There are reams of this stuff. Georgia felt by turns confused, embarrassed, and enraged. The simple form inspired by the curving neck and scroll of her violin didn't escape woman-centric interpretation (it was a fetus), nor did the powder-pink and turquoise-blue arches inspired by her love of music (it was something up there in the neighborhood of the uterus). Her alligator pears, as avocados were then called, were pendulous breasts. Her stalks of corn, penises—or vaginas. It hardly mattered. It got people riled up. Between the lines of the reviews you can sense the hand of the panting critic.

The Men, Stieglitz included, could hardly be blamed. Even geniuses are doomed to live in their times. By the early 1920s Freud's theories were on everyone's lips. Stieglitz and his circle were true believers, embracing and endlessly discussing Freud's basic theory—that sexual repression was the prime motivator of human behavior. For these forward thinkers, everything was about sex. In 1923, when Stieglitz opened *Alfred Stieglitz Presents One Hundred Pictures: Oils, Water-colors, Pastels, Drawings, by Georgia O'Keeffe* at the Anderson Galleries, well-regarded Fifth Avenue shrinks sent their women patients to view the O'Keeffes to gauge the level of their sexual repression. O'Keeffe, it was said, had somehow managed to escape it.

When I was a sophomore in high school in the mid-1970s, a tall, quiet boy who'd skipped two grades and was rumored to be a genius wrote a short story that he volunteered to read aloud to the class. No one ever volunteered; the teacher was forced to offer extra credit to get students to read their work aloud. Steve, the boy, stood in front of the class and read for half the period about the adventures of a butler who worked for a man named Mr. Bates. This allowed Steve, every few moments, to intone, *Is there anything else, Master Bates? How are you today, Master Bates? Shall I open the blinds, Master Bates?*

I had never heard anyone say the word *masturbate* aloud, except one of the singers on the soundtrack to *Hair.** If the stillness in that room was any evidence, no one else had either. We were sixteen. The more advanced among us knew about blow jobs. Steve had the class's full attention—even the boys at the back of the room who would later be moved into the class for people with learning disabilities. Our teacher, Ms. Dodd—who was not one of those hip English teachers who thought rock lyrics were poetry, but one of the old school, *Ethan Frome*-assigning ladies who wore her glasses on a chain around her neck—was too stunned to interrupt him. In writing about "the loud blast of sex" that was O'Keeffe's work, I imagine the Men felt the same thrill Steve did, saying over and over again what had been forbidden to say aloud in mixed company, with no one to stop them.

* The song was called "Sodomy." It's a tribute to my mother's essentially tolerant worldview that she never flinched when I put the album on the stereo and blared it throughout the house.

At first, O'Keeffe argued. She'd tried to disabuse the world of the fact that she was some primitive Midwestern goddess of female genitalia by giving an interview to the *New York Sun*. She talked about her theories of art. She portrayed herself, she thought, as careful and intelligent. Still, the journalist cooed about her work as being first and foremost "the essence of womanhood." It was that, yes, but so much more. Her forms were the forms of the natural world, her colors part of an inner, genderless vocabulary. Still annoyed, O'Keeffe wrote a piece for *Manuscripts*,* claiming, "I have not been in Europe. I prefer to live in a room as bare as possible. I have been much photographed. I paint because color is a significant language to me."

It's unknown how many people read her proclamation, but exactly no one took it to heart. As we've learned from hundreds of stand-up comedians over the years, the more hotly you deny being it, doing it, thinking it, the more obvious it is that you *are* being it, doing it, thinking it. The more O'Keeffe protested that, for example, *Blue Line* (1919), even now still Not Safe for Work, is merely an expression of feelings for which she had no words, and not the cunnilinguist's point-of-view, the more people believed that not only was she a sex maniac, but a sex maniac in denial.† Eventually, O'Keeffe stopped reading reviews and stopped commenting on them. For the rest of her life she went on the offensive, claiming in interviews that

* In the '20s, American literature was reinventing itself; to capitalize on the trend, Stieglitz founded a literary magazine. O'Keeffe designed the cover.

† One of Freud's famous primitive defense mechanisms.

what people saw in her pictures was more about them and their issues than about her, thereby using another defense mechanism, projection, to her own advantage.

"Look what you come to if you let yourself be photographed like this." She was in her eighties when she said this to C. S. Merrill, a poet who was caring for her on weekends. O'Keeffe had become, in the last decades of her life, a wizened, white-haired mystic in black communing with the beautiful, inhospitable wilds of Ghost Ranch in Abiquiu, New Mexico. She meant: Look how serious and no-nonsense I am; look how austere and humorless; look how my sleeves extend to my wrists, my hem to my ankles. She meant: Look how I have spent my life creating a self directly opposed to the one created by Stieglitz.

Meet the Stieglitzes

During the early summer of 1918, when most of the pictures were taken, Georgia stayed alone in Elizabeth's studio, in bed. Stieglitz tended to her during the day and returned to his wife, Emmy, at night. Their marriage was one in name only; despite Alfred's avant-garde aesthetic, he was an old-fashioned Victorian who, in his heart of hearts, didn't believe that being miserable in a marriage was a reason to leave it. He and Emmy had been estranged for years; he slept in a dressing room. Who knows how long this would have gone on if O'Keeffe hadn't sent him her drawings?

One day while Emmy was out, Stieglitz, resorting to a time-honored technique favored by people who want out of a relationship but can't bear to think of themselves as someone who would initiate a break-up, brought Georgia to the apartment for a photo shoot. Emmy returned from her errand and "surprised" them while Georgia was posed before Alfred's lens. Emmy demanded to know what was going on, in that slightly insane way betrayed lovers always want to know what's going on, when, of course, they know exactly what's going on. Stieglitz was incensed: Couldn't she see they weren't doing anything but making some pictures? Emmy, less savvy about how to play this game than O'Keeffe would be when it was her turn to be the betrayed wife, succumbed to her outrage, ordering them both out.

Later that night, Emmy's behavior illustrated a good life lesson: Never allow yourself to be provoked into issuing an ultimatum. The only time you should ever issue an ultimatum is if you can easily accept the worst outcome. This is a conundrum; if you can accept the worst outcome, you usually aren't moved to issue an ultimatum.

She said, "Get rid of that O'Keeffe woman or it's over, Alfred!"

He said, "Okay."

In less than two hours it was done: Stieglitz packed up his stuff and fled to Georgia's tiny studio, euphoric over his coup: He could now tell everyone "My wife threw me out over nothing. I am a photographer, and I was simply photographing Miss O'Keeffe."

The next day Emmy relented, begging him to come back, but it was too late. Alfred and Georgia, for better and much worse, were the love of each other's lives. They gave themselves to one another, but they also gave each other a new view of themselves. She was the red Porsche purchased by his middle-aged man; he was the football hero who falls in love with her awkward new girl in school. Anne Roiphe, in *Art and Madness*, speaks of "the thing of insanity that makes for both trouble and excitement" that's necessary for great, enduring love, and Alfred and Georgia were rich in this regard.

A few weeks later, the couple was summoned to Oaklawn, the Stieglitz estate in Lake George, by Hedwig, Stieglitz's mother and the family matriarch. After Edward, Stieglitz's late father, made his riches in woolen goods, he bought a "cottage" in the country, twelve acres of waterfront property* on Lake George, in the southern Adirondacks. The lake is long and narrow, surrounded by forested hills and studded with small islands. Stieglitz had spent summers there for thirty years, in a turreted, many-roomed Gilded Age monstrosity, furnished with gloomy oil paintings in gilt frames and heavy furniture designed in a way to make sure you banged your knee every time you passed through one of the dark rooms. He was more

* Perhaps there's a question half-forming in your mind. Why did Stieglitz and O'Keeffe live like grad students when there was obviously a load of Stieglitz money? Then, as now, just because the father makes a fortune, that doesn't mean the son has access to it. Alfred was a trust fund baby, but only to a point. The money he received from his father covered his photographic pursuits; his living expenses were covered by his wife Emmy.

attached to Lake George than he was (or would be) to any woman in his life. It would cause problems, but Georgia didn't realize that yet.

It was a little awkward, as you can imagine. Then, as now, no one knows what to say when one of the brothers shows up with a Woman Not His Wife, and everyone is supposed to pretend nothing's different. But Hedwig knew better than to cross her favorite son, and at dinner she placed Georgia at her side.

This first visit was charmed, as it always is when you're in the love shack. Alfred and Georgia tramped around the lake and took the rowboat out after dinner, and after lunch they left the table before everyone else was quite finished, giggling— *giggling*—and skipped upstairs to take a "nap," slipping out of the sleeves of their sweaters as they went. Their afternoon routine consisted of sex and photography. He took a picture of her sitting on the ground before a flower bed, her paper and watercolors at her side. She is wearing a white dress and a dark cardigan. One hand is around her knees and she holds a small brush. Her head is turned. She looks back and up at Stieglitz in an expression that says, to me anyway, "You're interrupting me. You will always be interrupting, and my heart will allow me no choice but to be interrupted by you."

They marveled at the signs that proved their unlikely union was meant to be. Georgia remembered how she had studied at Lake George one summer, on the scholarship she received from the Art Students League. Alfred realized that years earlier, his father, Edward, who had become a respected patron

of the arts and amateur painter, had been asked to judge an art contest. Since Alfred was the family-appointed artist, his father had asked him to choose the winning entry. The fifty-dollar first prize went to Eugene Speicher's portrait of a young woman named Georgia O'Keeffe.

The first visit ended in a flourish of typical Stieglitzian drama. Alfred's daughter, Kitty, had spent the early part of the summer at camp, after which she was expected at Oaklawn. Emmy had begged Alfred to allow their daughter, who was traumatized by their separation, to enjoy her visit without being forced to deal with the presence of her father's new lover. Alfred promised Emmy, then either forgot, or assumed that once Kitty met Georgia she would love her just as he loved her. Kitty arrived and pitched a red-faced fit, and Georgia and Alfred fled to New York.

O'Keeffe had fully recovered from her "flu," or whatever it was she'd suffered from in the spring. She was expected back in Canyon to teach the fall term. Stieglitz had no intention of letting her go, and made an extravagant offer: He wanted to underwrite a year of painting for her. Would she accept that? Would she allow him to be her patron of the arts?* She said yes. How could she not? She sent to Texas for her things, giving up everything that nourished her: the sense of liberation that comes with wide, windswept places, her agency over her own life. Was it worth it?

* Stieglitz borrowed $1,000 (about $15,000 in today's dollars) from a well-to-do friend to finance his promise.

How to Manage Living with the In-Laws

In our modern world that believes in the power and righteous-
ness of romantic love, no one looks past her lover to see the
army of irritating people with linked arms standing behind him:
his family. Every mother-in-law joke is about someone else.
So blinded by love are we, usually, we never stop to think that
unless our beloved was grown in a petri dish, he's got a mother.

As long as possible, find the in-laws entertaining.
Hedwig Stieglitz ruled Oaklawn. Every day she served three
artery-clogging meals, plus a full tea with cakes and sweets, to a
table of sons and daughters, their sons and daughters and nieces
and nephews, and a handful of guests Stieglitz had invited to stay
for the month. There could be twenty people at a meal, all talk-
ing at once, preferably arguing. The best meal would be one with
a heavy sauce and an emotional outburst. If someone left the
table in tears, the meal would be considered a complete success.

Like Alfred, they talked at you until you felt as if your ear-
drums would break from simple usage. They seemed to pos-
sess the gene that compels you to say every thought that comes
into your head, especially if it provokes an argument. The
O'Keeffes were Midwesterners who tended toward stoicism,
silent keepers of the elephants in the room. Georgia's crazy
love for Alfred was a case of opposites attract: The huge tribe
of Stieglitzes was opposite her as well.

At first, O'Keeffe found the Stieglitzes to be eccentric and
energetic. One of O'Keeffe's greatest gifts was her ability to

delight in the ordinary things of this world, and the wild and crazy Stieglitzes were, for a time, one of the things that amused her. She had spent so much time alone in Texas that it was fun to be part of this huge, rollicking gang.

Eventually, of course, her essential introversion reasserted itself, and she began to find the chaos first exhausting, then annoying. She survived, I think, by watching their antics as though she was watching a play or a movie. She didn't spend much time at the theater, and there is no evidence at all that she liked movies. The Stieglitzes seemed to meet whatever need she had for madcap entertainment. Admittedly, this only works for so long, or only works intermittently.

Find a shack of one's own.

It pays to have a good sense of how much you can take of your beloved's family before you do something everyone will regret. If your beloved's family is more along the Stieglitz model than the O'Keeffe model, pitching a fit probably won't cause much upset. Your contribution to the bedlam might even be appreciated. But Georgia internalized everything. She was inclined toward silent resentment, which always evolved into some psychogenic ailment that felled her like a redwood: brutal headaches, insomnia, weight loss.

This was a dilemma. Every year from 1918 on, Alfred and Georgia spent the late spring, summer, and early fall at Lake George. There was no question they would go anywhere else. Alfred despised travel. Georgia was torn. She preferred any

countryside to New York, where she never felt at home, but Lake George was not really her landscape: The crush of foliage, the tall pine and oak that crowded the house, the undergrowth, the humidity and smell of composting leaves, even in summer, didn't float her boat.

In 1920, Hedwig suffered a stroke. Georgia read her confusion and trembling accurately, called for medical help, and saved her life, or so Alfred claimed. But in 1922, Hedwig died; the Victorian-era days at Oaklawn were over, and the mansion was sold.* Fortunately, there was a farmhouse on the property suitable for refurbishing.† It was called The Hill, because the Stieglitzes belonged to a class of people who could only summer at a place with a name. The Hill was homier, more in keeping with what Georgia was used to, but much smaller. The staff was also reduced to a trustworthy local couple of a certain vintage, who worked as cook and caretaker.

Can you see where this is going? The same herd of family and friends came and went every summer, packing themselves into the smaller space, eating, sleeping, debating, shouting, making up, tromping in, tromping out. Georgia found herself unable to breathe.

Two things kept her from a rubber room. The first was the garden, which she made her own. It spoke to the farm girl in her, and she found herself restored by digging in the earth

* It may have been sold in 1919. Accounts differ. I find it hard to care.
† The farmhouse had belonged to a pig farmer, but the Stieglitzes bought the farmer out and sold the pigs. They lived downwind from the farm, and the odor ruined their vacations.

and all that hard, sweaty labor. The Stieglitzes, who believed in hiring people to do the sweaty work, watched her from a distance, mystified.

The other thing she did was claim one of the outbuildings as her studio. Stieglitz wanted to share "The Shanty" with her, but she told him no and closed the door, thus predating Virginia Woolf's radical call for a room of one's own by ten years. It hardly matters which cultural icon got there first: It still holds true. What neither of them realized is that having your own place to go to, where you don't have to answer to anyone, where you don't have to make conversation or listen to family squabbles, or eat heavy tea cakes every afternoon at four o'clock, helps to preserve everyone's good feelings for each other.

Bury Judith.

It never hurts—and indeed, it can help to solidify your position with the in-laws—to ally yourself with the most popular member of the family, which is usually the youngest.

In this regard, Georgia lucked out. She was fond of Alfred's younger sister Agnes, who had a teenage daughter also named Georgia who was energetic and sassy and pretty much everything teenagers would be known for forty years down the road, when the concept entered popular culture.* Everyone started calling her Georgia Minor, and Georgia Minor called O'Keeffe

* The term received its first big airplay in 1952, by Bill Haley.

GOK. Alfred was a strict teetotaler, and sometimes GOK and Georgia Minor would meet up at The Shanty for a drink or two. The best prank they ever pulled, in concert with a few of the other younger Stieglitzes, was the burying of Judith.

GOK despised the heavy Victorian furnishings of Oaklawn, particularly a hideous plaster bust of a woman that served no purpose other than taking up space. Judith, as she'd named the bust, stood for everything she hated in the art she'd refused to respect when she was at the Art Institute of Chicago: It was phony, fussy, meaningless, dead. A lot of the furniture was sold with Oaklawn, but Judith managed to make her way to The Hill. One night Georgia Minor and GOK stole the bust and buried it. They did such a good job, Judith was never found.*

* The Quarters at Lake George vacation condos were eventually built on the Stieglitz property. There were no reports of any hideous Victorian busts unearthed during construction. Book online and bring a shovel.

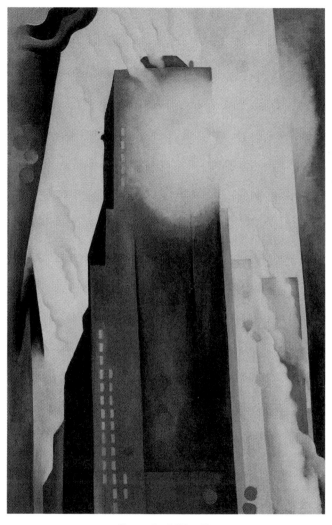

Georgia O'Keeffe
American (1887–1986)
The Shelton with Sunspots, N.Y., 1926
Oil on canvas, 123.2 x 76.8 cm (48½ x 30¼ in.)

Gift of Leigh B. Block, 1985.206. The Art Institute of Chicago

7

REBEL

Whether you succeed or not is irrelevant . . . making your unknown known is the important thing.

O'KEEFFE AND STIEGLITZ, STIEGLITZ AND O'KEEFFE. BY THE mid-'20s they had become a Famous Art Couple. There was no one like them. People began to recognize them on the streets of Manhattan, walking arm in arm in their twin loden capes, or sitting across from one another in a modest restaurant, eating soup. Georgia's black dresses had become uniforms. Sometimes, she donned a black turban.

Greenwich Village was the center of bohemian life, but O'Keeffe and Stieglitz lived in Midtown, and Lenox Hill. When O'Keeffe was first dazzled by Stieglitz, as an art student visiting 291, she had imagined he had money—or at least a lot more than she did. She was a poor student in a rented room, a

potted red geranium her only decor. Stieglitz ran his own gallery, published his own magazine, and in hard times was so generous to his artists he practically supported them, buying their paintings when no one else did, and accepting artwork in lieu of commission when they did make a sale.*

How dazzled Georgia must have been, how relieved. After years of scraping by on a teacher's salary, here was an older man who was obviously successful and apparently settled. Not long after she moved to New York, however, it became apparent that Stieglitz had no real income of his own. During his marriage to Emmy, it was her family money that kept them afloat, which allowed him to invest every penny of his small monthly trust settled on him by his father in his photography. Now, his trust had to support him, and Georgia. This didn't seem to bother Georgia much;† she was with the man she loved, and was free to paint. She was used to scrimping, and she didn't need much to get by. Also, Stieglitz was a high priest of modern art, and like high priests everywhere it was to be expected that he find money beneath his concern (an attitude made easier to hold since he also enjoyed the support and affection of a large, well-off family with apartments in upscale Manhattan neighborhoods).

Alfred and Georgia lived in his niece Elizabeth's studio for several years, until they were given notice it was to

* As a result, he amassed one of the largest and most varied collections of modern art in the world. O'Keeffe gifted a large portion of it to the Metropolitan Museum of Art, where it remains the foundation of their American modern art holdings.

† I would feel slightly duped, wouldn't you?

be gutted and remodeled, after which they moved in with Alfred's brother, Lee, and his family, at 60 East 65th Street. Lee's mother-in-law also lived there, so Georgia and Alfred, not yet married, had separate rooms.

When Lee sold the brownstone, O'Keeffe and Stieglitz were forced to move yet again, and took up residence on the twenty-eighth floor of the Shelton Hotel,* at 525 Lexington Avenue. It was then the world's tallest residential hotel, thirty-four stories, with 1,200 rooms. It had a solarium, a roof garden, a swimming pool, and three squash courts. Their apartment had pale gray walls and no kitchen, for which O'Keeffe was grateful. In New Mexico, in her dotage, she would take up cooking and publish a book called *A Painter's Kitchen: Recipes from the Kitchen of Georgia O'Keeffe.*† During her heyday, however, she saw it for the distracting time-suck it is, Master Chefs and all the other reality-cooking-show stars notwithstanding.

The woman who'd reveled in the vast skies of the Texas Panhandle loved living in the clouds above New York. She refused to put curtains on the windows. She sat at her easel in her black dress and painted while the sun moved from one side of the apartment to the other. The city roared far below. In that she could be happy at all in New York, she was happy at the Shelton.

* Now the New York Marriott East Side.

† As of this writing, only one reader has reviewed the book on Amazon.com. "Rikki" says, "As far as the recipes go, most are either pretty standard or weirdly gross. However, the book seems spiritual somehow and very connected to O'Keeffe. I loved it."

O'Keeffe had developed the habit of painting quick sketches of every new place in which she found herself. To Stieglitz's displeasure, she went through a skyscraper phase. It's no surprise, really. When the culturati weren't talking about Freud, they were talking about skyscrapers.* From the rooftop terrace of the Shelton Hotel, O'Keeffe and Stieglitz watched both the Chrysler Building and the Empire State Building go up. Every photographer and painter in New York was having a go at rendering the amazing structures, including Stieglitz, who felt he hadn't had much luck in capturing their alarming grandeur.

When it came to her work, O'Keeffe was completely deaf to the advice of others. Her first skyscraper picture was called *New York with Moon.* A brown skyscraper arches up from a corner of the frame into a blue sky bisected with rippling clouds. A nubbin of moon peeks out, dwarfed by the big streetlight in the middle of the picture. Like the best O'Keeffes, it appears both representational and abstract at the same time.

In 1925 O'Keeffe's work was represented in a group show: *Alfred Stieglitz Presents Seven Americans:† 159 Paintings, Photographs & Things, Recent and Never Before Publicly Shown, by Arthur G. Dove, Marsden Hartley, John Marin, Charles Demuth, Paul Strand, Georgia O'Keeffe, Alfred Stieglitz.*

* America's imaginative, optimistic, and grandiose contribution to world architecture—also one of the first symbols of crass materialism and dehumanizing technology.
† O'Keeffe noted that of all the "Americans," she was the only one who had been west of Chicago.

O'Keeffe always hung Stieglitz's shows. Her flawless eye guaranteed every picture was displayed in the best light, in the best location, in the best proximity to the other works. She found a perfect place in the gallery for *New York with Moon,* but when the show opened, it wasn't there. Stieglitz had removed it. He explained that after consulting with the Men they felt it was inappropriate. She was furious, but said nothing. The next year, in 1926, she had a one-woman show and rehung the picture. *New York with Moon* was the first painting to sell, for $1,200.*

Even today's young women, who believe feminism is a euphemism for Lonely, Disfigured Troll Beneath a Bridge, would have to allow that this was unfair, ridiculous, and sexist. But we're all victims of the times in which we live, and the Men were no different. They'd let O'Keeffe into their club on the condition that she stick to avocados, petunias, and abstractions that resembled lady parts. Rendering skyscrapers was man's work.

Sexism aside, something about this thinking is so familiar, so right this minute. O'Keeffe had, by the mid-1920s, what every working artist/writer/musician covets in our modern times: a Platform, a thing you are known for, which you can exploit until every last person with eyes to see and ears to hear knows that you are *the* expert on holistic closet-organization techniques, or the inner workings of Hezbollah, quirky sociological trends of your own invention, or pugs. It's made a certain amount of sense. We live in difficult economic times. If

* Roughly $15,000 in today's dollars. In 1924 you could buy a Chevrolet Superior Roadster for $490.

you've made a name and a fragrance line for yourself painting like a four-year-old coming off a sugar rush, you'd be mad to start drawing like the grown-up you are. If you've had success writing murder mysteries set in the Florida Everglades featuring kitchen utensils as murder weapons and a cross-eyed detective, it would be career suicide to refuse to write twenty-five more. French women have a built-in Platform; they can write about being French women until they sexily inhale their last Gauloise, but see how far the author of *How to Breathe In and Out Like a French Woman* gets when she tries to sell her treatise on the history of comic books.

These days, we don't need the Men to tell us what we can't do. We don't need them to sneakily remove our skyscraper picture from the exhibit. We've allowed the Market to dictate what we can and cannot do; if we're beneath the Market's notice, we imagine what the Market *would* dictate. Unlike O'Keeffe, we don't have much faith in our own creative instincts. We yearn to find a niche to which the Market responds, and set up camp there for the rest of our lives.

It's possible I'm simply envious because my Platform is that I have no Platform. Yes, I've written two previous books about other female icons of the last century, but before that— well, here's the footnote.[*]

[*] Before this trilogy there was a trilogy of YA mystery novels about a seventh-grade girl detective; a memoir about my father; three adult novels, sort of in the comedic literary vein, one about Russian émigrés in Los Angeles, one about a documentary filmmaker in Hollywood, one about motherhood. Also, a collaboration with beach volleyball player/model Gabrielle Reece.

Maybe I'm not being completely honest with myself. Maybe I would love a Platform, but I'm incapable of adopting one, for the simple fact that, for me, familiarity really does breed contempt. Once I've written a book about something or someone, I can no longer stand to think about it. The entire subject is like someone I've been forced to share a studio apartment with for six months longer than expected, or like the default marital spat, the one you resort to when you feel like having an argument. When I began my book about Coco Chanel, I could think of no one and nothing else. I loved her clothes, her life, her love life, her little hats. I admired her nastiness, I forgave her her Nazi lover, her cruelty to her workers. I wore Chanel 19.* Now, someone mentions her name and I sigh and think, *Oh, her.* I'm sure the same will happen with O'Keeffe.

But I do share one thing in common with her: Unlike my savvier and more-successful peers, I'm doomed to follow my interests. It cannot be helped. If someone told me I could not continue to do so, or, if someone said, "Here's $100,000 a year for the rest of your life to write an annual quirky love story set in the world of NASCAR," I couldn't do it. I would have to become a dental hygienist.

Like O'Keeffe, we must say "Screw the Men" and "Screw the Market." We must follow our instincts. We'll paint skyscrapers if we feel like it. And when we feel like stopping—she only painted about twenty of them, between 1925 and 1929—we'll

* Actually, I still wear it, but one's fragrance choice is another topic for another time.

do that, too. And if worse comes to worst—and here she was head and shoulders above Stieglitz, who always had a relative to bail him out—we can always go west and teach school in the Texas Panhandle. We can always make do.

Baby Wars in the Land of Modern Art

Georgia longed to be a mother. She'd adored the public school children she'd taught in Amarillo, and had always felt maternal toward her little sister, Claudia, who, at seventeen, had come to live with her in Canyon, after their mother died. In 1923 she turned thirty-six. If she wasn't that young, Alfred was almost old. If they were going to do it, they needed to get cracking.

Her desire to have a baby was understandable. Stieglitz's desire not to have a baby was equally understandable. They'd been at odds over this since the day they'd moved in together, before Stieglitz was divorced from Emmy. On January 1, 1924, Stieglitz turned sixty. He already had one daughter, Kitty, who as a girl had refused to pose for him, who wouldn't participate in his dream project of documenting her life in photographs, and so they had nothing to say to each other. Once he'd left her mother for Georgia, Kitty refused to have anything to do with him. Stieglitz was scalded by her rejection, especially since he was, as always, innocent of any wrongdoing. Kitty had not invited him to her wedding, in 1922, and in 1923, after she gave birth to a son, she was institutionalized with severe postpartum depression. She didn't want to see him, and his

own brother, Lee, her doctor, advised that Stieglitz respect her wishes and stay away.

Did he need more children to make him feel sad and guilty? No, he did not. Did he need a screaming plum in diapers distracting Georgia from her work? No sirree. O'Keeffe may have been Woman, but she was only one on paper.

To be fair: From the beginning of his relationship with O'Keeffe, Alfred had told anyone who would listen* that he didn't want any more children, and he didn't think Georgia should have any either, because it would wreck her career. There's a god-awful poem he composed in 1923, that includes the lines *she carries dawn/ in her womb*, which one might interpret as—well, I'm not quite sure what to make of it. Faulkner famously said, "If a writer has to rob his mother, he will not hesitate; the *Ode on a Grecian Urn* is worth any number of old ladies."† Stieglitz's theory was similar: *Blue Line* (1919) was worth any number of infants. By the mid-'20s, it was apparent that Georgia had accepted her fate: She would be Georgia O'Keeffe, American, with a world class painting career and dawn in her womb.

I suspect that like many women, some of whom do go on to become mothers, only one part of Georgia wanted a baby. The other part thought Stieglitz had a point. She wanted a baby,

* Anyone who engaged in conversation with him for more than three minutes.

† I've always been alarmed by this: Does the mother actually die during the robbery? And is the writer robbing her in order to lay in enough Red Bull and Hot Pockets so that he might write his ode? What if his poem is only just okay—is the robbery/homicide still justified?

but she did not want a baby *enough*. Few women in American history (I have no evidence to support this—you'll just have to bear with me) have lived a more self-determined life than O'Keeffe. Indeed, most people who admit to admiring her, admire her for this very fact. In the mid-1920s her career was firmly established, and from then until the end of her life, she did pretty much exactly as she pleased.

So why, if Georgia wanted a baby so badly, did she not have an Oops? She and Stieglitz had lots of sex and lousy 1920s-era birth control.* Then, as now, an Oops is a completely acceptable way of starting a family.

Even in the twenty-first century, when condoms are available 24/7 at convenience stores throughout the land, women still get pregnant accidentally-on-purpose. It's a time-honored tradition, like pretending to love horrific Christmas presents. Girls have also long known something that the social scientists who conducted a study for the National Campaign to Prevent Teen and Unplanned Pregnancy were recently surprised to learn: Most guys are secretly pleased by an Oops. The Oops proves they have strong swimmers. For already-married men, the Oops spares them from many interminable conversations with their women about *Should we have a baby?* And, if so, *When should we have a baby?* and *Should we wait to start trying until after the pay raise/kitchen remodel?* For the unmarried, the Oops

* A rudimentary diaphragm was on the market in the early '20s; later in the decade, magazines advertised a Lysol douche (ouch), which was supposed to have both cleansing and contraceptive properties.

forces them into adulthood without losing face among their bros. Sorry, dude, no [fill in raunchy activity from *Hangover* here] for me tonight! Gotta babysit.*

I'm not advocating for the Oops. It displays a lack of character to bring another human being into the world without giving a thought to whether you're going to be able to provide him with soccer camp, iPods, and SAT prep courses.† Still, I would have forgiven Georgia O'Keeffe for getting pregnant accidentally-on-purpose. There's no guarantee that the child of O'Keeffe and Stieglitz would not have inherited her way with the camera and his way with the paintbrush, his nose and her weakness for coming down with gnarly infectious diseases, and the lunatic aspects of both of them (the offspring of many a homely rock star and supermodel have inherited his looks and her brains), but the world could certainly use their genius genes paddling around in the pool.

Had Georgia become pregnant, everything in her life would have been different, but not in the way she imagined. Nature abhors a vacuum, or so we are told. One could make an argument that the moment O'Keeffe fully accepted the fact that she would never be a mother, the war of their marriage began, which made for brief spells of happiness amid a lot of misery, and which wound up propelling her art to even greater heights.

* Why even the best of fathers still refer to taking care of their own children as "baby-sitting" remains an irritating mystery.

† It takes the mother of a teenager to say, without a doubt, that your child will want these things, and they will cost more money than you will ever want to spend.

In fifth grade I wrote a paper on World War I in which, overwhelmed by the length of the World Book Encyclopedia entry, I said that the causes of the war were "too numerous to mention." Here, now, I'm resorting to the same tactic. The fallout of Stieglitz putting the kibosh on a baby are too numerous to include here. Their relationship suffered a serious setback, in terms of grown-up behavior. If there is a lesson here, it's this: You might as well go ahead and have the damn baby. One way or another, you'll be dealing with the urge; if a baby isn't around to have temper tantrums and throw things, the adults will fill in the gap.* There will be babies in the house, one way or another.

1. Stieglitz made a fool of himself doting over someone else's two-year-old.

In the summer of 1923, Stieglitz invited his young secretary Marie Rapp Boursault and her two-year-old daughter, Yvonne, to Lake George for ten weeks. Boursault was also pregnant with her second child.† Stieglitz doted on Yvonne, taking over fifty pictures of her. In addition, he fussed suspiciously over Marie. Georgia seethed, and referred to the child as a brat. If Stieglitz was so anti-child, why was she forced to

* In the form of acting out, yet another Freudian defense mechanism.
† Lest this didn't sink in: that's 2½ months of a pregnant woman and a toddler underfoot.

mop up the strained peaches and projectile vomit of another woman's baby? .

2. O'Keeffe developed a fierce and irrational hatred for a dumb lapdog.

O'Keeffe's least favorite Stieglitz sibling was Selma Schubart, Alfred's younger sister. She was the anti-O'Keeffe, a pretty dilettante who swanned around The Hill in chiffon gowns laden with big jewelry given her by male admirers,* batting her eyelashes with coy helplessness. She owned a Boston terrier named Prince Rico Rippe† that tore around the dining room during meals, yapping and nipping at people's heels. Georgia was appalled, then enraged, eventually refusing to stay in the house when Prince Rico was there.

3. O'Keeffe did something that was seriously uncalled-for.

More cyclical than the economy is the degree to which kids are welcome in the lives of adults-not-their-parents. When I was growing up in the '70s, no one wanted their kids hanging around; nothing ruined a party faster than having a kid in footie pajamas come downstairs and ask for a glass of milk.

* One was famed Italian tenor Enrico Caruso.
† Also a gift from Caruso.

Now, however, to be an adult and *not* want children around is to advertise yourself as a hater of all living things. So it was in the Stieglitz summer home at Lake George during Georgia's time. The many children of Alfred's siblings showed up with their parents unannounced, to run wild and break things for weeks at a time. Once, when there were a half-dozen kids terrorizing the household and Georgia was at her wits' end, one of the three-year-olds who'd just arrived introduced herself and said, "How do you do, Aunt Georgia?" O'Keeffe slapped her across the face and said, "Don't *ever* call me Aunt."

The Good Wife, O'Keeffe Style

December 11, 1924, was a bleak Tuesday, and also the day of the most cheerless celebrity wedding in modern history. In the office of a random justice of the peace in Cliffside, New Jersey,* Georgia O'Keeffe and Alfred Stieglitz were married. John Marin was their only witness. Several days earlier, driving to get their marriage license, they had crashed into a tree and had to walk the rest of the way in a downpour. At the ceremony, no rings were exchanged. She refused to say the words *honor* and *obey*. There was no reception. O'Keeffe had not wanted to get married. They had weathered the public disgrace of living together and were now accepted as a legitimate couple. What was the point? Especially since now there would be no children.

* As a divorced man, Stieglitz could not be married in New York State.

The point was the mental health of Kitty Stieglitz, who had not yet recovered after the birth of her baby. Her doctors thought that perhaps if Stieglitz and O'Keeffe got married, it would ease some of her anxiety. Her father would be safely married, even if it wasn't to her mother. Kitty was not Georgia's daughter, but she was Alfred's, and so she went along with it.

Georgia's own father, Francis, from whom she'd inherited her black hair, white skin, and droll sense of humor, had died in a fall from a roof he'd been repairing not long after Georgia had moved in with Stieglitz in 1918. As distraught as Georgia had been over her mother's death, the death of her father was the death of the heart of the family. Georgia was stricken. She had her siblings, but her sense of being an orphan was absolute. Not surprisingly Stieglitz had been there to fill in every possible gap. She said yes to marriage, even though she confessed decades later that she'd wanted to say no. In any case, their marriage had no effect on Kitty, and Stieglitz never saw her again.

This is so depressing, I'm tempted to forget about offering lessons from O'Keeffe's marriage and cut straight to home decorating. At least we can all agree that the interiors of her New Mexican houses were chic examples of mid-century design. I feel equally compelled to make an argument for the atypicality of their union, but every marriage is atypical, each one its own nation, with a population of two.

A few things O'Keeffe did that helped hers last:

1. By the end of the 1920s Georgia was able to support herself and Stieglitz with her art. She did not remind Stieglitz every chance she got that she was the breadwinner, like some people I know.

2. Once it was done, she never made herself crazy wondering how her life would have turned out if, say, she'd married Paul Strand, or stayed in Canyon to become the Official Eccentric Schoolmarm, or done anything else other than cast her lot in with Stieglitz. Despite his difficult personality, his possibly pathological gregariousness, his perfectionism, his need for control, his compulsion to make love with his camera to every female in their circle who would remove her blouse, there is no record that she ever met a girlfriend for an overpriced Cosmopolitan at an upper East Side watering hole and complained about having made the wrong choice. I suspect that Stieglitz was simply the man version of the hostile landscape and terrible weather that spoke to her soul.

3. She also found his foibles amusing. The Lake George farmhouse was usually packed with family, friends, friends of friends, and family of friends, plus the random colleague or ten from the art world. On the rare occasions when it was just the two of them, they sometimes found themselves together in the kitchen, doing the dishes. Stieglitz, who had no real life skills, could

not manage this. He either dried the dishes and put them back in the dish strainer, or put them into the cupboard while still wet. Georgia found this to be hilarious, instead of a metaphor for their relationship.

4. She nurtured all that they had in common. It perhaps comes as no surprise that what bound them together was their love of art, their respect for each other's work, and at the beginning, the receptivity they had toward each other as influences, and their us-against-the-world pleasure. Headboard-banging sex at the beginning of a relationship is never enough, if the only other thing you share as a couple is paying the bills.

5. She didn't cook.

It's a Flower. Really.

Did O'Keeffe have any inkling when she laid her brush upon the canvas in 1922, aiming to paint a big orange-red flower, that she was creating the breakout image of her career? Her first flowers were also orange, immersed in a glass of water. She painted them in high school. O'Keeffe's love of flowers was complicated. "I paint them because they're cheaper than models and they don't move," she once said.

There are several stories about how the big flower canvases came to be. In one, she is influenced by the jazzy technological advances of the Roaring '20s. Radio was becoming popular.

Middle-class families were purchasing Model T automobiles. Billboards were springing up along well-traveled highways. O'Keeffe, intrigued by the enormous size of the billboards, believed that in these modern times you needed to shout to be heard, and this meant visually as well. Flowers were so elegant and complex, so lovely. But they were also small—too small for those modern times. Her idea was simple: Make it big, and people will have to look.

Others believe that she was still smarting and furious over the critics' response to her earlier abstractions, in which she sang her one-note, one-line song: What every woman knows! What every woman knows! What every woman knows! Flowers were such a classic, representational still-life choice that they verged on cliché. The critics didn't know what to make of her previous abstract charcoals and watercolors? Fine. This is a petunia (*Petunia, No. 2*). This is a calla lily (*Calla Lily Turned Away*).

In her flowers you can see the influence of Paul Strand's mysterious close-cropped pictures of bowls, fence pickets, and typewriter keys, and Arthur Wesley Dow's belief in the power of pleasing composition and design. The flowers were luscious, feminine, and authoritative, rendered in outrageous hues: lavender, pink, and teal. O'Keeffe yearned to be taken seriously, and yet she refused to make her paintings somber and ugly. She still believed in the aesthetic she taught her students in Texas: that every aspect of our lives should be visually pleasing, even fine art. She stood behind pretty. She was proud, and unrepentant.

Stieglitz was not for it. Even though the flowers were part of nature, and thus approved for feminine rendering, he despised them every bit as much as the skyscrapers. With every year he grew more resistant to change of any kind. For most of his adulthood he frequented the same tailor, who always remade the same suit; he wore the same shirt, the same tie, the same socks, the same underwear. Every time Georgia ventured out in a new artistic direction, he sniffed with disapproval. He felt she should stick to small, deeply expressive charcoal abstractions like the *Specials* he had fallen in love with in 1917. He was like the husband of a woman I know who insists she wear her hair dyed and permed in the same tousled, crunchy mess that she sported on the day they met in 1987, and so she does.

Until the end of the decade O'Keeffe's shows were populated with big creamy calla lilies viewed from various angles, pink petunias whose stems were submerged in a white glass, orange and yellow cannas, black-bearded irises, white sweet peas, red poppies that fill the entire frame.

O'Keeffe was never not a minx. She loved playing pranks, even visual ones. While proclaiming that these were flowers, for God's sake, the most obvious of subjects, she painted their reproductive parts with her usual sensuality. But it wasn't just lady parts on not-so-secret display; the spadix at the center of her creamy calla lilies was never anything but a jaunty phallus.

By the mid-1920s her shows were attracting a lot of attention. It was hard for the critics to leave off talking about how

everything she painted was, as Stieglitz had suggested years earlier, an expression of some secret feminine voodoo. Someone called her "the Priestess of the Eternal Feminine," and reference was made in a *New York Times* review to her ability to channel the superheroish-sounding Mighty Mother. Lewis Mumford, writing in the *New Republic*, elevates her in a sentence that reads:

> *Miss O'Keeffe has not discovered a new truth of optics, like Monet, nor invented a new method of aesthetic organization, like the Cubists; and while she paints with a formal skill which combines both objective representation and abstraction, it is not by this nor by her brilliant variations in color that her work is original. What distinguishes Miss O'Keeffe is the fact that she has discovered a beautiful language . . .*

And so on.

It seems that for about ten minutes after Mumford's review was published, O'Keeffe had achieved the kind of serious critical reception she desired.* But then something happened that would drum her out of the highbrow art corps forever: Women discovered her. And I don't mean just the occasional heiress who would spring for a picture of a petunia, but women on the street, *flappers*, who smoked in public and wore

* O'Keeffe was one of those artists who claimed never to have read her reviews, yet her biographies are littered with quotes from thank-you notes she sent to critics who she felt especially understood her work.

short skirts and rouged their knees, the better to leave people with the impression that they'd just risen from the floor after having given someone a blow job. And not only modern working girls, but *housewives*. O'Keeffe had gone from being the shy schoolteacher girlfriend of the studly (by art world standards) Stieglitz, who made esoteric abstract paintings that communicated to men, on behalf of Woman-Children everywhere, how moving and erotic it was to have sex with them, to a popular painter embraced by their wives and girlfriends. She painted chick art.

Cheeky *New York Sun* critic Henry McBride reported, "I do not feel the occult element in them [the paintings] that all the ladies insist is there . . . there were more feminine shrieks and screams in the vicinity of O'Keefe's [sic] work this year than ever before."

Occult. Ladies. Feminine shrieks and screams.

There goes the neighborhood.*

I wasn't surprised to learn this. The higher O'Keeffe's stock rose with women, the lower it dropped with men, i.e., the educated purveyors of high culture. Fortunately, modern day O'Keeffe scholars have worked, and continue to

* The derision continues to this day. Writing in the *New York Times* on May 31, 2011, columnist David Brooks felt the need to report on an obscure, and frankly dubious, study in the Archives of Sexual Behavior on how hormones effect perception. Women in the first half of their monthly cycle were shown O'Keeffe paintings; one-third of them saw sexual themes. Only 6 percent of women viewing the same paintings in the second half of their cycle saw sexual themes. "The most amazing thing about the study," opines Brooks, "is that there are apparently people capable of looking at Georgia O'Keeffe paintings and not seeing sexual themes. These are the people who need to be studied." Har!

work, tirelessly to redeem her reputation, to make sure she is revered and appreciated by the right sort of people,* to make sure the people who tack O'Keeffe posters on their walls and buy pretty O'Keeffe calendars for their kitchens, and love the same paintings that the flappers and housewives loved, feel like the cultural riffraff they are.

I was fortunate to meet with one such Noted O'Keeffe Expert. I wrote a formal request for an interview and submitted it to her assistant, who said she would see if she could arrange an interview for me. The NOKE lives several time zones away from my home in Portland, but when I heard she would see me, I was overjoyed and immediately arranged a trip. I had so much to ask her. As I'm sure you've gathered, there are several different schools of thought on the nodal events of O'Keeffe's life. Take, for example, the Stieglitz photographic portrait. To what degree was Georgia a willing participant? Was she simply a woman in love, and therefore not in charge of all her faculties, or did she know exactly where the pictures would end up, and how they would propel her into the public eye?

The NOKE ushered me into her office and then sat crisply down at her desk and folded her hands. "What can I do for you?" Everything about her mien made me feel like the doomed movie heroine who is about to be turned down for the loan that would save the family farm.

* Not people who dropped their lone art history classes in college and secretly prefer the gift shop.

"I'm writing a book called *How Georgia Became O'Keeffe*," I said, sitting down in the chair in front of her desk. I opened my file folder and removed several pages of questions I'd wanted to ask.

She actually snorted. "Isn't everyone?"

"They are?" This was news to me. I felt myself blush. "A lot of people have books coming out on O'Keeffe?"

"Well, have you read my book?"

"Yes." No. Published last century, her book was out of print. I'd purchased one of two used copies on offer at Amazon.com. It was $40.99, cost of shipping not included, and had shown up on my front porch the day before I'd left Portland. I'd just started reading it that morning, but I'm a slow reader and hadn't gotten very far.

"My thoughts are in there," she said.

"Okay," I said.

We sat there.

"Um, I also wanted to hear your feelings on the real O'Keeffe. All the biographies have such different takes on her, and since you're an expert . . ." With each word that left my mouth I devolved: from the college student who studied the wrong chapter for the biology exam, back to the high school student who couldn't conjugate *mettre*, to the seventh grader who, pressed into reading a passage aloud in Social Studies, pronounced peninsula *penna-zula*, to the fifth grader who was, well, a fifth grader.

"Who do *you* think she was?" asked the NOKE.

"Well, a kind of a Midwestern person, a nice person from the Midwest," I said. "Practical and direct and . . . Midwestern. In that way Midwesterners are."

"If you read my book you'd know how I feel."

I busied myself making a note to read her book, even though I was already reading her book.

"All of those biographers are friends of mine, and in one way or another, all of their books are flawed," she said.

"I have a question about the sale of the Calla Lily pictures, people seem to be divided on—"

"My opinion is in . . ." She named the catalog of an exhibit.

"Okay," I said. I was davening to such a degree that I was on the verge of banging my chin on her desk.

"Um, do you feel her most revolutionary work was also her best work, or—"

"I wrote about that in my essay in the catalog right behind you," she said.

"Do you think she painted the flowers—"

"What bibliography are you using, anyway?" Her voice got higher and louder.

What bibliography was I using? Shit. All of them. None of them.

"I'm . . ." I started to say I was currently working from the bibliography at the back of Hunter Unpronounceable-Polish-Last-Name-Philp's book. I was in a full flop sweat. I was *half-Polish*—the pre–Ellis Island last name is Karbowski—and I

couldn't even pronounce Hunter's last name.* "*Full Bloom*," I said, remembering the title.

"Are you reading the letters? You have to read the letters. Sarah's book is coming out in June."

"I have an advance reading copy," I said.

"You must read all of the letters. There are 25,000, and you must go to the Beinecke and read them all. How did you get an advance copy?"

"My agent."

"Who's your agent?"

"Inkwell Management."

"What did you say the title of your book was?"

I told her.

The NOKE leaned back in her chair and looked at me, as if recalculating my worth.

"You must remember to say O'Keeffe was a staunch feminist. People never get that right about her."

Georgia O'Keeffe was a staunch feminist.

* Drohojowska-Philp.

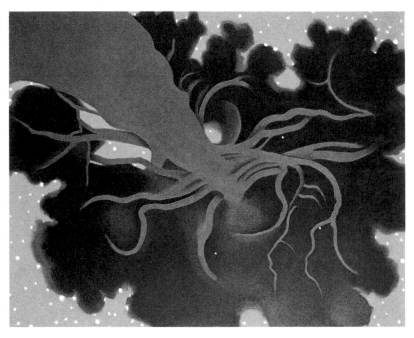

Georgia O'Keeffe
American (1887–1986)
D. H. Lawrence Pine Tree, 1929
Oil on canvas, 31 x 40 in.

The Ella Gallup Sumner and Mary Catlin Sumner Collection Fund. 1981.23

Wadsworth Atheneum Museum of Art, Hartford, CT

Wadsworth Atheneum Museum of Art/Art Resource, NY

8

DRIVE

*Flattery and criticism go down the same drain
and I am quite free*

FOR THOSE OF US WITH PARENTS WHO WERE CHILDREN
during the Great Depression, or those of us who paid atten-
tion during Modern U.S. History class, the year 1929 *looms*.
In October, the world would go to hell in a handbasket. By
1928, O'Keeffe was one of the most well-known artists in the
country. Her yearly shows were well attended, her paintings
purchased by dizzy heiresses and a growing number of seri-
ous collectors, including Duncan Phillips, one of the next
generation of collectors of modern art, who founded The Phil-
lips Memorial Gallery in Washington, D.C., the nation's first
museum of modern art.

In *Exhibition of Paintings by Eleven Americans*, O'Keeffe's works* hung beside those of Eugene Speicher. Yes, *that* Eugene Speicher—the same boy who was at the Art Students League with Georgia, and who had begged her to pose for him, telling her that she could easily afford the time since she was only going to become an art teacher anyway. When she found this out, did she do the 1920s version of the fist pump? Or maybe one of those dances football players do behind the goalposts after a touchdown?

It's possible she was consumed with her career, her painting, her suddenly bumpier-than-usual marriage. She'd had some health issues. She had other bigger and better fish to fry. Isn't that the way of it? Someone makes us feel like crap when we're already vulnerable and not making much progress in life. We vow that one day we'll make them pay! CALL ME NERD TODAY, BOSS TOMORROW goes the popular T-shirt saying. The irony is that once you get there, once you're the boss, or shown in the same gallery as the self-important twit who'd written you off because you were a girl, you've moved on.

If you haven't moved on, you should have. Yes, I know. Revenge is a dish best served cold, but that only really holds true for people in countries where much of the day is spent dozing in the heat, brooding. Anyone with a to-do list simply can't be bothered . . . or she shouldn't be.

I went to a big Southern Californian suburban high school where I was the friend of the homecoming queen. I

* The first O'Keeffe that Phillips had purchased was *My Shanty* (1922).

was the perennial sidekick, and friend to all the cute boys who had crushes on my friends. Even my mother wondered why, since I wasn't bad-looking, I never had any dates. Off I went to college, where I also had no dates. I vowed that one day I would come back and show them! Those girls would have boring husbands, colicky babies, and the ten pounds of post-pregnancy belly fat that went with them, and I would have—well, not that. Since I never had any dates, I would be unlikely to have a husband, even a boring one, and the resultant babies.

By the time my twenty-year high school reunion rolled around, I'd published two novels. I'd moved away from the Southern California suburb to Portland, Oregon, where I lived with (surprise!) my husband and little baby. Bruce Springsteen's "Glory Days" was playing, and I strode into that reunion in my purchased-just-for-the-occasion strappy bronze sandals, and I got myself a cocktail and lay in wait for the first person to ask me what I'd been up to. I'd left the husband and baby at home, even though some girls (losers!) brought theirs.

It happened in the ladies' room, which was packed with girls-now-women, peeing and primping. Someone asked what I was up to. This was it. Here was my moment to shine. I would make her feel the way Speicher must have felt upon learning that Georgia O'Keeffe had twice the career he could ever hope to have. But the moment the word *writer* left my lips, the girl who asked looked away and said, "Yeah, well I mean to read more, I really do. But I just don't. I have a library card,

though." This happened over and over again. No one wanted to hear about my books, except Mr. Pendell, the art teacher. Everyone else avoided the subject. I had gone from being the friend of the homecoming queen (who looked as beautiful and queenly as ever), to the person on the corner in front of your favorite Starbucks who works for a well-meaning under-funded grassroots organization that saves puppies from global warming, whose eyes you can't meet and who nevertheless makes you feel guilty as hell. You're probably ahead of me on this one, but the girls with the chubby husbands and boring babies loved them. They loved their lives.* They didn't envy my being a writer. Why would they?

It is unknown whether O'Keeffe ever attended a class reunion at the Art Students League, but if she did, I feel confident in saying that she never cornered Speicher and informed him that she was an artist, and not an art teacher, ha ha ha.

In any case, 1928 was a banner year for O'Keeffe, despite the fact that the art market wasn't as frisky as it had been several years earlier, perhaps a portent of the belt-tightening that was to come.†

On April 16, 1928, a slightly disingenuous *New York Times* headline read ARTIST WHO PAINTS FOR LOVE GETS $25,000 FOR 6 PANELS.‡

Maybe one of the reasons "everyone" is writing a book about O'Keeffe, and people remain as interested in her life as

* They didn't even seem too concerned about their baby weight.

† Provided you were lucky and still had a belt, and hadn't cut it up to add to your bear stew.

‡ As if she had never sold any pictures before—as if she was a woman who pottered about with her paints on Sunday afternoons.

they are in her work, is because certain key experiences remain tantalizingly open to interpretation. This is one of them. The sale was headline-worthy because it was the highest price ever paid for a work by a living American artist. Stieglitz had a dramatic story to go along with the high purchase price: The six panels had hung in a row at her 1928 show. A dashing, well-dressed stranger pulled Stieglitz aside and told him he wanted to buy the lot of them. Stieglitz was flabbergasted. His heart beat dangerously fast. He was extraordinarily picky about who could own an O'Keeffe, and he wasn't sure this flashy gent met his standards. He threw out a number: $25,000.* Without a moment's hesitation, the man agreed. Stieglitz made him promise to display them together, and never to sell them. The man agreed to this as well. The panels were whisked off to Paris, never to be seen again.

It's likely that Stieglitz made this up, to cover up the true, non-headline-worthy sale. It's one of the things he was best at, and for which, despite her many mixed feelings, O'Keeffe felt grateful: getting press. He knew that once a headline was run, the news was out. He was like those TV lawyers who throw out some damning statement that the judge then instructs the jury to pretend they've never heard. The paintings going to Paris is a nice embellishment, especially since for decades, the movement of masterpieces had been in the opposite direction, from Europe to America. Now there would be paintings by Georgia O'Keeffe, American, hanging over a blue velvet *récamier* in some swanky flat in Saint-Germain-des-Prés.

* $328,810 in today's dollars.

The Noted O'Keeffe Expert, whom I respect (even if she did make me feel like a brainless, red-poppy-poster-loving nincompoop), believes that the secret, anonymous buyer was Stieglitz wingman, Mitchell Kennerley, owner—until he went bankrupt—of the Anderson Galleries. Kennerley was British, but in every other way he was like someone out of *The Great Gatsby*, by which I mean a larger-than-life man-of-means. In addition to being an art auctioneer and gallery owner, Kennerley was also a publisher, famous at the time for having been sued by Harper & Brothers, the publishers of Mark Twain, for copyright infringement. Kennerley published *Jap Herron,* written by Twain from beyond the grave, and transmitted to Kennerley author Mrs. Emily Grant Hutchings by Ouija Board.

His literary exploits were dubious, but over the years he'd been a friend to Stieglitz. When Stieglitz moved into Elizabeth's tiny studio with O'Keeffe, Kennerley stored the rest of his stuff for him, and it was Kennerley's idea to mount a retrospective exhibit of Stieglitz's photographs, which included the famous forty-five pictures that launched Georgia's career.

Kennerley bought the Calla Lily pictures for $25,000, but Stieglitz agreed that he could pay in installments. Kennerley couldn't afford the pictures at the moment, but he was engaged to a wacky heiress,* Margery Durant Campbell Daniel, the daughter of the one-time CEO of General Motors, and his plan was to woo her with a gift of them; after they were

* It being the twenties, there was certainly no other kind.

married he would use her money to pay the balance. While wacky Margery was in Reno getting her divorce, she kept two of the smaller Calla Lilies with her for company, but alas, once she returned she fell in love with someone else and returned the pictures to Kennerley, who stopped making his payments a short while later, and was forced to return them to Stieglitz.

By then, all the newspapers had picked up the story, and O'Keeffe was besieged by interviews. She sat for them reluctantly. For the length of her long life she agonized over her mixed feelings about publicity. She knew it was important, but she was so private. She was never able to successfully convince herself that it didn't matter, or become more open. Her reputation, carefully crafted by Stieglitz, as Pure, Feeling Woman-Child Ruled by Intuition, was no less manufactured than his photographs and her paintings. O'Keeffe was a pragmatic Midwesterner. Like everyone who does not suffer from a personality disorder, her heart could lead her astray when it came to love, but when it came to her work, she was practical and hardheaded. She knew that regardless of whether the headline about the sale of the pictures was true or not, it would be foolish not to leverage the attention.

Her celebrity was thus refreshed. Only this time, instead of being a newspaper personality known for her naked torso and love affair with a married older man, she became famous for her work, and the high prices it commanded. To further burnish her growing and glowing image as one of the best, most exciting living American artists, male or female, she

traveled to Washington, D.C., at the behest of her old friend Anita Pollitzer, to address the National Woman's Party.

O'Keeffe really was a staunch feminist, as the NOKE insisted. I'm tucking this tidbit in here because I fear that if I lead off a chapter with it, or create a highlighted section within a chapter, calling it How to Be a Feminist, readers who love art, strong women, fascinating characters, life lessons, and cheeky modern narratives,* will run from this book the same way my dog does when she poops in the neighbor's yard.

When I was in college, and disco, not feminism, was king,† someone defined feminism for me as "believing the lives of women matter as much as the lives of men." Can anyone argue with that? If what women are posting on Facebook these days is any indication,‡ I think we can say that we now believe that pretty much everything that happens to us is at least as important as anything that happens in the lives of men. Like the word *gay*, which evolved from meaning "joyful" to "stupid or lame" in a few short decades, feminism has come to mean Humorless Female Who Will Never Wear Stylish Shoes and Has Issues with Waxing.

* Who might be one of those people who inexplicably start a sentence with "I'm not a feminist or anything, but I think it's unfair that women still don't get paid the same as men for the same work."

† Queen?

‡ A random sampling from my page, taken just this minute: new haircuts; shoes that one friend covets but that are no longer available; best methods for potty training; cute quips made by one's preschoolers regarding cat poop; eighteen pictures of someone's infant dozing in his stroller; a question about whether it's okay to drink beer or wine while breastfeeding, and if so, does it make any difference whether the beer is a microbrew?; pictures of a homegrown carrot; a dream wherein the dreamer is talking to Jon Stewart about how best to organize her home office; home pedicures.

The concept must be rebranded. Might we call it something like *esprito*?* From the French word *esprit*, which means "liveliness of mind and spirit." The added "o" places the concept across the universe from an -ism (boring!) of any kind, instead evoking a party atmosphere, making *esprito* sound like something you might enjoy with salsa, after a shot of tequila. It could also be spelled phonetically, *espreeto*. This makes it sound like it could be related to a shopping spree, and less like a religion that involves animal sacrifice.

O'Keeffe's brand of *espreeto* emphasized self-reliance. She felt that women should earn their own living, but, more important, that they had a responsibility to their true selves to find out what they were good at, and to pursue it.

A Lesson on Envy

Right about now you would be forgiven for envying Georgia O'Keeffe. It's one thing to read about her struggles living at the far end of the world, and borrowing money to go to school, and then having to quit school because the money ran out, and sleeping in a series of dingy, rented rooms, and carrying on a long-distance relationship with a man belonging to the Stop It Some More School of Courtship and then, just when it looks like things are finally going her way, being embarrassed by naked pictures made public by yet another man. We could root for her then, and empathize.

* There's already a Wikipedia entry for *esprito*, in a language I don't recognize.

By 1930 however, she was famous. Her yearly exhibits garnered plenty of notice, and her paintings sold. Increasingly, critics wrote about her work and not her gender; even the ones who thought she was overhyped and undertalented came at her for complicated issues related to her painterly technique, the quality of her brushstrokes, her choice of colors. She had realized her life's dream of earning a living by her art and was the first American woman painter to do so. To the world she appeared unflappable and weirdly elegant in her black vestments and flat shoes, her gleaming black hair always pulled straight off her face in a bun at the nape of her slender neck. Did I mention, she was also thin?

But all was not well. Indeed, everything else in her life pretty much sucked.

Her health had not been good. O'Keeffe could be as robust as a cowgirl, then would fall mysteriously ill from something undiagnosable that probably only affects geniuses. One time, she was felled by a smallpox vaccination. Shortly after being vaccinated her legs became swollen and Lee, Alfred's brother and the family physician, "cured" her by tightly binding them from thigh to ankle and ordering full bed rest. After *nine* weeks, she recovered (a cold pack and some aspirin would have solved the problem overnight). There was no middle ground, it seemed, no days when Georgia was feeling a little rough around the edges but soldiered on. She was either getting up before dawn to do her many-miled walk, planting a garden, writing eighty-seven letters, then dashing off a masterpiece,

or flat on her back in bed for months at a time. Maybe echinacea and zinc really do ward off colds, like the hippies say.

In December 1927, she underwent surgery for what turned out to be a benign lump in her breast.* It was her second such operation, and her recovery was slower than it had been before. Stieglitz wasn't doing so hot, either. Shortly after the success of the Calla Lilies sale, he suffered a kidney-stone attack, his second in as many years. Stieglitz was a lifelong hypochondriac, but now that he was in his sixties, his imaginary aches and pains were becoming real aches and pains. He had little accidents. He fell and hurt his back. He tore a ligament in his finger. In the late summer of 1928, he had an angina attack.

Eighty-five years from now, I'm sure people will look back in disbelief on our current, standard medical treatment,† but how anyone survived doctor's orders back then is a genuine mystery. When Stieglitz was recovering from his attack, his regime included three weeks of complete bed rest and a complicated regimen managed by O'Keeffe that required "strained spinach, peas, squash—ground lamb and beef—strained this—five drops of that—a teaspoon in a third of a glass of water—or is it half a glass—pulse this—heart of that—grind the meat four times—two ounces—1 oz.—½ zwieback—will all those dabs of water make up two qts—is this too hot—that white stuff must

* The elegant *Black Abstraction* (1927), with its pinpoint of white light at its center, was inspired by her experience of being put under.

† Put ice on a sprain—are you kidding me? Get up and walk as soon as possible after surgery? Barbaric.

be dissolved in cooler water—the liquid mixed with hot—castor oil every fifteen minutes and so on—divide those 25—or is it 21—ounces into five meals . . ." as she mock-complained.

If O'Keeffe sounds a little hysterical, she was.

Stieglitz, the impossible love of her life, had fallen for someone else.

Dorothy Stecker Norman was a dark-haired young woman looking for meaning, who wandered into the Intimate Gallery*one day in 1927, heard Stieglitz lecturing someone about the meaning of art, and fell under his spell. His intensity, his charisma,† his passion for his subject, was the bright flame to her lost moth. She was smitten. She became obsessed.

It would be one thing if Dorothy Norman had been a twit, but she was not. Like Stieglitz, Norman had been born into a wealthy German Jewish family. Her parents were typical parents of their time and socioeconomic class: They wanted their daughter to find a suitable mate and start breeding. The primary lesson they imparted to their only child was never wear glasses, and marry a Jew. But Norman was curious, rebellious, and not stupid; aside from her penchant for hero-worship, she was committed to social reform and had worked as a researcher for the American Civil Liberties Union. After high

* He ran this too appropriately named gallery from 1925 to 1929.

† Whenever I imagine encountering Stieglitz, I think of the famous image from the '70s Maxell cassette ad: "Blown-Away Guy" is slouched in a high-armed leather chair in front of a stereo speaker, presumably issuing such awesome sound that he's forced to hang on to the arms of the chair for dear life while his curls and tie are blown straight out behind him.

school she enrolled in Smith against her parents' orders. At nineteen, she had dropped out and married Edward Norman, an heir to the Sears, Roebuck & Co. fortune. From the first month it was obvious the marriage was a disaster, although Dorothy still managed to orchestrate an Oops, hoping against hope, as disappointed young brides have been known to do, that a baby would salvage the relationship.

When Dorothy discovered Stieglitz she was twenty-one, seven years younger than his own daughter, and pregnant. In Stieglitz's eyes she was perfection: naive, yearning, fertile, with both an unformed mind, which he could fill, and a husband, which freed him from responsibility. She hung around the gallery for a year, offering to do clerical work, buying pieces of art, *taking notes** during their conversations.

It's to Stieglitz's credit that he didn't succumb to temptation sooner. After all, he was about nine hundred years old, his time was long past, his younger wife was a huge success who also supported them and was grumpy when she had to interrupt her painting to prepare his special old-man heart-attack-prevention meals, and then also referred to him as "a funny soft little gray creature." Really, how could the man resist?

Learning all of this, doesn't any envy you may feel for O'Keeffe's success subside? If not, you should consider the Otto Rule of Envy developed by American novelist Whitney

* Please forgive the italics. I'm doing my best to present an impartial portrait of someone who had many fine qualities, I'm sure, and in many ways was probably far nicer than O'Keeffe, who, let's face it, could be caustic and coldhearted, but really, this is nauseating.

Otto,* who's both enjoyed a staggering amount of success and struggled through hard times.† According to the Otto Rule of Envy, if you're going to allow yourself to succumb to envy, you must agree to envy the person's entire life. You don't get to cherry-pick the good parts. You aren't allowed to envy the reviews in the *New York Times* or the ski cabin in Aspen without also considering the husband who's a bit of a windbag, or the chronic colitis. Following the Otto Rule, it becomes clear in a matter of moments that you don't want the enviable person's *whole* life; you only want one particular thing that the other person has—professional success, youth, money, or beauty.

The Land of Enchantment

O'Keeffe and Stieglitz were not bohemians, but they knew bohemians. Lady Dorothy Brett lived one floor below them at the Shelton Hotel. She was a genuine lady, born into the British aristocracy, and eccentric as only British nobility can be. She was incidentally a painter, but her true calling in life was as an acolyte of D. H. Lawrence. Brett, as she liked to be called, was plump, heavy-browed, and deaf enough to require the use of an ear horn. Brett and the O'Keeffe-Stieglitzes often

* Also a friend and neighbor.

† Her first novel, *How to Make an American Quilt,* sold over two million copies worldwide, and was made into a movie produced by Steven Spielberg, starring preshoplifting Winona Ryder and the late, great Anne Bancroft. Since then publishers have been waiting for a sequel that features Nice Women Doing Crafts, but Otto wanted to explore new, less-commercial subjects, and she's never reached the heights of that first success.

had lunch together on Sundays. O'Keeffe ate onion soup; Brett ordered duck. She often sang the praises of Taos, New Mexico, where she'd lived with D. H. and Frieda in 1923, and she pressed Georgia and Alfred into visiting. Stieglitz, who never went anywhere but Lake George, was completely uninterested. Georgia had always loved the West. As an old woman she would say that the happiest times of her life were those few years spent in the Texas Panhandle. She also didn't think she could stand another summer at Lake George, where she'd run out of things to paint. There was also the fact of her husband's affair with Dorothy Norman.*

The trip wasn't easy to negotiate. She would be gone for months. Stieglitz was sixty-five and increasingly frail. Life without Georgia made him anxious. She once remarked that Stieglitz loved it when she was sick in bed, because that way he always knew where she was.

How to Have a Life-Changing Experience

O'Keeffe arranged to travel west with Beck Strand, the wife of Paul and former Stieglitz model with whom Alfred did or did not have an affair in the summer of 1923. It was a mark of Georgia's basic equanimity† that she was thrilled to have Beck as a companion, even after the business with Stieglitz.

* Which Alfred denied. How could be possibly be having an affair with her? They were both married!

† Except when it came to the matter of Dorothy Norman, which, as you shall see, made her batshit crazy.

O'Keeffe and Beck arrived in Santa Fe in May 1929, and within forty-eight hours, Georgia knew without question that her life was going to change for good. To her sister Catherine she wrote, "I am West again and it is as fine as I remembered it—maybe finer. There is nothing to say about it except the fact that for me it is the only place."

Go with a friend.

Georgia and Beck were invited to stay at Los Gallos, Mabel Dodge Luhan's adobe compound in Taos. Mabel, the heiress to the White Sewing Machine fortune, was a kooky, middle-aged patron of the arts and collector of the famous, whose "intimate" memoirs ran to 1,600 pages. She'd moved to Taos with her third husband, then divorced him for Tony Luhan,* a full-blooded Pueblo Indian, who was tall, imposing, and kind. Both D. H. Lawrence and Willa Cather had stayed in "Mabeltown," and she was thrilled to have the most famous woman painter in the country under her roof. Initially, Georgia and Beck had been given The Pink Cottage, across a big alfalfa field from The Big House, but only a few weeks after they arrived, Dodge Luhan required an emergency hysterectomy and left for New York, leaving Georgia and Beck to their own devices.

This is the part where I extol the virtues of northern New Mexico. The light, the heat, the purple mountains majesty, the excellent enchiladas. But first, we've reached yet another

* His name was actually spelled Lujan, but at Mabel's insistence he anglicized it to Luhan.

juncture in the life of O'Keeffe, where no one is quite sure what happened, paving the way for endless conjecture that continues to this day: Did Georgia and Beck have an affair?

The main evidence seems to be that they were high-spirited and partook of some nude sunbathing. In addition, according to prim and disapproving John Marin, also a guest at Mabel's that summer, they washed Georgia's new black Ford sedan* while naked. They may have been giggling. It appeared there were no wash rags handy, so Georgia suggested they use sanitary napkins, which they found even more hilarious. As a resident of Portland, Oregon, which hosts the World Naked Bike Ride every June,† I'm not sure having a good, giddy time while naked is enough proof. So they did or they didn't. I'd like to think that we've reached a point where it's immaterial.

Beck was easygoing and had the energy of ten teenagers. Together, she and Georgia hiked, camped, and rode horses over the Taos plateau, a broad, high-altitude lava field covered with grayish-green sagebrush and surrounded by mountains. At night, when they weren't sleeping under the stars, they sat in front of the fire and sewed and talked. They ate quesadillas and smoked. They drank whiskey and played practical jokes on each other.

They set up their easels and painted. Beck lacked both Georgia's artistic gift and her staggering confidence; however,

* A week after her first driving lesson, Georgia purchased the black sedan with blue interior for $678.

† There were eight thousand participants in this year's ride; police do encourage the riders to wear helmets.

she had a great eye. Some believe it was Beck who discovered the great black Penitente crosses that became the subject of some of O'Keeffe's most striking and memorable pictures.

Learn a new skill.

There's a reason why all those cruise commercials on TV emphasize rock-climbing, salsa dancing, and other stuff you never do in your daily life, and why there's a whole subgenre of getaways known as Learning Vacations. The best vacations are always the ones where you learn to do something new. It has something to do with the novelty of both the place and the activity hooking up in the brain that creates pleasure.

Seventy-two hours after O'Keeffe had arrived in Taos, she coerced Tony Luhan into teaching her how to drive. She was terrible and fearless. She ran into fences, took out gateposts, drove into irrigation ditches. She sweated and swore. She had no natural aptitude for driving a car, but after a few weeks of practice, she was roaring all over the countryside. She then bought the car, which she named Hello!

Get a tan.

O'Keeffe was a sun lover. Whoever invented sunscreen hadn't even been born when O'Keeffe and Beck would drive Hello! out into the middle of nowhere, take off their clothes, and hike around in the brush. She loved the feeling of the sun beating down on her, burning her skin "clean to the bone," and would eventually have the deep wrinkles to prove it.

These days exposing yourself to the sun in the manner of O'Keeffe seems as wise as having unprotected sex with a local during your vacation in Bangkok. Strolling down the beach in midday sans SPF is living on the edge. Do it! Everyone looks better with a tan, but no one wants to pay the price anymore in wrinkles and possibly melanoma. But ask yourself: What are you saving yourself for?

In the Georgia O'Keeffe Room

The change in O'Keeffe's life after her summer in New Mexico was cataclysmic. The empty, dramatic landscape of the desert Southwest had done its mysterious number on her. Even in the worst of times O'Keeffe always knew who she was and what she was about; still, during those months she rediscovered her passions, strengths, and sense of humor. She had discovered her Place, something which most of us are never fortunate enough to do.

It's no wonder people* feel compelled to make a pilgrimage to northern New Mexico to see if perhaps the crystalline air, fantastic geography, and artsy/spiritual mojo will change one's life.

Jerrod and I drove to Taos in his parents' twenty-five-foot RV. Our original destination had been Ghost Ranch,† but we'd missed the turnoff driving north from Santa Fe. By the time we

* Okay, me.
† Where O'Keeffe lived from 1949 until shortly before her death.

reached the Rio Grande Gorge—an 800-foot-deep mini Grand Canyon that bisects the Taos plateau—we knew we'd made a mistake. No worries! Part of the reason we'd driven the RV was so that, in the spirit of O'Keeffe, we could keep our options open. We'd headed south from Oregon with no plans, other than to see if we could see what Georgia saw. Jerrod, who drove the RV, was fine with this. The only thing he needs in life, really, is an Internet connection and a bottle of Maker's Mark.

We decided to continue on into Taos, spend the night, then go to Ghost Ranch the next morning. The Mabel Dodge Luhan house sits at the end of a quiet, narrow road, just off Kit Carson Road. The day was bright and warm and the lilacs were in bloom. The Big House looks just as it does in pictures, like a big adobe birthday cake, flanked by a long low wing of guest rooms. Like everything else in Taos, it is charming-verging-on-too-adorable-for-words. The main entrance is a double door of whitewashed wood, with teal and red trim, and a four-paned window in the top half of each door. Inside, the doors are low and arched—people must have been much shorter in 1922 when the Big House was finished—and the floor is tiled and the high ceiling is lined with wooden beams, or vigas, as they are known here.

One thing you should know: If you are a woman of a certain age, and you like to wear your white hair long and parted in the middle and pulled back into a bun, with big turquoise earrings and maybe a dash of red lipstick, this is the place for

you. A beautiful woman with just this hair walked out from the small gift shop, offered us a cup of coffee, and reminded us that the MDL house was now a hotel and conference center. Meaning, you can't just come in and wander around, soaking up the artsy vibes.

We immediately followed her back into the gift shop, which was small and, yes, charming—although there were a few too many of those deadly Penguin classic editions of D. H. Lawrence titles on display for my taste. They had the same effect on me that I imagine I had on my classmates at my twenty-year high school reunion: I felt a sudden flush of slacker guilt for only having read *Lady Chatterley's Lover*,* and not remembering a single thing about it, not even the dirty bits. To compensate, I bought a pretty, cream-colored Vintage Classics edition of *Death Comes for the Archbishop*, by Willa Cather, and a Mabel Dodge Luhan stainless-steel Go cup.

On our way into town we'd noticed a nice Wal-Mart with two RVs parked under each of the two tiny trees on the parking strip, signaling that this was one of those Wal-Marts where RVs could park free overnight. Even though it was only early May and the sun wasn't anywhere near setting, it was still late enough in the day to cruise the Wal-Mart lot for a good spot.†
We closed the shades and put out the slide-out living room and the slide-out bedroom, and lay down to nap, but every

* A fat copy with yellowing pages sat in a wire holder, listing forlornly to one side.
† Near the other RVs, but not so close that you can see inside someone else's vehicle, in a level spot, facing west.

time a shopping cart trundled by outside, I woke up. I read some of the literature on the MDL house given us by the lady with the beautiful white hair, and suddenly sat up straight. For $125 a night, you could stay in the same room O'Keeffe had stayed in when she'd visited Mabel. Moreover, I looked at the date and realized that Georgia and Beck Strand had arrived in Taos eighty-two years ago *to the day.*

This was something; this was cosmic. I woke Jerrod. The sound of the trundling shopping carts clearly posed no problem for him. He phoned the MDL house and yes, the O'Keeffe room was available that night. We threw open the shades, pulled in the living-room slide-out and the bedroom slide-out and roared out of the lot, back to the MDL house, to check into the very room Georgia herself had slept in.

The room was in the long low wing of guest rooms, facing the big cobblestone courtyard. It had two high squeaky twin beds, and a framed and signed color poster* called *O'Keeffe at Ninety,* which showed her in her massively wrinkled, bushy-browed, thin-lipped glory, staring out from beneath her trademark black Zorro hat, giving the photographer her death glare. It was terrifying. We slid into our respective beds and turned out the lights. The elevation of Taos is almost 7,000 feet and the population is almost 5,000. For some reason, I imagined this helped to explain why the Georgia O'Keeffe room at the Mabel Dodge Luhan House and Conference Center is as dark as the back of a cave. There was no moon. I kept trying to

* From a photo by Malcolm Varon, 1987.

feel something light and creative and brilliant and inspired, but all I could think of was Georgia O'Keeffe at Ninety glaring over my squeaky bed, and how much she would disapprove of this book, and view my admiration* for her as a species of the same swooning, dim-witted, floppy-haired, back-to-the-land-inspired devotion that thousands of people who were very young in the 1970s had had for her. I slept poorly.

Sometime around three a.m. I heard an animal scrabbling around in the courtyard. I got up and peered out the window and saw that a storm had moved in, and tiny ice crystals were drifting down from the sky.

* Okay, adoration.

Georgia O'Keeffe
American (1887–1986)
Ram's Head, Blue Morning Glory, 1938
Oil on canvas, 20 x 30 in.

Promised gift, the Burnett Foundation. L.2002.2.1

© The Georgia O'Keeffe Museum

Photograph by Malcolm Varon

The Georgia O'Keeffe Museum, Santa Fe, NM

Georgia O'Keeffe Museum, Santa Fe/Art Resource, NY

BREAK

My feeling about life is a curious kind of triumphant feeling about — seeing it bleak — knowing it is so and walking into it fearlessly because one has no choice.

WHILE O'KEEFFE WAS IN TAOS, STIEGLITZ LIVED IN A STATE of constant fuming. He was jealous of everything: Georgia's fine moods; her high jinks with Beck Strand; her new friends; her new art. Beck reported that Georgia was happiest when she was free, which Stieglitz took to mean free from him. Georgia reported that Tony Luhan had taken her and Beck on a wonderful camping trip, which Stieglitz took to mean she was having an affair with Luhan. He was afraid Georgia was never coming back. One night, alone at Lake George, he built

a bonfire, and in a melodramatic gesture befitting a fourteen-year-old girl, burned his old work—prints and negatives and hundreds of old issues of *Camera Work*.

"Freedom is necessary to sincerity," he intoned to someone or other, doing his best to mean it as it pertained to Georgia, but believing it really only pertained to himself. He still wrote daily love letters to Dorothy, who disapproved of O'Keeffe's adventure, especially a camping trip she took to the Grand Canyon with filmmaker Henwar Rodakiewicz, his wife Marie Garland, and some of their Hollywood friends. Rodakiewicz drove O'Keeffe in his Rolls-Royce. Dorothy sniffed that people shouldn't indulge in that sort of thing *just because they wanted to*. To console Stieglitz for being abandoned, she chartered a private plane for him to come visit her in New York.

In the fall of 1929 O'Keeffe returned to Stieglitz. They were genuinely happy to see one another—perhaps because it relieved some of the guilt from which they both suffered, for different reasons. To celebrate their reunion, he took some pictures of O'Keeffe, including a three-quarter profile in which she's leaning against the side of a car, her curled fingers resting against her chin, a suppressed smirk upon her lips. She was badass. "The relationship was really very good," O'Keeffe said much later, "because it was based on something more than just emotional needs . . . of course, you do your best to destroy each other without knowing it."

The Part Where They Destroy Each Other:
An Object Lesson

No one is inside someone else's marriage, and no marriage is perfect. Still, O'Keeffe's stubborn refusal to acknowledge the full-throttle infidelity going on under her nose, and Stieglitz's nutty brand of narcissism—which forbade him from admitting that he was having an affair, despite the fact that he was boffing Dorothy Norman several times a week* in the back room of the Intimate Gallery—ruined not just their marriage, but their friendship, and possibly the good memories of their early years together.

I realize that a few chapters back I made what I hope is a convincing case for the power of sublimation. But, like anything in life, it can be taken to an extreme. Sometimes, rather than funneling our frustrations and forbidden feelings into our work, we must let the crockery fly. We must stand our ground and open our mouths and let the truth roll out and scorch everything in the room. To refuse to say anything is often to burn down the city. O'Keeffe knew what was going on, and yet she said nothing.

Because O'Keeffe and Stieglitz were frugal, and their investments modest, they didn't suffer much when the stock market crashed in October; however, Stieglitz was forced to give up the Intimate Gallery. This did not sit well with Dorothy Norman, who needed Stieglitz to be ensconced in a gallery

* Pre-Viagra!

if she was going to continue to worship him as a guiding luminary of the American art scene. She was able to squeeze $3,000 from her husband, Edward, to underwrite the opening of a new space. She solicited money from Paul and Beck Strand and a few other investors, and in December 1929, An American Place opened in a new office building on Madison Avenue. Stieglitz authored its manifesto: "No formal press reviews, no special invitations, no -isms, no theories, no game being played."

Norman had realized her dream of being indispensable to Stieglitz. She managed the gallery, wrote the bills, kept track of the exhibition artwork. O'Keeffe banished herself. The only time she set foot in the place was to hang the shows, which Norman had neither the skill nor guts to do.

Once again Mabel Luhan had invited O'Keeffe to Taos for the summer. O'Keeffe agonized over her decision, remembering how tortured Stieglitz had been the summer before. But she was still and always a feminist. That same year she had participated in a public debate with Michael Gold, editor of *New Masses*, during which he excoriated her for failing to take up the cause of the oppressed* in her art, and she coolly informed him that women were among the oppressed and always had been, and that as a woman expressing a female aesthetic—just read the critics!—she was furthering the cause of all women. He blustered and quoted Karl Marx, or one of those guys. She

* The art of the Depression was rife with images of those stricken jobless, breadlines, and misery. O'Keeffe's always-personal subject matter seemed distinctly out of step with the times.

said she thought perhaps he was simply confused, and invited him to come to dinner with her and Stieglitz.

Still, when it came to her personal life, things weren't quite so cut and dried. O'Keeffe had not wanted to get married, but now that she was, she felt like a "heartless wretch" to just up and leave her husband for months at a time. She wasn't such a modern wife that she could justify leaving simply because he was cheating on her. It didn't seem right to go, but she couldn't forget the euphoria of the previous summer, the sense of coming back to what was truest about her, every day.

Before leaving for Taos, she made a special trip to Lake George to open the house for the summer. She was frustrated, wounded, anxious, and guilty. Still, her habits of creativity were deeply ingrained. While taking a walk in the woods near the lake she stumbled upon a patch of maroon and green jack-in-the-pulpits.* Always up for proving to the world that her paintings were not actually lady parts, she knocked out six oils of the phallic jacks, each one more abstract than the one preceding it, and left them in the care of Stieglitz. The paintings, which would become among her most admired, were a reminder: She was neither young nor wealthy, but she could paint, the one thing Dorothy Norman would never have on her.

After she arrived in Taos, O'Keeffe didn't stay long at Los Gallos. Mabel required intrigue. She suspected her female guests, including O'Keeffe, of angling to steal handsome, chivalrous

* So named because the spadix is overhung with a striped, lifelike structure that makes the flower resemble a minister (named Jack?) preaching from a pulpit.

Tony away from her. Georgia and Tony had developed a genuine friendship: Both were silent types who loved the land and could ride on horseback for hours without talking, but there was nothing else between them. O'Keeffe couldn't stand the drama, and decamped to a nearby inn. Mabel was furious and disinvited her from a special night of entertainment, arranged with difficulty by Tony. A group of peyote singers were coming from the pueblo to perform at one of Mabel's soirees. When Tony heard that his wife had told Georgia she was no longer welcome, he refused to go, which enraged Mabel even further. On and on it went.

O'Keeffe really couldn't have cared less about what went on in Mabeltown. She painted like she was possessed, which she was. Mountains and foothills, black crosses, pueblos, adobe churches, and always, flowers. Stieglitz, for his part, had calmed down considerably. He spent the summer in Lake George playing miniature golf.

Once again, their reunion in the fall was sweet, as was becoming their custom. He made some pictures of her holding a cow skull she had sent back to New York. He didn't think the skull-and-bones phase would last. It was simply too weird.

Dorothy Norman had a second baby. Since O'Keeffe carried on as if nothing were going on, Stieglitz took no pains to hide his concern for Norman and his interest in her pregnancy, nor his sympathy pains. One can only imagine O'Keeffe's cold fury and sense of injustice: Stieglitz had denied her a child, yet here he was behaving like an expectant father. Maybe he

was an expectant father. Given the amount of times per week Alfred and Dorothy were knocking it out, it's hard to believe he wasn't, but Edward Norman, who'd studied at the O'Keeffe Institute for Turning a Blind Eye, claimed the child as his own.

That year, O'Keeffe bumped up her departure to April. She stayed in Alcalde, forty miles southwest of Taos, at H & M Ranch, owned by Marie Garland. Like Mabel, Marie was flamboyant, but less annoying. Every day for weeks on end O'Keeffe got up at dawn, hopped in her Model A, and drove until she found something she wanted to paint. It was the year she discovered Abiquiu, the village where she would one day own a house. She collected more bones: long thigh bones, horse skulls, entire vertebrae.

Meanwhile, Stieglitz had adjusted to his bachelor summers quite nicely, thank you very much. He who had spent decades proud of his refusal to travel anywhere, except Lake George, visited Dorothy and her husband at their summer home in Cape Cod. He shamelessly trumpeted his adoration of Norman. Even Margaret Prosser, the housekeeper at Lake George, got an earful about "the full-hipped Child-Woman with soul-brimming eyes . . ." Naturally, O'Keeffe was kept in the dark.

Stieglitz had had lovers before, most of whom wound up naked before his lens, but he'd never embarked on a big photographic portrait like the one he'd made of Georgia when they had first become lovers. Now, he began one of Dorothy Norman. That fall, not long after Georgia turned forty-four, history repeated itself. One day O'Keeffe, who had been at

Lake George, returned to New York earlier than expected to find Stieglitz in their apartment at the Shelton, photographing Norman in the nude. Georgia was not Emmy; she was not going to offer an ultimatum. Her natural defense mechanism wasn't hysteria but stone-cold silence. Even though she was supporting Stieglitz by now and could have easily thrown him out on his ear, she refused. I yearn to believe her behavior was mystifying, but I suspect I've fallen prey to Hollywood movie logic, where the only acceptable response to such betrayal is to stuff his clothes in a suitcase, always inexplicably at hand,* and throw it out the window. Instead, O'Keeffe did what she always did: She left.

In February 1932, Stieglitz opened a forty-year retrospective of his work. Prominently displayed were pictures of the new Woman-Child in town, next to some new ones of O'Keeffe. Georgia was handsome and interesting-looking, but Dorothy was young. Also, when Stieglitz photographed Dorothy, he instructed her to whisper his name over and over, to capture the proper expression of adoration.† The result was as you might imagine: The Woman-Child looked dewy and innocent, and O'Keeffe looked like the "before" picture in an ad for banishing fine lines.

Georgia fought back in the only way Georgia could: She created a new aesthetic, completely disavowing Stieglitz's influence. The one thing that had always united them was

* Instead of stored in the basement behind the Christmas decorations and camping gear.

† I'm told this paper will not dissolve if you vomit on it.

their art, their ability and willingness to influence one another's work. By the mid-1930s, O'Keeffe's art was completely her own. She might not have been divorced from Stieglitz, but her work was. In midlife, she reinvented herself, just as the current crop of women's magazines advises.

O'Keeffe's fascination with clean, elegant bones was not a passing phase. "To me they are as beautiful as anything I know . . . The bones seem to cut to the center of something that is keenly alive," she said in one of her increasingly frequent interviews. She painted a horse skull with a powder-pink rose resting jauntily in one eye socket* and a cow skull floating over low red hills, red and yellow flowers suspended in the clouds behind it.† As with her erotic-wait-they-are-erotic-right? abstractions of twenty years earlier, the critics weren't sure what was going on. Dead animal bones? Seriously? And in the same way that back then the theories of Freud were on everyone's mind, so O'Keeffe paintings must be Freudian, now surrealism was all the rage, which meant her work must be related somehow to Salvador Dali's melting clocks or René Magritte's large, lone hats. This isn't to say O'Keeffe wasn't influenced by the times, but even as she came into her own, and was gradually being acknowledged as the weird and singular genius that she was, it was still difficult for the critics to believe she came up with this stuff all on her own.‡

* *Horse's Skull with Pink Rose* (1931), Los Angeles Museum of Contemporary Art.

† *Summer Days* (1936), Whitney Museum of American Art, gift of Calvin Klein.

‡ Historian and critic Lewis Mumford did allow that "O'Keeffe uses themes and juxtapositions no less unexpected than those of the Surréalistes, but she uses them in a fashion that makes them seem inevitable and natural, grave and beautiful."

A marriage is a civilization, the couple at the center of it, king and queen. When it falls apart, the entire population suffers. In 1932 Stieglitz opened a show featuring the work of his old friends, Paul and Beck Strand—his photographs and her paintings. Dorothy Norman disapproved of them both. She felt that Beck was a bad influence on Georgia (who, by running off to Taos, had caused Stieglitz to suffer), and Paul was a schlemiel to put up with her. She didn't like their art, either. And so their exhibit, which was not even given a catalog, flopped. Strand turned in his key to An American Place, which he'd helped found, and the twenty-five-year-long friendship between him and his mentor was over.

The degree to which O'Keeffe was saddened by this, on top of everything else, is unknown. She believed in forward motion. She believed in living life in the moment, long before the Beatles went to India and returned to the West with a bad case of Eastern thinking. Years passed. Things got worse. No one said a word. Sex is merely sex. Love, too, is mere. Stieglitz, not satisfied with Norman's role in his life as patron, office manager, and lover, gave her a camera. To fully replace O'Keeffe, she needed to be an artist, too.

Stieglitz had hated museums since he was a young man working to convince the establishment that photography was art. His loathing intensified in November 1929, when the new Museum of Modern Art opened on the twelfth floor of a new building on Fifth Avenue and 57th Street. The founding members were three women who had married money: Abby Aldrich

Rockefeller (wife of John D. Rockefeller Jr.) and two of her art-loving friends, Lillie P. Bliss and Mary Quinn Sullivan. Stieglitz was hurt and enraged that these . . . these . . . *ladies* would dare to open a museum of modern art without including *him*.

He'd been slightly appeased when the museum's second show, *Nineteen Living Americans*, included pictures by his artists—Demuth, Marin, and O'Keeffe—but then, in the spring of 1932, O'Keeffe was invited, along with sixty-four other artists, to submit a proposal for a mural show. Without breaking a sweat, and without consulting him, his wife whipped out a cubist-inspired red, white, and blue skyscraper-scape, with a few trademark O'Keeffian flowers tossed in for good measure. The show bombed, but O'Keeffe's contribution was praised, and she was offered another commission: A brand-new performance venue called Radio City Music Hall asked her to paint a wall in the ladies' lounge. She would be paid $1,500, the same amount as every other contributor.

Stieglitz was so furious it's amazing the stroke that would kill him years later didn't drop him in his tracks there and then. Where to start? He despised murals—he called them "that Mexican disease"—and all that Diego Rivera peasant, man-of-the-people stuff that went with them. He was angry that Georgia had allowed herself to appear next to a bunch of hacks in the MOMA show, and then, even worse, that she would go behind his back and accept a commission to paint the bathroom wall* in a place of commerce, and then accept

* !!!

the paltry sum of $1,500, when he, the great Stieglitz, had spent decades carefully managing the outflow of her artwork, and making sure he placed each work with the most appropriate, appreciative collector, massaging the prices ever upward as her fame grew. Even worse, she did all this *on her own*.

When O'Keeffe informed him of the project—can't you just see her folded hands and smooth forehead, his eyes bulging out of his head like a cartoon character, with the accompanying sound effect spelled, I believe, *aooooooooga?*—he marched over to wherever he marched over to—the designer's office? the project headquarters?—and demanded that the agreement be nullified, saying that his wife was a child—not even a Woman-Child—and had no idea what she was doing.

The Radio City Music Hall people were unmoved. O'Keeffe had signed a contract. The next day, Stieglitz revised his request: His wife would paint the ladies' lounge for free, but she would require $6,500 in expenses. But the sway Stieglitz had held in the world of New York culture was no more. All those images he and his circle of artists had made, depicting the dehumanizing effect of unparalleled urban growth and the rise of technology, really did reflect the reality of the modern world. The contract stood.

In September 1932, O'Keeffe was set to begin work painting the mural, but construction was behind schedule. The room still wasn't ready by November 15, her forty-fifth birthday, even though the hall was scheduled to open for the Christmas season. O'Keeffe was given the go-ahead to begin sketching her mural, but as she began, the canvas started peeling off the

wall. Or, she was standing in the room having a conversation with the designer, and the canvas started peeling off the wall. However it went down, the canvas came away from the wall.

Then, she either marched out, as was her custom, or burst into hysterical tears, which, then and now, makes men nervous. O'Keeffe did suffer an eventual breakdown, but not then. She was well enough to travel to Lake George the next day to prepare for her December show, and also to return on her own to Manhattan. But Stieglitz, thrilled to have an excuse to break the contract, called the Radio City Music Hall people the very next morning and said his wife had suffered a complete nervous breakdown and had been admitted to a psychiatric hospital. Although this was untrue, the Radio City Music Hall people—smelling too much crazy somewhere in the mix—released O'Keeffe from her obligation.

A few months passed. Georgia complained of skull-splitting headaches. She couldn't sleep or eat. She couldn't stop crying. In February 1933, she was admitted to a swanky facility called Doctors Hospital under the care of Alfred's doctor brother, Lee. The initial diagnosis was early menopause, but Lee must have known that was bogus, because his first order of business was to forbid his brother to see her. After a month, Alfred was allowed to visit Georgia for ten minutes a week. Meanwhile, An American Place, which was apparently now also in the business of legitimizing Dorothy Norman as an artist, published a book of Norman's poetry, after no publisher* would touch it.

* Alfred had written to a number of them on her behalf, trying to persuade them that Norman was a poet on par with O'Keeffe the painter.

At the end of March, O'Keeffe was declared recovered. She couldn't bear the thought of going home, so she went to Bermuda for a few months. There, she swam, walked on the fine sand beach, and bicycled to the point of exhaustion. She didn't go to New Mexico that summer, but instead holed up at Lake George. Stieglitz came and went. The housekeeper fed her and she ate and ate. She slept late and got fat.* She didn't draw or paint. Her "recovery," it seemed, was a lateral move into clinical depression.

In the midst of all this *mishigas,* Stieglitz faithfully opened an O'Keeffe exhibit every year. One can't help but think this was his guilt at work, even though he maintained to the end that he wasn't doing anything wrong, that he loved Dorothy because she was Woman, and to him Woman was God, and by worshipping her he was only . . . I can't go on. You get the idea.

Anyway. In January 1933 he showed a few dozen oils, but there was no new work. During his weekly visit to O'Keeffe, he brought pictures of the exhibit, the packed gallery, the admiring crowd. The next year, 1934, there was still nothing new. The show was announced as a retrospective, focusing primarily on the early abstractions that Stieglitz loved. The *New Yorker* reviewed the show and declared that Georgia O'Keeffe's work was universal. The hallowed Metropolitan Museum of Art purchased its first O'Keeffe: *Black Hollyhock, Blue Larkspur.* O'Keeffe was too bored and tired of her own self to really care.

* Well, for her; she was five-foot-five, and at her heaviest weighed 142 pounds.

How to Repair a Marriage that's Beyond Repair

1. Stay together and hope things improve before you kill each other.*

Arnold Newman, a photographer who made a name for himself by making arresting and revealing pictures of iconic artists and politicians, made a picture of Stieglitz and O'Keeffe in 1944 that's about the saddest picture of a pair of famous people I've ever seen. She's sitting in a chair facing sideways, her chin slightly lowered, eyes cast down, looking defeated. He stands facing the camera, wearing his black cape and holding a book, his hair thin and white and flyaway. He glares at the camera as if to say, "It's not my fault," or, possibly, "How on earth did this happen?" The same year O'Keeffe completed a modest pastel of two gray rocks on a pinkish-coral background. O'Keeffe almost never gave her work titles that contributed anything to their interpretation. A *Calla Lily* was a calla lily, the *D. H. Lawrence Pine Tree*, just that. She called this little pastel, *My Heart.*

Life wasn't notably bad for Stieglitz and O'Keeffe that particular year, but the picture seemed to be an expression of all the difficult years that had come before; they simply looked

* I realize I've violated the rule of outlines by having a "1" without a "2," but alas, there is nothing else to say here.

wrung-out. Indeed, by the time this picture was taken she had mostly recovered, in no small part because she now had a new love: Ghost Ranch.

I have the same misgivings about introducing Ghost Ranch as I had about introducing Stieglitz in an earlier chapter: Once you start talking about O'Keeffe's mad love for this part of New Mexico,* those hundreds of paintings of red and yellow sandstone cliffs, the flat-topped Pedernal Mountain, the purple hills, the blue hills, the gray hills, and the rest of the breathtaking stuff out there† take over the narrative. The semi-mystical terminology starts creeping in: the White Place, the Black Place, the Faraway Nearby.

The semi-crackpot anecdotes assert themselves. "What are those people doing in *my* house?" O'Keeffe demanded of the ranch's owner, Arthur Pack, in 1936, when she arrived unannounced and a family was renting the cottage she'd rented the year before. "It's my private mountain," she said of the Pedernal, which she could see from the windows of the house she eventually purchased from Pack in 1940. "God told me if I painted it often enough I could have it." In marched the esteemed photographers—Cecil Beaton, Philippe Halsman, Todd Webb, Horst—to codify her solitude, her regal, aging face. The black dress. The black hat. The cow skull hung on the wall. In rushed the gaggle of lifestyle magazines to rave about the chicness of O'Keeffe's houses and decor. Once you start talking

* Ghost Ranch is located in the northeastern corner of the Piedra Lumbre, a high desert valley about seventy miles north of Santa Fe.

† I'm more of an ocean person.

about Ghost Ranch, it's hard to see the woman inside O'Keeffe the Icon.

After she found and fell in love with Ghost Ranch, poor old Stieglitz—and by now, he *was* old—and creepy Dorothy Norman,* and everything else that went on in New York no longer concerned O'Keeffe. She spent the winters in New York with Alfred out of a sense of duty, or because she felt obligated since he had done so much to launch her career, or because of a shared history. She fussed over his clothes, sewing buttons on old shirts and seeing that his suits were faithfully copied, as they always had been. Now that she'd made a life all her own, a strange thing happened: She enjoyed his company once more.

In 1936, the Elizabeth Arden Beauty Salon commissioned O'Keeffe to do a painting for the exercise room. Although this was no more elevated than the ladies' lounge at Radio City Music Hall, O'Keeffe asked Stieglitz to take care of the business end. He negotiated a staggering $10,000 for her fee, about twice what her paintings were going for at the time.† She painted a big, sexy, spirited jimsonweed and everyone was happy.‡

Despite all their insane letter-writing, O'Keeffe and Stieglitz were visual artists; she was his artist, he her manager and promoter, and it was in this realm that they made their apologies. They moved from the Shelton Hotel that year as well, to a penthouse on East 54th Street. Georgia had tired of

* For her side of the story, read *Encounters: A Memoir.*
† Inflation reality check: A good upper-middle-class salary at that time was about $4,000 a year.
‡ *Town and Country* ran a piece on it called "Beauty Is Fun!"

living in a hotel, and also felt she needed more space to work. The lease was in her name. Stieglitz grumbled: He felt it was too fancy. It had a terrace and a view of the East River. Georgia was unmoved by his protestations. She was going, and he was welcome to come along.

The same year, Henry R. Luce founded a new kind of magazine, focused not on words but on pictures. The arrival of a lightweight, compact 35mm camera had led to the advent of something called photojournalism, and *Life* magazine was created to celebrate photojournalists and their images. Did Stieglitz ever imagine photography, which had at one time been written off as a passing fad, would catch on this way? Was he gratified, appalled, or jealous because the art he had legitimized had, like his wife, ultimately escaped his control?

In 1938, *Life* did a four-page spread on O'Keeffe, with pictures by her friend Ansel Adams, declaring her "the most original painter working in America today," and borne out by a large, alarming picture of O'Keeffe wearing jeans and a cardigan,[*] holding a full cow's vertebrae with ribs attached (I counted nine) in one hand, and a cow's head in the other. This is not a clean, sun-bleached skull, but the head of a cow dead no more than two weeks.[†] Even in the grainy black-and-white photo you can see the matted curls on its cheeks, the eyes staring vacantly.

[*] Interesting to see her in a pair of pants, but that's not the alarming part.

[†] According to Jerrod, who once worked as a mobile slaughter guy in the Ojai Valley for about a year, the head could actually be mummified, but as it still has its lips, this is unlikely. Furthermore, he feels the vertebrae and the head probably belong to two different animals.

The caption reads IN NEW MEXICO O'KEEFFE GETS MATERIAL FOR A STILL LIFE BY LUGGING HOME A COW'S SKELETON.

Perhaps this is an appropriate, if grisly, metaphor for what can happen in a marriage when there's no premium placed on communication or honesty. At first, it's a sweet, big-eyed calf swishing its tail, so cute, then it ages and gets less cute, and eventually it dies and the buzzards swoop down and feast on the rotting corpse. Time passes, the bones are picked clean, and it becomes once again a thing of beauty, albeit seriously pared down. If you can stand the buzzards, you might wind up with the sort of fond friendship O'Keeffe and Stieglitz shared in his later years. On the other hand, maybe she's holding *his* dead and rotting metaphorical head.

In 1938, at the age of seventy-four, Alfred suffered a heart attack, followed by a case of double pneumonia. O'Keeffe nursed him most of the summer, until he was well enough to be looked after by Margaret Prosser, who had worked for the Stieglitz family at Oaklawn, when she was still in her teens. Stieglitz begged O'Keeffe not to go, but it was too late for that. New Mexico had claimed her heart, and even though she said she felt like a heartless wretch for doing so, she left.

During the last years of Stieglitz's life, their letters to one another were especially affectionate. They'd developed the habit of writing many letters in advance of her yearly departure for Ghost Ranch. She would hide hers around the apartment for him to stumble upon, and he would mail his in advance, so they would be there when she arrived. "I greet you on your

coming once more to your own country," he wrote, "I hope it will be very good to you . . . I'm with you wherever you are. And you ever with me." During Georgia's long absences Stieglitz kept regular hours at An American Place, even though the gallery had few visitors. Stieglitz had become a relic. He often napped on a cot in the back office, and on his desk he kept a single red flower stuck in a water glass, to remind him of Georgia.

". . . I will be thinking of you all through the night and all through the days," she wrote to him.
"You will be with me in my country
I will be with you here
Be good to your self for me—
It means so much for me—
But I need not say—
You know without my saying—"

Shortly before Stieglitz's death, the Museum of Modern Art, his old nemesis, opened a show of Georgia's work, the first retrospective of a woman artist in its history. Alfred wrote: "Incredible Georgia—and how beautiful your pictures are at the Modern . . . Oh Georgia—we are a team."

The summer of 1946, while O'Keeffe was in New Mexico, Stieglitz suffered a stroke while sitting at her desk reading one of the letters she had left for him. O'Keeffe received the telegram while she was grocery shopping in Espanola, a small town about forty-five miles south of Ghost Ranch, and drove straight

to the airport. She arrived at Doctors Hospital to find Dorothy Norman at his bedside. The two women took turns sitting vigil, but O'Keeffe was there when he died, the morning of July 13.

I wish I could report that O'Keeffe, in her role as legal wife and Most Famous Woman Artist in America, took the high road and simply snubbed Norman, or looked right through her using the Native American blank-gaze-of-belittlement she'd picked up from Tony Luhan. Instead, she behaved badly. She was silent until the day after the funeral, then she called Norman and told her that by the fall, she needed to get her shit out of An American Place, and she didn't care about the lease being in Norman's name, or about the stupid rent fund Norman had been maintaining all these years, or about anything Norman had invested in the gallery or Stieglitz.

Norman tried to explain that she was also grief-stricken and heartbroken; O'Keeffe's response was to tell Norman she thought the affair she'd had with her husband was absolutely disgusting. She wanted Norman *out*. People who had been friends to both Stieglitz and O'Keeffe were stunned at her behavior, at her lack of grace and generosity in the face of death, but she didn't care. She was, after all, a heartless wretch.

O'Keeffe traveled alone to Lake George, to scatter Stieglitz's ashes. With cupped hands she carefully scattered them among the roots of an old tree, but never revealed the exact location to anyone. Sixty years later, in 2006, a 1919 palladium print of those same hands, which Stieglitz had found to be so ethereal and hypnotic, sold at auction for $1.47 million.

Georgia O'Keeffe
American (1887–1986)
Above the Clouds I, 1962/1963
Oil on canvas, 36⅛ x 48¼ in.

Gift of the Burnett Foundation and the Georgia O'Keeffe Foundation

Photograph by Malcolm Varon, 2001

The Georgia O'Keeffe Museum, Santa Fe, NM

Georgia O'Keeffe Museum, Santa Fe/Art Resource, NY

10

PRIZE

There is a bit of a bitch in every good cook. [*]

IN 1949, THE SOVIET UNION DETONATED ITS FIRST ATOM BOMB, and the People's Republic of China was officially proclaimed by Mao Tse-tung. In Paris, Samuel Beckett was putting the finishing touches on *Waiting for Godot*. *South Pacific* opened on Broadway, and *All the King's Men* was in movie theaters. Americans were buying one hundred thousand television sets a week, and the first Polaroid camera went on the market in New York, and sold for $89.85. Gene Simmons, lead singer of the rock band Kiss, was born. Georgia O'Keeffe, aged sixty-two, moved to New Mexico for good. That August, she was elected to the

[*] A note O'Keeffe wrote to herself inside the front cover of one of her cookbooks.

National Institute of Arts and Letters, over the protestations of "the men."*

It had taken O'Keeffe three years to settle her husband's estate. There was the predictable tussling over the will with Dorothy Norman, but in the end Georgia won out, and with ferocious care saw to it that each one of Stieglitz's 850 pieces of art, thousands of photographs, and tens of thousands of letters, found the perfect home. We forget, or at least I do, that in addition to his seminal roles in photography and the modern art movement, he was also a prodigious collector. He owned Picassos, Matisses, and Rodins. He owned hundreds of Marins, Doves, and Hartleys, as well as some good pieces of African sculpture. Long before there was a voluntary simplicity movement, O'Keeffe was an adherent. She didn't believe in owning a lot of stuff. She gave away everything, keeping only a few paintings from her old cronies—Hartley, Dove, and Marin—for her collection. Stieglitz's letters, totaling 50,000 pages, all went to the Collection of American Literature at the Beinecke Rare Book & Manuscript Library at Yale.

The majority of the art collection went to the Metropolitan Museum of Art to which O'Keeffe also wanted to donate Stieglitz's "key set."† The curator had an issue with the irregular shapes and sizes of the mats, which Stieglitz had cut in

* These were a new set of nay-saying males. The notable objectors were the painters Edward Hopper and John Sloan.

† A complete collection of the best existing prints of a mounted photograph in a photographer's oeuvre. Like everything else about Stieglitz, his key set was monumental, numbering 1,642 photos.

relation to the individual size of the print. To accept the gift, the mats all needed to be the same size for ease of storage. When O'Keeffe objected, the curator said that this was standard, and that even their Rembrandts had been altered this way. O'Keeffe said, "Well, Mrs. Rembrandt isn't around, is she?" Neither side would give in, and in the end O'Keeffe gave the key set to the National Gallery of Art.

Eventually, everything had been sorted and cataloged and photographed and placed, and O'Keeffe, as her parting farewell to the city she'd tolerated but never loved, did a painting of the Brooklyn Bridge. The focus of the painting is the bridge's Gothic arches, placed side by side on the canvas. They look like a pair of tall, vacant eyes.

O'Keeffe Goes Domestic

One of the reasons O'Keeffe was so remarkable during the last four decades of her life is that her life stages had been reshuffled. Her twenties were spent in the same way many young adults today spend these early years of adulthood: taking random jobs, moving hither and yon, believing fervently that this guy's The One—no, this one . . . no, this one. When she moved to New York on impulse to be with Stieglitz (another classic young-adult maneuver), she skipped the young-married business that consumes most of us in our thirties and early forties—buying a house, making a home, getting a kitten or a puppy, having babies who grow into children who need

school supplies, after-school snacks, bedtime rituals, cooking endless meals for a growing passel of ingrates, remodeling, redecorating, and eventually, caring for your elderly parents (husband)—and skipped straight to being an Empty Nester Treating Herself to an Intensive Art Retreat, living in other people's flats, Elizabeth's tiny studio, Lee's brownstone, and then a hotel,* eating meals out, arranging her living space according to her creative requirements, taking off on a whim to Maine, Bermuda, New Mexico, wherever.

After the death of Stieglitz, when O'Keeffe moved to Ghost Ranch, the demands of living in what was essentially the wilderness, forty-five miles on a dirt road from the nearest town (Espanola), and sixteen miles from the nearest telephone and general store (Abiquiu), pressed her into joyous domesticity.† O'Keeffe was sixty-two, and because she hadn't already logged thirty years of wondering what smells at the back of the refrigerator, and how can the roof be leaking when the guy was just out to repair it, and how on earth can it be time to make dinner when we just ate lunch, and so on and so forth, she was delighted by homemaking. She was not only fresh for the task, but was also now a rich widow, and had the deep pockets required for living a life of elegant, rustic simplicity that people, then as now, covet.

* Pretty much the dream of every middle-aged woman I know, who's had it with worrying about the state of the water heater and who the fuck is going to mow the lawn (not me, that's for sure).

† An oxymoron in my book, but I realize this is not a view shared by everyone.

Food became important to her as never before. She was friends with health food "nut cake"* Adelle Davis. In 1947 Davis published *Let's Cook It Right*. Before Michael Pollan had his omnivore's dilemma, Davis was a proponent of eating organic fruits and vegetables and avoiding processed food. O'Keeffe was on board. She was a confirmed locovore, before anyone knew what that was. She† grew two acres of organic fruits and vegetables. When an infestation of grasshoppers threatened to ruin her crop, she bought a gang of turkeys to solve the problem. She thought sugar could kill you. She believed in whole grains. She ground her own flour, purchased eggs from the neighbors. The most exotic item in her pantry was brought by her sister, Claudia, when she came to visit in the summer: alligator pears (avocados) that grew on a tree in her yard in Beverly Hills, California.

Her average day in meals looked like this:

Breakfast: Whole-grain bread, fruit, some kind of meat, teas

Midmorning snack: Homemade yogurt or protein drink

Lunch: Salad, made from whatever was ready to harvest in the garden

Dinner: Fruit and cheese

* My mother's word, a cross between "nut job" and "fruit cake."
† With a lot of local help, it must be continuously noted.

❧

In addition to the Ghost Ranch home, O'Keeffe also owned a place twelve miles down the road in Abiquiu. When she had first glimpsed the Spanish-style house during one of her summer visits in the mid-1940s, it was being used as a pigsty by the local Catholic parish. The house was in such disrepair that the traditional adobe was crumbling back into the earth from which it was made. O'Keeffe purchased the building for a dollar, and spent four years overseeing its heroic restoration.

The rigors and expense of this cannot be overstated. For the job, O'Keeffe hired a young woman named Maria Chabot, a free-spirited jill-of-all-trades who wanted to be a writer, but wound up doing just about everything else, as often happens, including acting as O'Keeffe's general contractor. Open their massive (542 pages) collected letters* at random and you will come across phrases like, "I had eight men lined up for wall building today. . ." and "I will plant the apples, the plums, the apricot and the weeping willow—and we will see if they will grow" and "There is a large crack in the studio west wall." You get a sense of the magnitude of the undertaking. Before O'Keeffe moved to New Mexico, Chabot stayed on, investigating, for example, how they might drill for water at the Ghost Ranch house, or how to install a butane gas system. Chabot, who was in love with O'Keeffe, would have worked for free, but O'Keeffe insisted she accept a stipend, advising her that

* *Maria Chabot–Georgia O'Keeffe: Correspondence, 1941–1949,* edited by Barbara Buhler Lynes and Ann Paden.

for artists, it never mattered where the money came from, as long as it gave you time to work.

O'Keeffe Style

Once the houses were made livable, she decorated them with impeccable, mid-century style that looks as chic right this minute as it did back then. Also, in a move that belies the image that her husband had so carefully tended—that of a naive Woman-Child from the heartland who lived according to her feelings and intuition—O'Keeffe set aside an entire room in Abiquiu for her book collection, three thousand volumes, everything from a large assortment of cookbooks to first editions of French modernists.

Sometime during the fifties writer Christopher Isherwood visited her and marveled at the "Zen simplicity" of her environment. As we now know, any decor worthy of the adjective *Zen* is aesthetically, morally, and spiritually superior to whatever hodgepodge of Pottery Barn, IKEA, neighbor's-garage-sale thing you may currently have going on. Fortunately, emulating O'Keeffe style is not outside our reach.

The less furniture the better.
Time to get rid of that love seat you rescued from the neighbor's garbage in 1997. If you have not sat on a chair, or put a glass down on a table for a week, get rid of it. Empty space always trumps something stuck there just because you can't think of anything else to do with it. Once you've gotten rid of

the dust bunnies, and your rooms are beautifully empty, pur-
chase an Eames chair, or a Le Corbusier–style lounge chair.*

Paint the walls white.
If it's in your budget, hire a team of Hopi women to come in
and apply mud plaster to the interior walls. They can pat your
walls into a homely, earthy sheen like nobody's business.

Have as many fireplaces as possible.
O'Keeffe had seventeen, combined.

Bring the outside in.
Collect some beautiful stones and stick them on window
ledges. Wash them often: Nothing makes a rock look less like
an *objet d'art* than three weeks' worth of dust. Go wild and
hang a cow skull on the wall, but only if you can bear being
completely unoriginal. No one in her right mind, aside from
O'Keeffe, can live with one of those things staring at her day
in, day out. Splurge on one great piece of art.

Get a Calder mobile and hang it in your bedroom, where
only you and a select few can enjoy it. This is key: The point
is not to display art, but to live with it. Your bedroom should
be the most austere room in the house, your own private art
museum. Use only white linen. Cover one wall with one of
your own masterpieces, if possible.†

* No one ever said Zen simplicity was cheap.
† Georgia chose one from her abstract *In the Patio* series.

Georgia O'Keeffe, American, Sees the World

In the fifties, travel replaced painting as O'Keeffe's primary occupation. Her final show at An American Place, which she'd kept open after Stieglitz's death against the advice of people with a more finely honed business sense, *Georgia O'Keeffe: Paintings 1946–1950*, opened in October 1950 to the unthinkable: No one paid attention. There were a few small notices, but nothing like the old days, when the Men would go on and on for many column inches.

Many of the paintings, particularly those of the square patio door in her house in Abiquiu, were in keeping with Abstract Art, which was enjoying its heyday in New York; still, critics didn't make the connection between her work and that of, say, Clyfford Still or Mark Rothko. O'Keeffe was just O'Keeffe, doing her weird O'Keeffe thing. It mattered not that she had been painting abstractions since the early teens. She knew the show was good, but few people came; her star had dimmed, it seemed.

O'Keeffe's reaction was unexpected: She got the travel bug and embarked on the kind of trips we all say we're going to take, then never do. She drove through Mexico with Eliot and Aline Porter: Mexico City, Cuernavaca, Oaxaca. They met Diego Rivera and Frida Kahlo. With Rose Covarrubias, wife of illustrator Miguel Covarrubias, who years earlier had done a caricature of O'Keeffe for *Vanity Fair*, she hopped on a plane and flew to the Yucatan. They watched the sun rise at Chichén Itza.

In 1953, when O'Keeffe was sixty-five, she finally got to Europe. One of the most famous painters in America could no longer say she'd never been to Paris. Like everyone the world over, she made her obligatory pilgrimage to the Louvre, only to leave with the same tired feet and slight headache. She liked the Fra Angelicos. She was happy to meet Alice B. Toklas, the longtime companion of the late Gertrude Stein, but she didn't think it necessary to make the acquaintance of Picasso, claiming they didn't speak the same language.* In Spain she went to the Prado and to the bullfights. She loved the country; their brand of morbid Catholicism appealed to her. As did the bad vibes of Peru. She was there for two months in 1956. She was stunned by the grim, malevolent-seeming Indians, the jungle-choked mountains shrouded in dark mist.

When she was seventy-one she flew around the world with a small tour group. I see that I've made it sound as if she set out on her own. As intrepid as she was, she always had a companion. One of her favorite traveling buddies was Betty Pilkington, the daughter of the man who owned the gas station in Abiquiu.

Tokyo, Hong Kong, Taiwan, Saigon, Bangkok, Phnom Penh. She spent seven weeks in India. For some reason this gives me pause: Fastidious O'Keeffe, who only liked salads made from the red-leaf lettuce and watercress grown in her own garden, who cultivated clean, bright empty spaces, who was also seventy-one years old, and probably couldn't just sleep on any

* In more ways than one.

old bed, or satisfactorily use any old toilet, loved India. "I like the dirty places of the world," she once quipped.

Everyone who knew O'Keeffe as she aged said she was abrupt to the point of rudeness and increasingly obstinate and impatient with anything that was not to her exact specifications. Then I think of her negotiating the chaos of India for days on end, traveling in her flat shoes and black suit from Bombay to Kashmir to the foothills of the Himalayas, and I think she was simply a genuine introvert. She was direct and had no time for nonsense, both traits that are respected in men, but in women, not so much.

When she was seventy-four she took an eleven-day trip down the Colorado River with a gang of old friends and their children and children's spouses, including Tish Frank, the granddaughter of Mabel Dodge Luhan. By day they floated downstream in a raft, stopping in the afternoon so that O'Keeffe could hike along the ribbon of sandy shore in her red sundress and PF Flyers. During the 185-mile float, she occasionally manned the oars, saying that if she couldn't row, she shouldn't be there. It was sweltering. The sun felt hot enough to melt their scalps. Thunderstorms flooded their raft, the drops falling hard enough to hurt. O'Keeffe was in heaven.

O'Keeffe's Secrets to Aging Well

Even people who don't like O'Keeffe's work, or who only like some of O'Keeffe's work,* can't help but be amazed by the way

* Me.

O'Keeffe marched through her life with complete disregard for prevailing fashions. She was a beautiful woman who had no real interest in enhancing her beauty. She never wore makeup or dyed her hair. In 1936, when she painted *Jimson Weed* for the exercise room at Elizabeth Arden, Elizabeth insisted O'Keeffe submit to a makeover. She did, then promptly scrubbed all the makeup off. Which isn't to say she didn't take care of herself. Her lack of lipstick did not signal a lack of self-regard, which those of us who grew up with *Glamour* magazine find hard to accept.

It all comes down to the skin.

Like all of us, O'Keeffe was more insouciant about her skin care when she was younger. But, in 1929, at the age of forty-two, she was still baking herself for hours at a time under the New Mexican summer sun without a care. She was so ahead of the times when it came to food and exercise, you would think she would have figured out that daily, year-round sun exposure was turning her slowly into a piece of living, human jerky. In her fifties she got a hat, but by then the damage had been done. This did not, however, prevent her from taking care of her skin. She put cream on her exquisite hands, morning and night, and also used a special moisturizer on her face. She continued to do this long after she could no longer really see her face. We, of course, live in the age of SPF 9000. My larger point is that regardless how freckled we may become, how lined and spotted, it's good to take care of what we have.

Motion is the lotion.

O'Keeffe never abandoned her body, simply because it was growing older. She believed in the power of movement, whether through exercise or massage. She walked, hiked, gardened, rode horseback until she was in her seventies and after that, she was still of the opinion that you could add years to your life by walking a mile a day. When she was very old she measured the distance around her Abiquiu property with small stones; with every lap she moved a stone from one pile to another. Georgia was also an early devotee of Rolfing, a system of (excruciating) soft tissue manipulation* founded by Dr. Ida Rolf, meant to improve your posture and the way your body moves through space. Rolfing was big in the 1970s, and as I write this, is enjoying a resurgence in the form of a recent article in the *New York Times* Style Section. O'Keeffe would drive to Santa Fe for her monthly sessions.

Experience your experiences.

Perhaps O'Keeffe was just a woman of her time—by which I mean a time when it wasn't a character flaw to look your age; when women didn't swear off any activity that might cause a wrinkle; when we didn't spend all our free time and discretionary income doing whatever it takes to look no older than thirty-eight. An argument can be made—and I've made it—that looking young isn't just a matter of vanity: For women, still,

* According to Dr. Oz, it feels like someone is doing yoga for you. Against your will, I might add.

youth and beauty are our top currency. To be effective in our jobs, it's better to look young and beautiful; ditto to having the self-confidence to venture out and try new things, expand our horizons—all the things women's magazines advise women in midlife to do, failing to mention that unless you *do* look thirty-eight, you'll be attempting to strike out into a world in which you're viewed with near contempt for having the lack of self-discipline and bad manners to look middle-aged.

O'Keeffe, who looked fifty when she was forty, and continued to look fifty for the next twenty years, never would have deprived herself of experience for the sake of looking younger. To the end, she preferred to focus on how she *felt* over how she *looked*, while at the same time having enough self-respect to take care of herself.

During her final years she had a lovely companion, a young artist named Christine Taylor Patten. Once Patten heard O'Keeffe on the phone with a friend, saying, "They tell me I look good, like I have no right to look good. Everyone's mad at me . . . I have three more years until I'm a hundred."

O'Keeffe never lost her spunk, or her conviction that what she was up to at any given moment was somehow less important because she was older. This was also true of her fellow extreme seniors Katharine Hepburn and Coco Chanel. Hepburn lived to be ninety-six; Chanel, who smoked, died young at eighty-eight. Like O'Keeffe, they were skinny, busy, and irritated until they declined a bit, then died. They were active, didn't eat a lot, and followed their interests. They never

let anyone tell them what to do. They were always a bit pissed-off. I can only assume that this is the real recipe for longevity.

Georgia O'Keeffe is Alive and Groovy

The brief eclipse of O'Keeffe's career in the fifties ended in 1962, when O'Keeffe was elected to the American Academy of Arts and Letters. One of only five women, she was the lone painter. Four years later, in 1966, she became a Fellow of the American Academy of Arts and Sciences. *Vogue* ran a feature story on her in 1967. In an interview in the *Chicago Daily News* she said, "You turned page after page of beautiful young things leaping through the hay before coming to eight pages—eight pages!—of this old face. I thought it was rather grand."

Meanwhile, back at the only place that really mattered to her, her studio at Ghost Ranch, she was painting what would be the last great series of her career, *Sky Above Clouds,* seven paintings of clouds as seen from a jetliner at cruising altitude. The last painting in the series was the largest of her entire career. The canvas was twenty-four feet long and took four days, and a few assistants, to help stretch. When the painting itself began, O'Keeffe worked twelve hours a day, from dawn until dusk, working from top to bottom. She stood on a ladder, then a table, then a box, then a low chair, then lay on the ground. She was seventy-eight. Despite the fancy awards and the occasional magazine story, people wondered whether she had died. She would live another twenty years.

In 1970, the Beatles broke up. Earth Day was established. Four unarmed college students were killed by the Ohio National Guard during antiwar protests at Kent State. The Chicago Seven were convicted of having crossed state lines in order to incite a riot at the 1968 Democratic Convention, two years earlier. *Patton* won the Oscar for Best Picture, and the Whitney Museum of American Art mounted a career retrospective of the work of Georgia O'Keeffe. The show was arranged thematically rather than chronologically. There were her early abstractions in watercolor, charcoal, and oil; her landscapes of Lake George, Maine, and New Mexico; her flowers, cornstalks, clamshells, and skyscrapers; her floating skulls; her puffy clouds. O'Keeffe was eighty-three. To the opening she wore a gray silk suit and a pair of purple velvet slippers.

The second wave of feminism was on the rise. Is it any wonder that the same year *Our Bodies, Ourselves* was published, when women all over the country were gathering for consciousness raising parties, where not infrequently one of the activities included peering at their own cervixes with the aid of a make-up mirror clamped between their thighs, that the woman who painted all those abstractions about "what every woman knows," all those irises and pansies that reminded people of genitalia, who had chosen to live freely with a married man back when it was a serious scandal, and who also made her own money, became instantly and once again famous?

After the show at the Whitney, O'Keeffe gained sudden and powerful cred with the counterculture—both with feminists who worshipped (there is no other word) her as a

strong, independent role model, and with the back-to-the-land crowd who found the life O'Keeffe had made for herself to be properly cosmic and groovy. Letters arrived by the bagful, written by earnest young people who wanted advice on becoming an artist. She always said the same thing: Go work. When the feminists came calling, even though she was behind their cause long before they were born, she told them a version of the same thing: "Too much complaining and too little work." These women further annoyed her by wanting to celebrate her as a woman artist without realizing that she'd been spending her whole life fleeing from that limiting label.

She was unmoved by her inclusion in Judy Chicago's epic and still-impressive mixed-media installation, *The Dinner Party,** an imaginary banquet table set for thirty-nine of history's most creative and innovative women. Each leg of the triangle is forty-eight feet long, and each place setting is set with a chalice and china-porcelain plate fabricated in a manner representative of the woman's life. O'Keeffe's setting is a three-dimensional rendering of a vagina, with a nod to its flower-like qualities. As the most-contemporary guest at the party, her setting was also supposed to represent the distance women have come† since the first place setting, Primordial Goddess.

That sound you hear is O'Keeffe snorting with derision from her perch in Heaven. When art historian John Richardson asked O'Keeffe in an interview how it felt to be the only living

* Your mind can still be blown by this piece at the Brooklyn Museum.

† Then as now, we still have vaginas.

guest at the imaginary party she drolled, "You mean Chicago's still alive?"

The Last Lesson

One day in 1971, O'Keeffe walked out of a shop in Abiquiu and was surprised to see that the sky was dark and overcast. When she'd entered the shop, the sun had been blazing. Then she realized the sky was not dark with clouds; it was her eyesight. The doctor diagnosed macular degeneration. At eighty-four, O'Keeffe was going blind.

Since Maria Chabot had helped her make a life in this unforgivable part of the world, O'Keeffe had always had, in her employ, handymen, housekeepers, cooks, secretaries, and various assistants for special projects around her houses. Doris Bry, who'd worked for Dorothy Norman at the time of Stieglitz's death, had been hired away by O'Keeffe* to serve as her manager, and came to visit every year to attend to business. Her old friends, or the ones who were still alive (and to whom she was still speaking),† came to visit, as did her surviving sisters,‡ Anita, Catherine, and Claudia. Also, the longer she lived in Abiquiu, the more involved she became in the community. She employed as many local people as possible, and

* Georgia offered Bry more money. Bry was happy to take it. She found Norman to be undiscriminating in her taste and otherwise "slushy."

† Somewhere along the way O'Keeffe dropped Dorothy Brett, her compatriot from her early New Mexico years, because she felt she'd gotten too fat.

‡ Ida had died in 1961.

when the local basketball team needed to travel for an away game, she lent them her car.* They called her the Empress of Abiquiu.

Despite her well-burnished reputation as a lone woman living her life of Zen simplicity in the mystical high desert, there were always people around, and the guest rooms were usually full. She was never an easy employer. She was exacting, with an unforgiving sense of fairness, but she also had a tendency to want to draw people close, to become friends with her staff, to expect them to want to stay with her long after they were off the clock, to devote themselves to her. And they would do it, her housekeepers and cooks. They would be drawn in by the O'Keeffe mystique, would sit and sip orange pekoe tea out of china cups, and listen to music with her into the night, and sometimes she would talk about Stieglitz or share a memory of a time, now long ago, when she made a painting that now hung in a museum in New York, and they would be bewitched, as she had intended them to be. Then, the next day or week or month, when they'd failed to properly dress the salad, or inadvertently forgot to mail a letter, or had to get home to their child who had a worrisome virus, she would get angry, and that would be the end of them.

As she went blind, she became more inflexible and irascible. It's impossible not to forgive her this. Her eyes were her work, and her work was her life. She never complained. She

* She also built a gym, so the kids would have somewhere to play in the snowy winters, and donated $50,000 for the building of a new elementary school.

tried to make the best of it, painting the walls white, the better to be able to distinguish dark objects before it, and laid a white carpet in the studio of the Abiquiu house. Still, her eyesight deteriorated further; people were hired and fired.

In 1973 O'Keeffe hired a young man to do some odd jobs around the Ghost Ranch house. John "Juan" Hamilton, so called because he'd grown up in South America, where his father had worked as a Presbyterian minister, was a twenty-something poster child for 1970s counterculture America: a college dropout who'd just divorced his old lady, a ponytailed potter* rambling from town to town, in search of something or other. In 1955, Arthur Pack had given Ghost Ranch to the Presbyterian Church. O'Keeffe had suffered a slight freak-out, never having been much into the Presbyterians, and worried that her privacy would now be invaded. But over the years O'Keeffe had warmed to the new regime, and often people who worked at the ranch offices would help her out. Juan Hamilton, leveraging the connection of his minister dad, had been hired by the church, and one day he showed up at O'Keeffe's door looking for work. In no time at all he became indispensable to her.

Here is the last lesson: Even when we are very old, all the people we ever were still live inside of us. We are just as surprised as anyone to have thinning hair, strange spots on our skin, folds on our back, and failing eyesight. Her entire

* O'Keeffe was far too old to know that every one of that generation who ever successfully threw a pot in his high school art class considered himself to be a potter.

life O'Keeffe had harbored a weakness for dark-eyed men who were full of themselves. Her sister Claudia thought Juan was no more than a common gigolo, but O'Keeffe became enchanted. She wasn't a complete idiot;* when Hamilton would try to compare himself to Stieglitz, whom he resembled, she always said the two men had nothing in common but her.

Say what you will about Juan Hamilton (and people have said plenty), he kept O'Keeffe going and connected to the world. He introduced her to ceramics, which she could do by feel. He helped her to complete a book and participate in a documentary about her life. In 1982, he took her to a show in San Francisco where one of her rare sculptures was being exhibited. Hamilton guided her hands along the piece, a large, elegant black spiral of cast aluminum, to help her "see" it. He made her laugh, according to other people who worked for her during that time, and in his presence she began to wear colors, even though she couldn't see them.

In those last years, pilgrims arrived on a regular basis. Gloria Steinem brought a bouquet of red roses and was turned away. Calvin Klein showed up and was given lunch and allowed to nap on her favorite daybed. Pete Seeger came by and played a song for her on a flute made out of a bird's leg.

Where should we leave O'Keeffe? Perhaps in her studio, painting one last watercolor, a blue abstraction, every bit as mysterious and compelling as those she made in 1918. As

* Perhaps only 75 percent.

O'Keeffe's contemporary Dorothy Parker once said, "There are no happy endings." Georgia O'Keeffe died of natural causes in St. Vincent's Hospital Santa Fe on March 6, 1986. She was ninety-eight.

I couldn't write about Georgia O'Keeffe without seeing Ghost Ranch. As per our plans, we arrived the day after our stay at the Mable Dodge Luhan House in Taos. The ice crystals I'd seen falling from the sky that morning had become your standard issue history-making spring blizzard that afternoon. The windshield wipers couldn't keep up with the heavy flakes. The visibility was five feet, possibly six. At O'Keeffe's Ghost Ranch there were no blizzards in May, only sandstone cliffs rising up into the vast blue sky, only beauty so singular it couldn't help but transform you. We crawled up Highway 68, found the turnoff, and slithered up the slick, red-clay road to ranch headquarters, where we checked into the RV campground.

We were the only people in the place. We sat and watched the snow fall all afternoon. This was no spring squall. It could have been December. We could have been in any snowy place. By late afternoon the snow let up a bit and we went for a walk. The wet clay adhered to the soles of our boots until our feet became too awkward and heavy to lift. We took pictures of our boots—adobe platforms!—and of ourselves slipping and sliding in the mud, and of the cherry trees in bloom, covered in

snow, and of ourselves pretending to admire the nonexistent vistas. Then we scurried back to the RV, where we split a can of chicken noodle soup.

The next morning the western sky had cleared, and there was the Pedernal, blue-gray and flat-topped, looking both close and faraway, just as it did in O'Keeffe's pictures. We were eager to be on our way and hastily performed all the tasks traveling in an RV demands: pulling in the bedroom and the living area, stowing the plates and glasses. As we drove down the main road to the highway, we saw a man standing in the middle of a wide snowy flat taking a picture of the Pedernal.

As we got closer, the man turned out to be a woman. She was wearing black pants and a black jacket. We were the only vehicle for miles around. There were no cars parked by the side of the road, no horse standing around waiting for his rider. The Indians in this part of the world believe that the spirits of people who died here walk the land after they're gone. I don't believe it. I don't even like New Mexico much. I'm more of an ocean person. But as we approached her we heard something crash at the back of the RV. Jerrod pulled over to investigate. One of the cupboard doors hadn't been closed properly and a can of soup had fallen out.

Within minutes we were back on the road, but the woman in black had vanished.

Acknowledgments

With each book it becomes harder to adequately thank my literary pit crew who, over months and years, cheers me on, listens to my endless complaints, turns a blind eye when I stomp around in a bad mood, brings me burritos, asks how it's going (often at their own peril), forces me to go to yoga or even just run around the block for God's sake, reads and rereads my manuscript, offers constructive criticism even though it might result in a beheading, promotes my unsung genius to dubious strangers, and responds to neurotic e-mails with respect and good humor.

Among them, my agents at Inkwell Management, Kim Witherspoon and David Forrer, support my work and believe in me in a way that qualifies them for superhero status.

Likewise, I cannot say thank you enough to my editor *par excellence* Lara Asher, and everyone else at Globe Pequot: Gail Blackhall, Shana Capozza, Allyson Coughlin, Himeka Curiel, Melissa Hayes, Sheryl Kober, Jennifer McKay, and Kristen Mellitt.

I am also deeply grateful for Jerrod Allen, Fiona Baker, David Biespiel, Hilary Black, Hannah Concannon, Kim Dower, Debbie Guyol, Karen Rae Johnson, Stephanie Loftis, Whitney Otto, Danna Schaeffer, and Cheryl Strayed.

A special thanks also goes to the wise women of the Georgia O'Keeffe Museum: Barbara Buhler Lynes, Eumie Imm-Stroukoff, Elizabeth Ehrnst, and Fran Martone.

❧

I cracked wise about the length of the Georgia O'Keeffe Museum's Bibliography, but in truth it's a fantastic resource, available online at www.okeeffemuseum.org.

Some O'Keeffe biographies I'm especially fond of, whose margins are now filled with my scribbles include, *Full Bloom: The Art and Life of Georgia O'Keeffe* by Hunter Drohojowska-Philp; *O'Keeffe and Stieglitz: An American Romance* by Benita Eisler; *Portrait of an Artist: A Biography of Georgia O'Keeffe* by Laurie Lisle; *Georgia O'Keeffe* by Roxana Robinson.

Other books that captivated me and helped me more fully understand the complex woman behind the art: *O'Keeffe* by Britta Benke; *Georgia O'Keeffe: In the West*, edited by Doris Bry and Nicholas Callaway; *Georgia O'Keeffe and the Camera: The Art of Identity* by Susan Danly; *Georgia O'Keeffe at Ghost Ranch: A Photo Essay* by John Leongard; *O'Keeffe, Stieglitz and the Critics, 1916–1929* by Barbara Buhler Lynes; *Weekends with O'Keeffe* by C.S. Merrill; *From the Faraway Nearby: Georgia O'Keeffe as Icon*, edited by Christopher Merrill and Ellen Bradbury; *Some Memories of Drawings* by Georgia O'Keeffe; *Georgia O'Keeffe: Abstraction* [exhibition catalog, Whitney Museum of American Art]; *Miss O'Keeffe* by Christine Taylor Patten and Alvaro Cardona-Hine; *In a Painter's Kitchen: Recipes from the Kitchen of Georgia O'Keeffe* by Margaret Wood.

For a woman who said, famously, that she and words were not good friends, O'Keeffe wrote a staggering amount of letters. These collections capture her intelligence, humor, and

esprit: *Lovingly Georgia: The Complete Correspondence of Georgia O'Keeffe & Anita Pollitzer*, edited by Clive Giboire; *My Faraway One: Selected Letters of Georgia O'Keeffe and Alfred Stieglitz, Vol. 1 (1915–1933)*, edited by Sarah Greenough; *Maria Chabot–Georgia O'Keeffe: Correspondence, 1941–1949*, edited by Barbara Buhler Lynes.

Finally, the astounding two-volume, 1198-page *Georgia O'Keeffe: Catalogue Raisonne*, assembled by Barbara Buhler Lynes, depicts every piece of art made by O'Keeffe (2,045) during her lifetime, and confirms, in case there was any doubt, what all the fuss is about.

Endnotes

Abbreviations of names cited in the notes

Dorothy Brett	DB	Georgia O'Keeffe	GOK
Anita Pollitzer	AP	Alfred Stieglitz	AS
Catherine O'Keeffe Klenert	COK		

Chapter 1

p. 1 "I don't see . . ." GOK to AP. Clive Giboire, ed., *Lovingly Georgia: The Complete Correspondence of Georgia O'Keeffe & Anita Pollitzer* (New York: Simon & Schuster/Touchstone, 1990) 40

p. 3 "When there are . . ." GOK to AS. Sarah Greenough, ed., *My Faraway One: Selected Letters of Georgia O'Keeffe and Alfred Stieglitz: Volume One, 1915–1933* (New Haven: Yale University Press, 2011) 40

p. 11 "I always have . . ." GOK to AP. *Lovingly Georgia*, 46

Chapter 2

p. 15 "Where I come . . ." Sharon Rohlfsen Udall, *Carr, O'Keeffe, Kahlo: Places of Their Own* (New Haven: Yale University Press, 2000) 70

Chapter 3

p. 35 "The best course . . ." GOK to AP. *Lovingly Georgia*, 24

p. 48 "I had stopped. . ." GOK to AP, 1916. Collection of
American Literature, Beinecke Rare Book and Manuscript
Library, Yale University

p. 50 "I enjoyed teaching . . ." Roxana Robinson, *Georgia
O'Keeffe* (New York: Harper & Row, Publishers, Inc., 1989)
91

p. 54 "Thats the hole . . ." GOK to AP. *Lovingly, Georgia*, 84

p. 54 ". . . wonder and fight . . ." GOK to AP. *Lovingly, Georgia,*
68

Chapter 4

p. 61 "Imagination certainly is . . ." GOK to AP. *Lovingly,
Georgia*, 78

p. 67 "I believe I . . ." GOK to AP. *Lovingly, Georgia*, 40

p. 73 "I work on . . ." GOK, 1962. O'Keeffiana: Art & Art
Materials exhibit (Georgia O'Keeffe Museum, Gallery 8)

p. 75 "Like a thunderbolt . . ." GOK to AP. *Lovingly, Georgia*, 87

p. 78 "Am I not . . ." GOK to AP. *Lovingly, Georgia*, 54

Chapter 5

p. 81 ". . . the intensity of you . . ." GOK to AS. *My Faraway One,*
302

p. 82 ". . .brass band in. . ." Georgia O'Keeffe, intro., *Georgia
O'Keeffe: A Portrait by Alfred Stieglitz* (Metropolitan Museum
of Art, 1978)

p. 83 "If at all possible . . ." AS to GOK. *My Faraway One,* 4

p. 84 "When Georgia O'Keeffe . . ." Laurie Lisle, *Portrait of an Artist: A Biography of Georgia O'Keeffe* (Albuquerque: University of New Mexico Press, 1986) 228

p. 91 ". . .wriggling up alone. . ." GOK to AS. *My Faraway One,* 40

p. 92 "Give me flies. . ." ibid., 27

p. 92 "A greeting from. , ," ibid., 10

p. 92 "Flower of my . . ." ibid., 307

p. 93 "You know—I—. . ." ibid., p. 27

p. 104 "You see I'd never known . . ." Mary Lynn Kotz, "A Day with Georgia O'Keeffe," *ARTNews* 76 (1977): 36

p. 105 "Whenever I take. . ." Dorothy Norman, *Encounters: A Memoir* (New York: Harcourt, 1987) 102

Chapter 6

p. 107 "If I stop . . ." *Georgia O'Keeffe,* 224

Chapter 7

p. 129 "Whether you succeed. . ." GOK to Sherwood Anderson. *Georgia O'Keeffe,* 256

p. 137 "she carries dawn . . ." *Portrait of an Artist,* 107

p. 145 "I paint them . . ." *New York Herald Tribune,* Apr. 18, 1954

p. 148 "Miss O'Keeffe has. . ." Lewis Mumford, *New Republic* 50 (March 2, 1927): 41

Chapter 8

p. 155 "Flattery and criticism . . ." *Portrait of an Artist*, 133

p. 165 "strained spinach, peas, squash . . ." Hunter Drohojowska-Philp, *Full Bloom: The Art and Life of Georgia O'Keeffe*, (New York: W.W. Norton & Company, Inc., 2004) 290

p. 167 "a funny soft . . ." GOK to Sherwood Anderson. *Georgia O'Keeffe*, 270

p. 170 "I am West . . ." GOK to COK, July 1929. Estate of Catherine O'Keeffe Klenert

Chapter 9

p. 179 "My feeling about . . ." GOK to DB, 1930. Beinecke Rare Book and Manuscript Library

p. 180 "Freedom is necessary . . ." *Full Bloom,* 308

p. 180 "The relationship was . . ." ibid., 310

p. 185 "The full-hipped Child-Woman . . ." Sue Davidson Lowe, *Stieglitz: A Memoir* (New York: Farrar, Straus and Giroux, 1983) 314

p. 187 "To me they . . ." Ernest W. Watson, "Georgia O'Keeffe," *American Artist*, June 1943

p. 194 "What are those people . . ." www.ghostranch.org/museums-and-activities/okeeffe-tours

p. 194 "It's my private mountain," ibid.

p. 194 "God told me if I painted it often enough I could have it," ibid.

p. 197 "I greet you. . ." AS to GOK. Anita Pollitzer, *A Woman on Paper* (New York: Simon & Schuster, 1988) 249

p. 198 ". . . I will be thinking. . ." GOK to AS, July 1946. Beinecke Rare Book and Manuscript Library

p. 198 "Incredible Georgia . . ." AS to GOK. *A Woman on Paper*, 250

Chapter 10

p. 201 "There is a bit . . ." *Full Bloom*, 441

p. 211 "I like the dirty . . ." Grace Glueck, "It's Just What's in My Head," *New York Times*, October 18, 1970

p. 214 "They tell me . . ." Christine Taylor Patten and Alvaro Cardona-Hine, *Miss O'Keeffe* (Albuquerque: University of New Mexico Press, 1998) 21

p. 215 "You turned page . . ." Michaela Williams, "Georgia O'Keeffe visits Chicago," *Chicago Daily News*, June 17, 1967

p. 218 "You mean Chicago's . . ." John Richardson, *Sacred Monsters, Sacred Masters: Beaton, Capote, Dali, Picasso, Freud, Warhol, and More* (New York: Random House, 2001) 215

About the Author

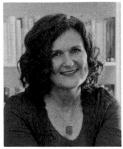

Susan Seubert

Karen Karbo's first novel, *Trespassers Welcome Here*, was a New York Times Notable Book of the Year, and a Village Voice Top Ten Book of the Year. Her other two adult novels, *The Diamond Lane* and *Motherhood Made a Man Out of Me*, were also named NYT Notable Books. Her 2004 memoir, *The Stuff of Life*, about the last year she spent with her father before his death, was an NYT Notable Book, a People Magazine Critics' Choice, a Books for a Better Life Award finalist, and a winner of the Oregon Book Award for Creative Nonfiction. Her short stories, essays, articles, and reviews have appeared in *Elle*, *Vogue*, *Esquire*, *Outside*, the *New York Times*, *Salon.com*, and other magazines. She is a recipient of a National Endowment for the Arts Fellowship in Fiction, and a winner of the General Electric Younger Writer Award.

How to Hepburn, published in 2007, was hailed by the *Philadelphia Inquirer* as "an exuberant celebration of a great original"; *The Gospel According to Coco Chanel* (skirt!), published in 2009, was a BookScan bestseller. Karen grew up in Los Angeles, California, and lives in Portland, Oregon, where she continues to kick ass.